THE MACROMEDIA WEB DESIGN HANDBOOK

THE MACROMEDIA WEB DESIGN HANDBOOK

Richard H. Schrand

CHARLES RIVER MEDIA, INC.
Hingham, Massachusetts

Publisher: Jenifer Niles
Production: Publishers' Design and Production Services
Printer: InterCity Press
Cover Design: The Printed Image

CHARLES RIVER MEDIA, INC.
20 Downer Avenue, Suite 3
Hingham, Massachusetts 02043
781-740-0400
781-740-8816 (FAX)
info@charlesriver.com
www.charlesriver.com

This book is printed on acid-free paper.

Rick Schrand. *The Macromedia Web Design Handbook.*
ISBN: 1-58450-047-6

Library of Congress Cataloging-in-Publication Data

 The Macromedia web design handbook / Richard H. Schrand
 p. cm.
 ISBN 1-58450-047-6 (paperback w/ CD-ROM : alk. paper)
 1. Web sites—Design—Handbooks, manuals, etc. I. Macromedia
(Firm) II. title
TK5105.888 .S36 2001
006—dc21

 2001001581

Printed in the United States of America
01 02 7 6 5 4 3 2 First Edition

CHARLES RIVER MEDIA titles are available for site license or bulk purchase by institutions, user groups, corporations, etc. For additional information, please contact the Special Sales Department at 781-740-0400.

Requests for replacement of a defective CD must be accompanied by the original disc, your mailing address, telephone number, date of purchase and purchase price. Please state the nature of the problem, and send the information to CHARLES RIVER MEDIA, INC., 20 Downer Avenue, Suite 3, Hingham, Massachusetts 02043. CRM's sole obligation to the purchaser is to replace the disc, based on defective materials or faulty workmanship, but not on the operation or functionality of the product.

DEDICATION

To my daughter, Cyndi, with all the pride and love a father can have.

Contents

ACKNOWLEDGMENTS

This, to me, is the hardest part to write, because I hate the thought that I'll inevitably leave somebody out.

To David Pallai and Jenifer Niles at Charles River Media who whole-heartedly jumped on the bandwagon when I turned in the proposal for this book.

To Leona Lapez, JoAnn Peach, Suzy Ramirez, and everyone at Macromedia who provided software and support as I began work on this book. There are so many of you that all I can say is thank you very much.

To Susan Nicholls who introduced me to the joys of the Macromedia experience.

To Donna Drachunas at MediaLab for all the help and support, and for allowing me to play with all those great plug-ins and programs.

To everyone at all the software companies who provided me with their programs to use as I was writing this book. This includes everyone at Curious Labs, Coolfun, Electric Rain, Tech-Smith, and Wildform. There are just too many names to list here – it would take up an entire book just to do that!—but you all know who you are. You're the best!

To my agent, David Fugate and his assistant, Maureen, at Waterside Productions. See! I told ya I could do it!

To my parents, Ed and Jane, and all their friends at the Anderson Senior Center in Cincinnati, OH.

And, of course, to my wife Sharon, my daughters Cyndi and Courtney, and my sons Richard and Brandon.

INTRODUCTION

TRUE CONFESSIONS

I am a web surfing junkie.

There. I got it out of the way.

All the rest of you who are like me, spending what little free time I have between writing and family sitting in front of a monitor soaking up the phosphorous emissions, can now feel more comfortable knowing you are not alone.

What's interesting in my case (at least to me) is the fact that I'll look at any site that pops up. This is because, once again in my humble opinion, every legit site has something to offer. It's fascinating to look at each individual's vision; their way of depicting what their interests are. It's fun getting inside a person's head to figure out why they used a certain color scheme, a particular graphic, or that overall layout. It's intriguing to find out what gets a person's motor started—be it archery, painting, securities trading, or collecting metal shavings. Ultimately, from each site I visit, I take away ideas.

These ideas can be stored away for later use, or for the express purpose of making sure I never inadvertantly recreate it. Because let's face it, there are some fantastic sites out there and there are some really, really bad ones. But one thing to remember is that, no matter how good or how bad the site is, someone put a lot of time and effort into it. And usually those bad sites had more time invested in their creation than the good ones.

Many of the sites I visit are links provided in e-mail groups. Many of those people are asking for opinions on their work—either the new design of their site or a particular image they have just created. From there, I click on other links to other sites which in turn lead to other sites. It's the ultimate pyramid scheme with an innocuous overtone. In over 12 years of surfing, I'm not sure I've ever duplicated a path. And with the web's explosive growth, I doubt I ever will.

CHANGE IS INEVITABLE

I first entered the world of web surfing in 1988 while living in Burbank, California. I entered using a portal that, today, seems as antiquated as a Conistoga Wagon – a 2800 baud modem. Of course at that time the web was nothing more than a glorified Bulletin Board Service with page after page of text. The thought of entering a site with a graphic on it that could ultimately take a quarter-of-an-hour to a half-hour to download was scarier than Linda Blair in The Exorcist.

Shortly thereafter, I purchased the Lambourghini of modems, one that gave me access at the amazing speed of 9600 Baud. Now, that same graphic that took fifteen to thirty minutes to download only took five to ten. It was a marvelous time; a glorious time of lightning fast speed. I was in e-heaven.

Of course those days of patience and perseverence are long gone. The average connection speed around most of the world is between 33.6kBps and 56.6kBps. I, meanwhile, surf with the speed of the USS Enterprise using the gravitational pull of the sun to slingshot myself into the future. Yep. I have one of those high-falootin' cable modems. And this means that, when I have to wait for more than 30 seconds for a full-screen graphic to appear on my browser's window, I'm outta there so fast it makes my monitor spin on my desktop. Patience is a thing of the past. Instant gratification is the name of the game in today's world of surfing.

With the standard phone line using a 56.6kBps modem, it is virtually impossible to reach that speed. The average maximum connection speed with this type of modem is approximately 44kBps.

Twelve years ago I would have laughed in anyone's face if they said that we'd be viewing streaming movies and that the general populace could create and display complex vector animations over the web. Of course twelve years ago I would have been hard-pressed to tell you that I would ever be creating web sites. Back then you had to know HTML. And while I was becoming adept at graphic design using my Mac Plus (and had been overseeing designs and animations for television stations), learning HTML was not in my plans.

These days, HTML, DHTML, Java, and other codes are written for you. All you need to do is design, drag and drop, and—viola!—your page is ready to be viewed by millions of discerning eyes world-wide. Of course that's an over-simplification because there is a lot more to web design than

drag and drop. But that's what this book is all about, giving you ideas on how to utilize the Macromedia family of design tools and create world-class sites that will be the envy of friends, family – and that guy sitting in the cubicle next to yours.

THE BOOK IN BRIEF

This book will be covering the latest versions of Macromedia's programs. This includes Flash 5, Fireworks 4, Freehand 9, Director 8, Coursebuilder, and Dreamweaver 4. On top of that, I'll be either introducing you to or helping you get to know a couple other programs that when added to your suite of tools will make your Web site design life much simpler. And, if you're like me, anything that will help expedite the production process without affecting the quality of the final product, I'm all for it. These programs include Swift 3D for the PC and Mac, Wildform F/X, and PhotoWebber.

It seems like a lot to cover. And it is. That's why this book should be used in conjunction with the User Manuals that come with each program. It is not meant to take the place of them. It is, however, designed to augment those manuals by showing real-world examples of each of them, as well as how various elements were created. Toward this end, The Macromedia Web Design Handbook is set up differently than most any other book on the market. It is split into two distinct parts. The first part (Chapters 1 through 8) give an overview of how each of the Macromedia programs works, as well as some hands-on work specific toward the Web site that is being designed. The second portion of the book, Chapter 9 specifically, deals with final element creation in Flash and Fireworks, and leads to putting together the web site itself, as well as more detailed thought processes regarding why things were done as they were.

You can consider the Macromedia Web Design Handbook as a guide to help you hone the craft of web design creation, offering insight into the changing face of the internet, and how to decide what and what not to include to help make your sites fast-loading and professional looking.

WHO THIS BOOK IS FOR

With that in mind, this book is geared toward everyone who wants to gain an understanding of the ways the Macromedia design tools can be integrated into your daily workflow.

THE BEGINNER AND HOBBYIST

When first diving into web design, the production process can seem rather daunting. You've probably just bought Dreamweaver. More than likely you decided on this program rather than its competition because you have another of Macromedia's products residing on your hard drive. So how do you get one to talk to the other? How do you efficiently bring your vision to the Internet? By following along with the projects in this book, you'll gain a better understanding of how the programs work, talk to each other, and compliment that creative process.

THE INTERMEDIATE USER

You're the ones who may have all the tools but are still trying to get a handle on one or two of them. You're probably looking for new ideas or ways of creating more intricate content. This is what will happen within these pages.

THE ADVANCED USER

You know what? You guys are the hardest people to write for. You're already power users. So what do you need a book like this for? Ideas. Simple as that. All of us who are considered extremely knowledgeable about something find ourselves in the unenviable position of having to continue to top ourselves. This means we need to continually view what others are doing, modify their techniques, and take them to their next level. This isn't stealing, as you well know; it's literally the way that any advancement in any field of endeavor has been accomplished since time immemorial. So for you, this book will hopefully give you ideas from which you can build, expand, and ultimately make your own.

CHAPTER CONTENT

As has been mentioned, we'll be taking you through the creation of a website using the various tools in Macromedia's program stable.

CHAPTER 1 – PRE-PRODUCTION

Get tips and tricks on the thought processes that went into the production of this site, as well as a background on the company that is featured.

CHAPTER 2 – GRAPHIC DESIGN WITH FREEHAND 9

Rather poetic title, don't you think? Here we'll create the graphic elements that will be used within the site. This includes the creation of the logo and

sub-logo, the button designs, and special elements that will be brought into Flash 5 for further effect generation.

CHAPTER 3 – THE POWER TO EXPEDITE

This chapter explores various programs that can expedite your Flash design workflow. The programs include Swift 3D, Wildform's sWfx, Poser Pro Pack, and others, allowing you to build fantastic 3D and complicated text animations in a—well, in a Flash.

CHAPTER 4 – EXPLOSIVE SITES USING FIREWORKS

OK…bad play on words. But in this chapter we'll go further into getting your photographic elements ready for the web and for use in Flash.

CHAPER 5 – ANIMATIONS IN A FLASH

Here we'll create various animations that will show off some of the cooler aspects of the show that's being promoted on the site. We'll use many of the elements created in Chapter 2 to this end.

CHAPTER 6 – USING DIRECTOR

Director, as you know, is the big boy in Macromedia's arsenal. It's used for everything from creating interactive CDs and DVDs to effects in movies and television shows. Here, we'll use Director to create animations that incorporate video clips that both stream and can be downloaded for further viewing.

CHAPTER 7 – DREAMWEAVER VS. DREAMWEAVER ULTRADEV

While they appear the same at first glance, the latter adds additional functionality that is important to know about for added functionality. We'll also discuss what you can do to add this functionality to Dreamweaver through the use of a product called Lasso Studio.

CHAPTER 8 – BUILDING AN INTERACTIVE GAME

One portion of this site has an interactive trivia game—just for the fun of it. We'll build this portion of the site using Coursebuilder, a really cool add-on program that's perfect for this type of content.

CHAPTER 9 – COMPLETING THE SITE

Here's where we put it all together. Throughout this chapter you'll be able to follow along as I build the site that will be placed onto the web. It will include elements from each of these chapters, as well as new elements that will—hopefully—turn this site into one of the most original of its kind on the web.

LEGALESE

The content of this book is taken from the Summer Of '66 musical, performed in Myrtle Beach, South Carolina. It is owned by Jim Owens and the Jim Owens Companies of Nashville, TN, and Myrtle Beach, SC. The material is used with permission of Jim Owens and the files on the CD may be used in conjunction with this book. They may not be used for professional purposes or be redistributed without the written consent of the owner.

WHAT'S WITH THE SONG TITLES?

You'll notice that prior to each chapter I have listed songs from 1966. These songs listed represent their placement on the Billboard charts; so, in other words, the songs listed in Chapter 1 were number one songs of that year, Chapter 2 lists some of the songs that reached number two on the charts, etc.

TIME TO CREATE

So, enough talk. Let's start building that site and discovering the power of the Macromedia Web Design tools.

Site Preparation

THE TUNES OF 1966

Help!—The Beatles
You've Lost That Lovin' Feelin'—The Righteous Brothers
Downtown—Petula Clark
This Diamond Ring—Gary Lewis & The Playboys

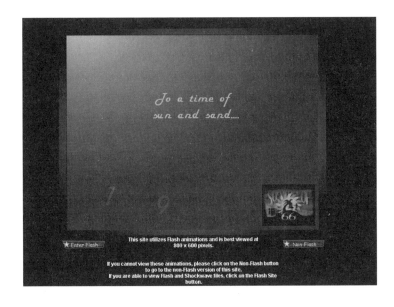

PREPRODUCTION

There are three cardinal rules to Web design:

- Continuity
- Continuity
- Continuity

There is a lot involved with creating a Web site; especially a top-notch Web site. It's much more than just creating a series of elements and links and sticking them on a Web page. Doing that will do nothing but create a site with no continuity; and continuity is the main key to success. If you build a site in which every page layout is different, every element changes, or master links are positioned differently, you're going to lose your audience. They'll quickly become discombobulated.

I'm sure that during your e-travels, you've visited sites with no semblance of continuity. You probably wanted to immediately contact the people who created it and tell them that you have special rates for the Web-site-design-impaired and would be happy to fix it as an e-public service. I'm not referring to graphic elements because, as with anything creative, graphic design is a very subjective subject. Yes, there are basic rules that you should follow, but if it weren't for those individuals willing to break some of the rules, we wouldn't have ever experienced Grunge typefaces.

Hmmm . . . maybe that wasn't such a great example after all. If you're like me, you feel that that whole grunge look became massively overdone and, hence, became more obnoxious than cutting edge.

Anyway, page layout is highly personal, and I wouldn't presume to tell someone that their artwork choices, on a scale of 1 to 10, rate a –15. What I'm talking about in this instance is the way a site is laid out. When you have one that uses different backgrounds for each page, has links at the bottom on page one, on the left side on page two, and none on page three, and the clip art for those recurrent links is different for each page; you definitely know you've reached the site of a Web design novice, and a site that was created in 10 minutes or less. Moreover, unless you go back there for a reminder of what *not* to do, you'll more than likely never visit that site again.

Here's a rather strange way of looking at Web site development: it's much like working in a fast-food restaurant. Now why compare these two rather disparate occupations? Let's break it down.

First, you have the basic elements for all the sandwiches they make. These elements—lettuce, tomatoes, pickles, ketchup, mustard, mayonnaise,

and that secret sauce that tastes like Thousand Island dressing—are comparable to the recurring artwork on your site. You have your art for links, a logo, and a modified logo for every page other than the home page.

Second, whether talking about a fast-food restaurant or the Web site, the production elements are combined in a sensory-pleasing way that is the same on Monday as it is on Sunday. When you walk into that fast-food restaurant, you know exactly what you're going to get, no matter where in the world you are. It should be the same when you visit a Web site. As visitors navigate from page to page, they should feel like they are in familiar territory.

Third, each particular fast-food chain targets its audience. One markets to the younger kids, another to the 'tweens (preteens and early teens), and some to young adults wanting to envision themselves in a time long gone that their parents talk about with joyful nostalgia. While each fast-food chain will also offer something they hope will appeal to other groups, their focus remains on their core client. It's the same with a Web site. You need to know your target audience and keep your focus on them. You can offer things to others as well—those who might come upon your site accidentally – but you should never lose your true focus.

In the Beginning

At this point, we're going to discuss some Web design basics. If you're an experienced designer, you might want to skim through this section, or skip it altogether. The only thing is, as is the case with any profession, it's always good to get a refresher on what you already know, and add kernels of new ideas from which you can draw as needed.

The Business Plan

At the start of any successful venture, there is the business plan. This plan outlines the overall concept, chief competition, a timeline, and a budget. Let's break these down to see how a normal business plan equates to Web site design.

> **Concept**. This is literally the core of your vision. It states what you plan to offer and who your core audience will be. This is where you go into great detail about your vision. Included in this are ideas for promotion and publicity.
>
> **Competition**. You need to do some heavy research for this section. You need to know your chief competitor, and how many others are

offering similar services. You then need to visit their sites and see how they present themselves and, if they actually do this online, how much they charge. This will ultimately affect your concept, as it will give you the ability to know what you need to modify to make your site/company stand out.

Timeline. A timeline gives you an idea of your proposed modification schedule and, if you are building this site to become profitable, an income projection and an expenditure chart. Usually, in a business proposal, this is a five-year projection.

Budget. In a regular business proposal, this would be a spreadsheet showing projected income and outflow for the first five years of your company. For our purposes, this can be the type of graphic elements you will need, broken down on a page-by-page basis. You would create this after you draw your site map (which we discuss in the next section of this chapter).

You should definitely take your time when creating this plan, because it is an extremely important part of making sure you meet your goals. While it may seem tedious and duplicative, you'll find that when working this way, everything will come together more efficiently when you're ready to create your site map and do your actual site design.

SECTION 1: THE INITIAL CONCEPTS

The *Summer of '66* Web site is one of those rare occurrences. I had worked for Jim Owens in an upper management capacity for almost a decade, so he hired me to do the logo and show program design work for the musical. The show program, by the way, is the booklet the audience receives as they enter the theater. I was also given the opportunity to make suggestions during the rehearsals as the show was being staged. Therefore, it was natural that my company build the Web site for the *Summer of '66*. It was a perfect match because I knew the style of artwork Jim likes, and I understood what he was trying to do with the show.

Originally I used a lot of 3D models for background imagery on the site, but with this redesign, which is the topic of this book, I wanted to get it back to the two-dimensional feel like the logo. Figures 1.1 and 1.2 show this new look.

The main reason for building the site was to promote that the show was playing in Myrtle Beach, South Carolina. The Myrtle Beach Chamber of Commerce and other non-theater-related organizations had Web sites that would provide links to the show. That meant that tourists planning to

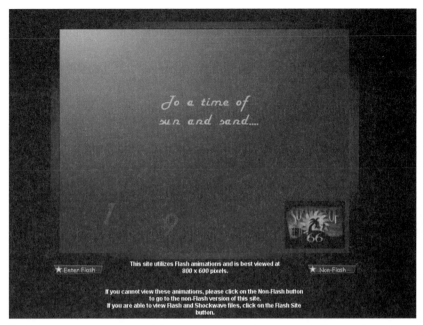

FIGURE *The entrance page of the newly revamped* Summer of '66 *site. This page*
1.1 *features an animated introduction created in Director 8.*

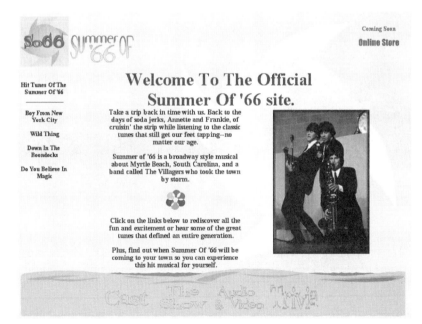

FIGURE *The home page for the site, which keeps the flavor of the logo design while*
1.2 *giving extra room for special announcements. We discuss this more fully in*
 Chapter 9, "Completing the Site."

come to the resort community could find out about the *Summer of '66* production before arriving. Other theaters had links from the Chamber of Commerce's site, and it made sense that we do the same. In many cases, when it comes to tourist areas such as Myrtle Beach, visitors make their plans well ahead of time. Therefore, it made sense to try to capture theater goers any way we could, especially via the Web, so that they could order their tickets (by calling a toll-free number) and have them waiting at the theater when they arrived for the show.

As Jim Owens and I sat down with other theater management, we began to strategize about the site and its layout. As is so often the case, the people with whom I was speaking knew very little about what it takes to get a Web site up and running. They liked the logo shown in Figure 1.3, the style of it, and the colors. We decided the site needed to have that fun flair throughout, while the graphics should not overpower the content so peo-

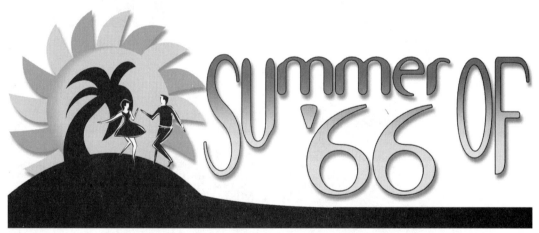

FIGURE *The* Summer of '66 *logo. The design was created to reflect the type of artwork that was used in*
1.3 *that period, and to convey a feeling of fun that was representative of the show itself.*

ple could focus on what *Summer of '66* is. The other aspect that was a definite for the site was relaying that the play takes place at the beach, storywise and physically.

The following is the initial site concept.

Let's take a moment to discuss key terms and search words. When you need to do a search on the Web to find a specific area of interest, you use

SITE NAME: Summer of '66

CONCEPT:

The *Summer of '66* is the only Broadway-style musical in the Myrtle Beach area. Filled with toe-tapping songs that appeal to a broad audience, this show tells the true story of television producer Jim Owens as he turns The Villagers, a band he created for a television program in Charleston, South Carolina, into regional stars.

Songs featured in the show include:

Wild Thing
Boy from New York City
Under the Boardwalk
Leader of the Pack
Unchained Melody
Carolina Girls
I Love Beach Music
Hang On Sloopy
I Only Want to Be with You
Be Young, Be Foolish, Be Happy
Double Shot of My Baby's Love
I Cried
Up on the Roof
You Really Got Me
Loco-Motion
CC Rider
You Don't Own Me
One Fine Day
. . . and over a dozen more hits

Also included on the site:

An interactive jukebox with 10–20-second musical snippets of the hits
A video montage
Detailed background information on the story
Information on the band, The Villagers

The italicized titles are the ones I plan to showcase on the site. These, to me, are very representative of the variety of songs that are featured in the show, and extremely recognizable from that era.

We will design the site with a look reminiscent of the early to mid-1960s. This leaves a lot of room for design work because, while the show telescopes everything into one summer in 1966, in real life it took place from approximately 1965 to 1967. During this time, America entered the most tumultuous period in its history. We went from the innocence of Annette Funicello and Frankie Avalon in *Beach Blanket Bingo*, to the start of the psychedelic works of Peter Max and Andy Warhol (as well as the social upheaval of the pre-Viet Nam War protests). The main graphical focus, though, will be in the *style of the early '60s*, because the show deals with what was pretty much the last summer of innocence for America's youth.

The design will be such that it reflects the feel of the show, and (hopefully) appeals to a wide range of visitors. The core audience is the people who lived during this period, meaning anyone aged 40 to 60. This is the audience who listens to radio stations that play Oldies-style music, and who have fond memories of groups such as The Beatles, Little Richard, The Chiffons, The Embers, and other classic groups and performers. While the core audience is that 40–60 age group, many younger people (ages 25 to 39) and older audiences (61–75) enjoy the variety because it doesn't move into the realm of so-called acid rock, or into the type of music popular prior to 1956. It's literally *toe-tapping, good-time music* that appeals to an extremely broad group.

COMPETITION:

First, there is no other show of its type playing in Myrtle Beach. No other theater presents a daily Broadway-style musical, and there is nothing offered that is both a true story and a look at the history of the Myrtle Beach area.

Myrtle Beach, South Carolina has been a tourist destination for the past 30 years—almost 10 miles of beaches, over 100 golf courses, and a mild climate. In the early 1990s, theaters began to be built to provide more entertainment in the area. Most of these theaters host concerts by top name acts, and some have special variety shows or themed entertainment.

There are almost 30 theaters in Myrtle Beach, each offering some form of nightly entertainment. That means that there are 29 competitors, many of which are within a 20-minute drive from the Crook & Chase Theater where So66 is staged.

Crook & Chase appeals to the Country music audience because of its former television show and ongoing Country music countdown radio

program. This guarantees an initial flow to the site. However, there is so much Country music competition in Myrtle Beach—with more than half of the theaters focusing on Country music—that marketing to this crowd will be extremely difficult. What's interesting, though, is that today's Country music is very reminiscent of late-1950s/early to mid-1960s rock and roll, so there is some worth in marketing to the young Country music fan. However, the thrust of the promotion for this theater should be to the Oldies listeners.

COMPETITION ON THE WEB
There isn't much. Most theaters in the Myrtle Beach area are accessed via the official Myrtle Beach tourism site, which is also accessed via the State of South Carolina Tourism site. The Crook & Chase Theater and *Summer of '66* will be unique with its own dedicated Web site.

 This also means that the show is not dependent on search terms set up by the Chamber of Commerce.

key terms to tell your computer what to look for. Many times, the company you use to house your Web site gives you the ability to assign key terms for search engines (Yahoo!, Excite, etc.) to help people locate your site. In addition, you can assign key terms that search engines will recognize inside the Head tag of your index page. If you do it that way, you also need to submit those key terms to the various search engines so they can then add you to the list of pages that contain those terms. We discuss index pages in Chapter 9.

Key terms are usually one or two words that succinctly describe your site. When you create key terms for your site, you want to consider what most people are going to use first; for example, *cars* if they are looking for information on automobiles, the name of a city they planning to visit, and so forth. You need to take a step back and really think about what words best describe your site and then try to put yourself into the minds of your audience, because your choices can determine where your site will fall in the list of sites that are found in the search. It's tricky, but with a little planning, you can find definitive words that will help place your site at the head of the line.

The following are some of the key terms used for the site (not in order):

Musical
Musicals
Myrtle Beach

Crook & Chase
Lorianne Crook
Charlie Chase
1960
'60s
rock music
60s rock music
Beach Music
Oldies
Broadway Musicals
Grand Strand
South Carolina
Theaters
Theaters in Myrtle Beach
Myrtle Beach Theaters

What will people more than likely use when they are searching for information on Myrtle Beach? Well, if you were going to vacation there, the first thing to type in as a search is "Myrtle Beach." If you wanted to go to a show, you would type in "theaters in Myrtle Beach." Therefore, *Myrtle Beach* is definitely at the top of the key term list. *Theaters in Myrtle Beach* is next, and then *Myrtle Beach theaters*. The references to Crook & Chase are due to their popularity with the many Country music fans who go to Myrtle Beach on vacation (most theaters in the area feature Country music acts), because of their long-standing television show on the former The Nashville Network. After that, the other terms can be used. In the next section, we'll talk some more about marketing concepts to help flesh this out.

The final portion of the concept notes was a note to me on how long it would take to produce the site on a full-time basis.

SITE TIMELINE

Due to the various elements that are production-heavy, such as video clips and interactive elements such as the online jukebox and a short quiz-style game, the timeline for producing the Web site is approximately 6 to 10 weeks.

This sample of the concept for the site should give you an idea of how to lay one out, and it will really help in focusing your artistic direction. Again, this is a shortened version of the proposal because the original takes up about 20 pages.

BUDGETING

Let's take a few moments to look at what you need to consider when putting a budget together. If you are a freelance designer who is doing this for extra income or you do this full-time, you need to establish a base rate. It could be a certain dollar amount per hour based on what competitors in your area charge, or a certain amount for a base number of Web pages designed. For example, you might charge $25 per hour, or $100 for four basic Web pages. Your rates can then go up if the number of pages exceeds that base.

What's a basic Web page? One that contains the basic elements that comprise a Web site. It would include scanning of images and/or the client's logo, text, and links. Your rate reflects the time it would take to scan the images, and develop and create the Web site. In many cases, a company will include the creation of a basic logo for the client if needed.

You then need to decide on either a base rate or hourly rate that would come into play for the following:

1. Extra pages for the Web site
2. Animations
 a. Flash
 b. GIF
 c. Freehand
3. Audio
 a. Transferring into the computer
 b. Editing
 c. Preparation for Web delivery
4. Video
 a. Transferring into the computer
 b. Editing
 c. Preparation for Web delivery
5. 3D design and animation (if you do 3D modeling)

Each of these should have an increasing hourly or flat rate. In other words, creating extra pages of a basic nature should have the lowest hourly rate based on your minimum fee. Creating GIF or Freehand animations should cost less than creating a Flash animation, but should cost extra over the basic page rate. Editing audio and video, as well as creating 3D models and/or animations, should cost the most because these are highly specialized areas. Think of it this way: anyone can buy a Web design program and create a basic Web page. Many don't have the time or the interest or knowledge to do numbers 2 through 5 on the list.

Remember that you're the expert and you need to price yourself accordingly. You need to exude that aura of expertise and always be ready to justify your pricing structure. It's a fact of life that, whether you charge

$75 or $10 per page, your client will think it's expensive. You have to be prepared to tell him or her why it's not only well worth it, but cheaper in the long run to pay you to do this work.

MARKETING/PROMOTION OF YOUR SITE

Let's think of marketing for a moment. Key terms, as discussed previously, are probably your top priority when it comes to a marketing plan. Those key terms come from a good knowledge base, which is where you need to do some homework, especially if you are not overly fluent regarding the industry of your client. However, whether you know the client's industry intimately or not, the direction for marketing a site is pretty much always the same: target your audience. This means reaching the people who use that particular product. In the case of *Summer of '66*, it's reaching the people who listen to Oldies rock music as well as current Country music, because modern Country music draws heavily from the rock and roll of the early to mid-1960s.

If you know an industry already—such as the logistics industry (companies that specialize in delivery of packages and goods such as the trucking, shipping, and freightline industries), fast-food industry, or retail—then you probably know the types of industry publications the managers read. If you don't know the industry, you need to find that out.

How? First, by asking. Ask tons of questions and don't think that doing so will make you appear stupid—quite the opposite. All managers love to talk about their industry and show their knowledge of it—they'll be impressed that you are asking. Also, there is absolutely nothing wrong with asking for examples of trade publications. All you have to do is say that you want to use them for research so you can better represent the client on the Web.

Here's another idea: If the client has advertised in the past, ask for samples of the designs. This lets you see exactly what look the client likes and gives you a base from which to start. Don't be afraid to tell your client exactly why you want to see the samples; more times than not, they'll be impressed with your eye to detail. What you *don't* need to tell them is that it will also give you an insight as to what their marketing strategies are—how the company tries to separate itself from the competition.

To flesh this out some, let's use the context of the *Summer of '66* site. We knew whom we wanted to reach; that was determined early on (and discussed at the beginning of this section of the chapter). The bulk of the work was already complete. Some more research was in order, though. Here's what I still want to find out:

1. What are the main tourist months?
2. From where do most of the tourists come?

3. What Oldies stations are in those markets?

We'll take these in order—after some explaining. Along with the logo design and the Web site, I was also hired to do some extra marketing for the show. I was to perform a two-week marketing blitz, traveling to the major cities in regions that were home to Myrtle Beach visitors and line up ticket and trip give-a-ways. I also used this opportunity to make some deals to generate traffic to the Web site when it came online.

First, I went to the Myrtle Beach Chamber of Commerce, and then spoke with the Marketing Director of the Crook & Chase Theater. I knew I'd get the same answer as to when the tourist season started, but I also knew I'd get different answers regarding to whom these two groups were marketed. The theater did most of its marketing to areas within a day's drive of the town; the Chamber marketed to a much broader base. The former was built around the weekend getaway group, those who would come to the area on a Friday and leave on Sunday. The latter wanted to reach anyone in the country who was interested in golf, the beach, and the entertainment in the area. When combined, the bulk of the tourists came from as far west as Missouri, to as far south and north as Florida and Ohio.

Because I only had two weeks to make the initial contacts and get the promotions set up, we decided to focus on the following cities: Knoxville, Tennessee; Asheville, Raleigh-Durham and Charlotte, North Carolina; Greenville-Spartanburg, South Carolina; Columbia, South Carolina; and Charleston, South Carolina. That allowed me one day to drive between cities, spend a day in meetings at the various Oldies and Country radio stations, meet with the editors of local papers, and then move on to the next town.

The idea—and to bring this back to the topic of marketing—was to get radio stations and newspapers to provide links to the *Summer of '66* site, thereby generating extra traffic from a targeted group of people. That, in turn, would (again hopefully) generate ticket sales, which would then lead back to my being kept on to oversee the site and do some more freelance marketing. As you can see, with some creative thinking you devise a plan that will almost ensure a base level of visitors to a site by looking beyond the normal and providing incentives to build mutually beneficial relationships with other potential clients.

You can come up with ideas like this regardless of your client's industry. A little research, a few pointed questions, and you could help generate traffic to any site you create.

SECTION 2: PRODUCTION ELEMENTS

So far, you have gotten a good feel for what research should occur as you start the site design process. There are also a number of things you should do to act as visual cues and reminders (a cheat sheet, if you will) for your reference as you begin focusing on the layout of your site. This entails drawing a map of the pages that make up the site, as well as doing extra research that can be referred to in order to keep the theme consistent throughout.

THE SITE MAP

The site map is a graphic layout of your design. Usually, you can fit it on one page as shown in Figure 1.4. Don't underestimate the value of the site map. While it may seem like extra work, it acts as both a visual reminder to yourself and a pre-evaluation page for your client. You can show it to your client, discuss how it works, and give them a better understanding of the basic structure you are creating.

The site map acts as a basic table of contents that shows how each page of your site relates to all the other pages. This also gives you a visual reference to help you remember what links you need to create, and gives you a start on ideas of what type of copy you'll need to write for each page.

A site map is pretty straightforward and only takes a little while to put together when done following the writing of a site proposal.

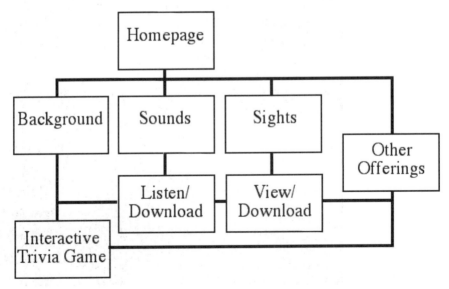

FIGURE *A sample site map.*
1.4

SOME MORE RESEARCH

As you read in the sample business plan, the *Summer of '66* site will have a pretty strong mid-1960s artistic flavor. Graphically, what did the 1960s look like? If you lived through them as I did, you have a fairly good idea of what was hot; it was a transitional time between extremely colorful and the tried-and-true duotone layouts similar to Figure 1.5.

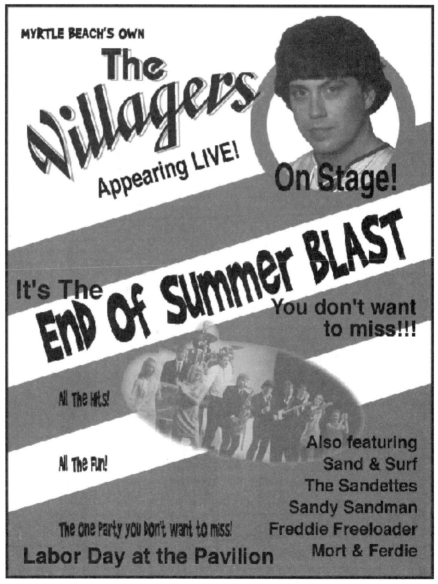

FIGURE *A look at the style of posters advertising concerts in the late-1950s to mid-1960s.*
1.5

The poster styles could be used rather effectively as the overall theme. Look at the one on the left, the one that represents the most basic poster style that was used for almost a decade of rock-and-roll concert promotion. While it definitely gives the feel of the early 1960s, it really doesn't lend itself as a site theme.

Think of how difficult it would be to recreate this style while also showing samples of the show. It's one thing for a poster to show one or two performers, but to show an entire cast of a musical such as this and create excitement for the show would be more trouble than it's worth. Moreover, if you look even deeper into the design, you can see how tiring the look would become as page after page recreated this poster look.

We also need to add the logo and its stylistic approach into the design equation. Refer back to Figure 1.3, which shows the *Summer of '66* logo. The colors are a gradation between yellow and yellow-orange. It has both the feel of that transitional time between the simple stylistic approach of the poster recreation on the left in Figure 1.2, and the more psychedelic style of the mid- to late-1960s look on the right.

Where's the middle ground? You'll find out as you move through the book. Now is probably a good time to give you a preview of where my head is at as I design a site, because it will give you an insight into where we're going as you work your way to the end.

FINDING A NEAT, KEEN, SUPER-COOL, AND GROOVY LOOK FOR THE SITE

We need to consider a few more design issues. Today's hot Internet look is what I call a futuristic recreation of every space movie ever created—from *Flash Gordon* to *The Terminator*, with 10-ton metallic machinery filling the screen as in Figure 1.6. I could use that look, turning it into a time machine type of site that takes the visitor back to the 1960s. However, to me, that's forcing an issue because it's not really appropriate for what I stylistically want to accomplish. I also believe it's starting to become overused, losing its impact much like grunge fonts. I don't want heavy—I want light, airy fun.

Here, then, is where some more research comes in. It's been 34 years since the summer of 1966, so it wouldn't be out of the question that, for those of us who were around back then, our memories might not be as clear as we'd like. I'm not even going to go into the possible reasons for this other than sheer age. That means we need to find samples that will help jog our memories and to use as possible templates for our artwork. The Web is the perfect place to start. Here are a few sites that deal with this time period:

FIGURE *A sample of the futuristic machinery that is proliferating across the Web.*
1.6

Trivia: www.1960sflashback.com
The *Batman* TV show: www.geocities.com/Hollywood/Hills/1391/
 bp1966.html
Top Songs: top40gold.com/album/1966-BillboardTopRocknrollHits.html
Fashion: www.geocities.com/modmiss
Art: www.petermax.com

This will give you a good start and a nice sprinkling of what made 1966
. . . well, 1966.

COLOR YOUR WORLD

As has been said (and proven true over and over again), "what goes
around comes around." Many of the color schemes from the mid-1960s to
early 1970s (not to mention the clothes) have come back into style. Greens
and purples, yellows, and many other primary colors were the hot colors
during that time, as were earth tones and muted hues. Again, 1966 was that
center point where two divergent graphic ideas were competing with each
other. Earth tones and muted colors were being pushed out by the bright-
ness of the primary colors. However, in 1966 they co-existed; not neces-
sarily harmoniously, and not necessarily for the betterment of our visual
enjoyment.

The colors you choose for your site are extremely important. There is so much more to color than just choosing what is fashionable or what compliments another color on the page. Color is a subliminal entity; it triggers a subconscious reaction—whether it is sorrow, fear, worry, happiness, or calm. For instance, red triggers a response that tells us to be on the look-out and to stop. It's also the color associated with anger. Green, of course, is the color associated with envy, but it also connotes growth since nearly every plant on earth is either green or has green in it. Blue is associated with peacefulness (picture sitting on a beach late at night, the waves gently splashing on the shore) as well as cold. You can see where color choice becomes very important to your site design.

There are, of course, other factors that come into play that go beyond the emotional significance of color. Black, which usually connotes emptiness and dread, can be used (and very often is) because it makes colorful images look more vibrant. If you're creating a site that will focus on artwork, black is usually a good choice to use—either as a thick frame around the image or as the entire background. White is overused because it is so glaring—it tires the eyes very quickly. You can offset this problem by adding a touch of gray to white to lessen the harshness. Other colors, such as yellow, purple, or green, are just painful—literally. Therefore, unless there is a definite need to do so, and unless they are well thought out, bright multicolored backgrounds should be avoided like the plague. They grab attention away from the content you're trying to convey, and making that content readable is almost impossible.

There are a number of books on the subject of color creating mood, including Charles River's *3D Lighting: History, Concepts, & Techniques* by Arnold Gallardo.

For the purpose of this site, I'll be leaning more toward primary colors, because these were prevalent during the time period. We'll use those colors in decorative elements of the site, however, not as the main colors. Instead, my background will actually be an extremely light blue so as not to take away from the actual content of the page. When it comes to little highlights or decorative elements such as the series of circles dividing one set of text from another as shown in Figure 1.1, I will use bold reds, blues, greens, and yellows.

Muted tones will also be included on the site, and will come from some old photos I have of the original Villagers that have been modified to look like sepia-toned images. Those muted colors will stand out nicely from the background, and the sepia tone (which is a light gold-brown color you see in very old photographs) won't clash with the background color.

K.I.S.S.

The one phrase that always goes through my mind whenever I begin a design—be it for a television station look, an on-air promo, a print ad, or the Web, is *Keep It Simple, Stupid*. I personally believe there is no better phrase for Web design than that. I like clean layouts that don't force me to spend inordinate amounts of time trying to find the link that I want to go to or the information pertinent to my interests.

When you consider all the visual clutter we have to endure during our daily existence, some relief can be very compelling and calming. Not only do we face this clutter on television and in the newspapers, many Web designs are cluttered as well, whether they need to be or not. For whatever reason, that seems to be the design style du jour. If you really think about it, the print ads that don't try to fill up every available centimeter of space are the ones that first catch your attention. Creative use of space can really add to the attractiveness of your design.

I try to bring this idea to the sites that I design. By incorporating blank space as part of the design, a feeling of calm is transmitted to the viewer. It's a subliminal element to my design process, but one that has proven very successful for me. When you consider that the *Summer of '66* site is emulating what is now considered a simpler time without the frenetic pace of the end of the twentieth century, the use of "white space" will fit perfectly. Remember, 1966 was just prior to the beginning of the psychedelic days and artwork that used all primary colors in a swirling dervish that went from edge to edge.

Simple doesn't mean *simplistic*. Simplistic is stick figures. Simple is using only the elements that are absolutely necessary without going overboard with extraneous artwork that has nothing to do with the overall concept. With that in mind, each element in the upcoming pages was created for its content value rather than as filler.

Simple means using black-and-white photographs saved as duotones that incorporate colors that are reminiscent of the time instead of trying to build a site using design elements from those same posters. It's simple to do, but when done correctly is highly effective.

A FINAL THOUGHT BEFORE STARTING

As we begin to design the site, it might be good to get in the mood. Remember, we're traveling back in time. We need to get into the mind-set to keep us on track. Turn on an Oldies station, buy some CDs by The Embers, The Beatles, The Stones (pre-1967 for both of these groups), Beach

Boys, or others, and get into the toe-tappin' good times of the period. Play the music as you're building the elements. Use it to remember (or discover) the fun you are ultimately trying to convey. Then move on to Chapter 2, "Graphic Design Using Freehand 9," where we'll begin creating elements for the *Summer of '66* using Freehand 9 and some of its cool new tools.

2

Graphic Design Using Freehand 9

More Hit Tunes of 1966

(I Can't Get No) Satisfaction—The Rolling Stones
Yesterday—The Beatles
Turn! Turn! Turn!—The Byrds
I Got You Babe—Sonny and Cher

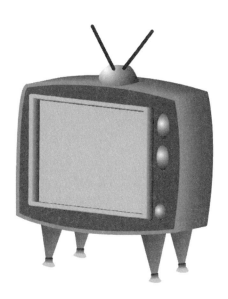

INTRODUCTORY NOTES

Anybody who has used Freehand in any of its incarnations knows that it almost becomes a way of life. With so many features offering so much potential for creative output, Freehand fanatics would rather give up their right foot than be handcuffed to any other program. Therefore, it only makes sense that as we start the design of our Web site that Freehand be the first program to which we turn. With version 9.0.2, there are even more reasons for this to be true.

The Perspective Grid. A really cool addition that gives you a grid to create precision perspective views of your work. The grid itself, seen in Figure 2.1, does not print.

Path Editing. Now you can edit segments of paths without using Bezier control points.

Envelopes. Gives you the ability to create envelope transformations that you can assign to any selected elements.

New Selection Commands. These new commands include a Lasso tool, and Invert Selection and Subselect commands.

Path Blends. You can now assign blends to one or more composite paths.

FIGURE *The Perspective Grid on the workspace.*
2.1

These are just a few of the added features and some of the ones we'll be using as we build the elements for the *Summer of '66* site. While you can create Shockwave (.swf) files for use in Flash, we aren't going to necessarily focus on that aspect. Although we will look at this option, there are so many other elements that need to be built that creating .swf files in Freehand is not necessary for this book.

STYLIN'

What were great about the mid-1960s were the diverse stylistic approaches to advertising and design. There were many patterns, a lot of what we would now call seamless texturing, and, as the late 1960s took a foothold, things became rather . . . well, psychedelic. Black lights, strobe lights, beaded curtains—they all made appearances around this time, so Day-Glo colors (the type that reacted under black lights) became all the rage. These started to appear near the end of 1966 and, since some of the music in this show fell within the late-1966/early-1967 timeframe (such as *Black Is Black*), we can use some of those brilliant hues to decorate our e-landscape.

We have some literary license because the line between these two extremely diverse styles is so blurred. When people who lived through that period think back to it, the more staid looks of 1957–1965 meld almost seamlessly with the wilder look of 1966–1970. What's also interesting is how the latter part of the decade stands out so much more vividly. It's almost as if anything prior to the days of hippies and psychedelia are the looks of the entire decade, while anything connected with Frankie Avalon, Frank Sinatra, Edd "Kookie" Burns, and Fabian was part of the 1950s.

This means that we have much more freedom in our designs. We can fudge a little bit; not a lot, but a little, because if we go too far toward the end of the decade, we'll be found out by someone, somewhere. Therefore, what we'll do is use a lot of bright colors, some interesting patterns, and elements that evoke a certain feeling rather than are a recreation of the actual art of that period. We will attempt to keep that innocence that was *Beach Blanket Bingo* and *Love Me Tender*, and avoid the emerging state of unrest that ended the 1960s.

ELEMENTS

The elements that we will create in Freehand 9 for the *Summer of '66* site are as follows (although we won't build them in the order listed; we'll go from easiest to most difficult):

- Rollover buttons for the various links
- A highly stylized television set
- An animated sun (which is where we'll build a .swf file)
- Stylistic frames
- The various parts that will become a stylized jukebox

The first isn't any surprise; what site doesn't include rollovers? The television set will be used for remote rollovers (or advanced rollovers, depending on which term you'd prefer). The sun will act as a repeating element that holds the site together. The jukebox will be used for music clip selections. We'll use the frames for . . . well, for framing photographic elements. Figures 2.2, 2.3, 2.4, and 2.5 show what the last four elements will look like.

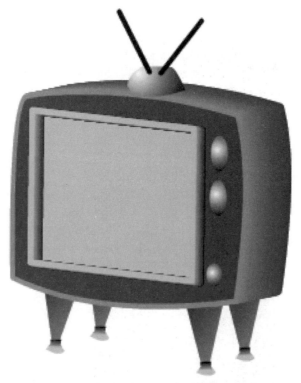

FIGURE *The stylized television set.*
2.2

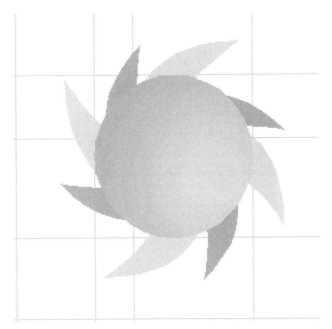

Figure **2.3** *The sun.*

Figure **2.4** *The completed jukebox.*

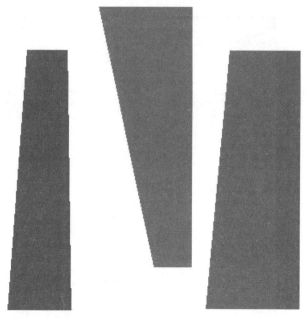

FIGURE *The photo frames.*
2.5

TYPE CASTING

First, we need to choose some fonts. We could create fantastically appropriate graphics, but without the right font, those graphics would all be for naught. Typefaces are as much a part of a concept as your artwork, your color scheme, and your layout. If you think about it, if a script font like the one used for virtually every wedding announcement was used for the title of *The Terminator* or *Star Wars*, the entire feeling of the movie would be lost. In addition, while it may seem like a small part of the overall package, the smallest links, when faulty, can turn success into failure.

There are numerous sites on the Web where you can download high-quality original fonts for a small price or for free. While many fonts are rather mundane, shall we say, or make small changes to existing font families, there are some that are unique. This is where I found four font families, all of which can work perfectly on this site. The first font family, Brady Bunch, shown in Figure 2.6, looks exactly like the typestyle used on that cult favorite television show.

The next font family I found was Action Is, a tribute to font styles used in films such as the Austin Powers series. This one uses what could be con-

SUMMER OF '66

Summer Of '66

FIGURE *The Brady Bunch typeface.*
2.6

sidered a late-1960s style with plenty of flowery frills as you can see in Figure 2.7.

The really cool fonts that can be used in many different ways are StereoHiFi and Stereofidelic, seen in Figure 2.8. StereoHiFi, unfortunately, does

SUMMER OF '66

FIGURE *The Action Is typeface.*
2.7

summer of

SUMMER OF '66

FIGURE *The StereoHiFi (top) and Stereofidelic (bottom) typefaces.*
2.8

not contain numerals, but it looks a lot like the typeface used for a logo found on a popular stereo system of that decade.

Finally, there is the fontdinerdotcom font family seen in Figure 2.9. This is a much thinner, yet highly stylistic font that can be used in many different ways. Some lowercase letters also have some added frills that fit with design elements used throughout the site.

SuMMER OF '66

Summer Of '66

FIGURE *The fontdinerdotcom typeface.*
2.9

You can find these and other fonts at www.fontdiner.com. You can find a number of free font styles there, and typeface groups sold at nominal prices. You can find the fonts used in this site on this book's companion CD-ROM.

 You can find the entire family of fontdinerdotcom fonts on
ON THE CD *the companion CD-ROM.*

DESIGN TIME

Enough of this build-up; it's time to actually begin to work on the various site elements. To begin, we'll create some designs that will only appear occasionally.

One aspect of Web design (or any type of design for that matter) is having more elements than you might actually use. As with virtually anything else in life, it's better to have choices. I'd rather spend some extra time at the beginning creating elements that won't be used, than find I actually need more elements three-quarters of the way through the creation of the site, and then have to go back to create more, which makes me lose my

train of thought. Since my focus is on building the Web page, to stop and return to Freehand, Flash, or some other program to create more image files breaks my mental flow (or what's left of it).

MAIN DESIGN ELEMENTS

The first elements to create are misshaped rectangles that we will use as various frames for overlaid text or images when we bring them into DreamWeaver 4. These are extremely simple elements that when used correctly will really add to the overall feel we're going for. These rectangles were a staple of designers everywhere during this period of time. So, let's open Freehand and get started.

First, turn on the Rulers option by going to View > Page Rulers > Show. If it isn't set up for Inches, go to the bottom of the workspace and choose Inches from the pop-up menu as shown in Figure 2.10.

Next, make sure the Rulers show the upper-left corner of the page as 0 by clicking and dragging from the upper-left corner of the document window (the area that looks like off-centered crosshairs) to the upper-left corner of the page display.

These frames should be .75" wide by 2.5" tall. To make sure we get the correct dimensions, set guides by dragging from the Ruler area onto the workspace, linking the horizontal guides with the vertical ruler display, and the vertical guides along the horizontal ruler display as shown in Figure 2.11.

Now use the Pen tool to create the first rectangle. Remember, this isn't supposed to be a perfect frame; rather, it should be angled along one or more sides. Figure 2.12 shows the first rectangle outline.

FIGURE *Changing the Ruler display to Inches.*
2.10

FIGURE *Guidelines set.*
2.11

FIGURE *The first stylized rectangular frame.*
2.12

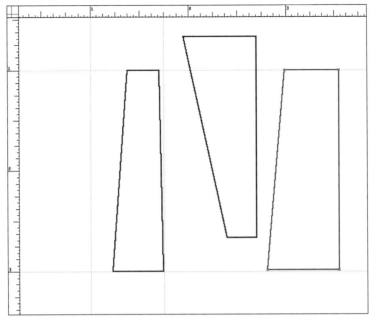

FIGURE *Three rectangles ready to have color added.*
2.13

Create two more rectangles that look similar to Figure 2.13. Then it will be time to fill them with color.

I assume that you know how to assign colors to an object in Freehand. If you are unsure of how to do this, refer to the Using Freehand *manual included with the program.*

We want the color of these frames to be bright and fun; therefore, staying with the style of this decade, we'll use primary colors. This means we can use our system colors (whether Mac or PC). For the first frame you created, assign a bright purple (R-220, G-48, B-173). The second frame should be green (R-93, G-163, B-30), and the third should be Red (R-239, G-31, B-39). Select None for the Stroke.

Save these three frames as PrimaryRectangles. Why? First, as mentioned earlier, you want to have more elements than you might actually need so you don't have to create something during the site design process; and second, because the subdued colors might actually add a more accurate and less overpowering look to the site than the bright colors. The brighter colors could be too bright and work against me by being too obvious. So, assign the following colors to the frames from left to right:

1. R-250, G-212, B-168
2. R-224, G184, B-105
3. R-255, G-233, B-87

Save this set of frames as MutedRectangles. Place these three files in a special folder where you can find them easily.

The next elements we'll create are the buttons. We only need to do one design here, because each button design will be the same. These will be rollover buttons, both standard and advanced, so we'll need to create a look for the Main and a look for the Over state.

To stay with the site theme, these buttons will be overlapping triangles that almost appear to form a six-point star. The bottom triangle will be drawn on one layer, while the top triangle will be on a second layer. These buttons will be drawn at 1" × 1", so set up your guides appropriately. Also, create a horizontal and vertical midpoint guide between the ones you just set so your workspace looks like Figure 2.14.

FIGURE *The button guidelines.*
2.14

Make your first triangle, starting at the upper midpoint and working around the guides. Then make a second layer and draw another triangle, this time making the start point the leftmost midpoint. Your document should look like Figure 2.15.

FIGURE **2.15** *The two triangles that will make up the rollover buttons. I turned off the guides so you can see them better.*

The lower button will be the purple color you assigned to the first rectangular frame. The upper triangle will be assigned the green color. Rotate the purple triangle 15 degrees and the green triangle –15 degrees. Then, using the Rotate tool, manually rotate the green triangle and position it as shown in Figure 2.16.

FIGURE **2.16** *The two triangles in their final position.*

For a third layer, we'll add a text box that incorporates a blend to give it some depth. Create a rectangle over the center of the triangles with the following dimensions:

Width: 1.117
Height: .35

Fill this rectangle with black, and select None for the Stroke. Change the Corner Radius to .5. Once you've done this, you will probably need to reposition the newly created oval to center it over the two triangles as shown in Figure 2.17.

Copy this oval, and go to Edit > Paste in Front. Change the dimensions of this second oval to:

Width: 1.031
Height: .304

Assign a bright red color to this oval and center it inside the first oval. Use the Shift key to select the bottom oval along with this red one, and choose Modify > Combine > Blend. In the Information window, change Number of Steps to 50 so your image looks like Figure 2.18.

FIGURE *The first oval in position.*
2.17

FIGURE *The finished text oval.*
2.18

Notice how the elements look jagged. Look closely (if you really need to) at the edges of the triangles. This is because you're more than likely in Preview mode. To find out, look at the bottom of your workspace window and you'll see, immediately to the left of the Measurement pop-up, another pop-up that says Preview as shown in Figure 2.19. Click on this to open the various view options. At the bottom of this list is a feature called Flash Anti-alias. Select this and watch your artwork smooth out significantly as shown in Figure 2.20.

This is that area I told you about at the beginning of the chapter. You can use this feature to find out exactly what your artwork will look like when imported into Flash for final animation.

Now might be a good time to discuss Flash animation export using Freehand.

First, you can export single page and/or layered frames, Flash (.fla) format, or as Shockwave (.swf) (Shockwave) files. Supported features include:

| 100% | ▼ | ◁ | ▷ | 1 | ▼ | Preview | ▼ | Inches | ▼ |

FIGURE *The screen display pop-up location.*
2.19

FIGURE **2.20** *An anti-aliased look at the artwork using Flash Anti-alias.*

Basic strokes

> *Fills*
> *Gradient fills*
> *Transparencies (known as Lens fills)*
> *Blended paths*
> *JPEG, PNG, and GIF image files in RGB or CMYK TIFF files*
> *Text converted to paths*
> *Composite paths*
> *Arrowheads*
> *Blocks of text*
> *Clipping paths with vector or image files*

This gives you a great deal of power, and ultimate control over the content of your Flash files.

Back to our Freehand elements.
We need to create six text layers, one line for each of the buttons:

Text Layer 1: Home
Text Layer 2: The Story
Text Layer 3: Tunes
Text Layer 4: Cast
Text Layer 5: Videos
Text Layer 6: Extras

Rename the layers by double-clicking on the name in the Layers window and typing in a more descriptive one.

Since the buttons are small, we'll use the Brady Bunch font because it's nice and thick. To get the greatest effect from this font, make sure you use both upper- and lower-case letters. Figure 2.21 shows the Tunes text with a color assigned. The text needs to be resized and positioned to fit inside the red area of the text box.

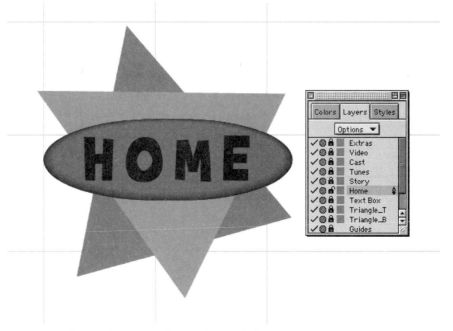

FIGURE *One layer of text using the Brady Bunch font.*
2.21

If you don't have the Brady Bunch font, you can go to www.fontfreak.com. Select the PC fonts section of the site. Another cool font that you can use is Bellbottom.Laser, available at www.fontempire.com. (You'll find Brady Bunch at this site as well.)

When downloading PC fonts, Mac users will need to convert them to Mac format by using a program such as TTConverter (TT stands for TrueType). You can find this shareware program at www.ngenious.com/signaturefactory/ttconverter.htm.

Lookin' pretty groovy. I don't know about you, but I almost feel like heading to the laundry room and creating some tie-dyed t-shirts.

That's basically all we need for the buttons because, once the triangle layers are imported into Flash 5, we can rotate them to create the rollover effect, as well as make the appropriate text appear. We'll begin working on projects like this in Chapter 5, "Animations in a Flash." We'll also be creating rollover buttons in Chapter 9, "Completing the Site."

HERE COMES THE SUN

OK. It's time to create the sun, which will act as the logo tie-in throughout the site. The sun is an extremely prominent part of the logo and perfect for this purpose. Plus, when you really think about it, if we were to play a word association game and I said "beach," the first thing you'd probably say is "sun." Sand could be a close second. Possibly the phrase "sun and sand" would come to mind. No matter in which order these words or phrases popped into your head, "sun" would definitely be right up there. Moreover, since we're talking about a musical that has a storyline based at the beach, the sun again makes perfect sense as the main repetitive element on the site.

The sun itself is an easy element to make. It's made up of three layers: a back ray layer, a front ray layer, and the sun itself. Begin by creating a new document, open the rulers, and set the measurement to Inches. The globe of the sun is going to be a 1" × 1" circle, and the rays that flow out from the globe will be .5" tall (at least the visible part of the rays is that size). Set up your guides as shown in Figure 2.22. (Hey! 222! A kewl old TV series— *Room 222* with Michael Constantine as the principal. How's that for some trivia, dear reader!)

Create two more layers and name them, from the top of the list down, Sun, Ray_F, and Ray_B. Lock the Ray layers, and select the Sun layer and the Ellipse tool. Hold down the Shift key to constrain the proportions of your globe, and draw out the circle that will be the sun inside the guides as shown in Figure 2.23.

The sun uses a gradient fill of yellow-orange (outside color) to yellow (interior color). In the Fill Inspector window, select Gradient, and change to the Radial gradient by clicking on the button below the first color pop-up (see Figure 2.24). Select a yellowish-orange color and assign it to the top chip in the gradient bar. Then select a bright yellow and assign it to the bottom color chip. Make sure to add these colors to the list, because they will be assigned separately to the Ray layers. Finally, choose None for the Stroke and lock the layer.

FIGURE *The sun guides.*
2.22

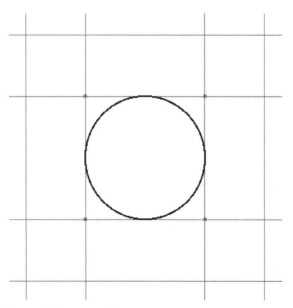

FIGURE *The sun in place.*
2.23

Select the Ray_F layer. With the Pen tool activated, start creating the first ray from the sun. Do this starting at approximately the 1/4 point of the guideline at the top of the sun, and create a curved line with the tip at the upper-right corner. Repeat the process to create the other side of the ray, and then connect to close it out. This ray is much too large for the sun, so you'll want to move it down into the sun until it's in the position you see in Figure 2.25.

Assign the yellow color as the Fill and remove the Stroke. Duplicate this ray, select Edit > Paste in Front, and rotate it 90 degrees. Repeat this process two more times so you have a sun ray coming out from each cardinal direction as shown in Figure 2.26. Finally, group the four rays, lock the layer, and make it invisible. Only the outlines of the rays will be visible, and you'll use those as a template for the first ray layer.

Unlock the Ray_B layer. Trace any of the Ray_F outlines and then follow the procedure just discussed to duplicate and finally group them. The color of these rays should be the yellow-orange color you saved. Rotate this layer 45 degrees, and then Scale it to 90%. Your sun will now look like Figure 2.27.

FIGURE *The Radial gradient*
2.24 *chosen in the Fill*
Inspector window.

FIGURE *The first sun ray in position.*
2.25

FIGURE *The four rays. (Sounds like the name of a singing group, doesn't it?)*
2.26

FIGURE *The completed sun.*
2.27

If built differently, we could save this file as an animated Shockwave file. To simulate the movement of the sun rays, alternating between the yellow and orange layers, put each ray on its own layer. Then, go to the Xtras > Animate > Release to Layers and, from the pop-up menu seen in Figure 2.28, choose Sequence. This would make the rays appear, in sequence, around the sun. The only thing to be aware of is that the sun itself will drop out until its layer comes up in the sequence. To avoid this problem, save the sun as a separate file to place over the ray rotation sequence in Flash. After the sequence is set, go to File > Export > Macromedia Flash (SWF), choose the options you want from the subsequent screen shown in Figure 2.29, and save it to your files folder.

Release to Layers

Animate: [Sequence ▼]

Trail by: [] [☐ _____]

☐ Reverse direction
☒ Use existing layers
☐ Send to back

(Cancel) (OK)

FIGURE *The Release to Layers window.*
2.28

Flash Export

Objects

Path Compression: [None ▼]

☐ Trace dashed strokes

Image Compression: [Low ▼]

Text: [Maintain blocks ▼]

Frames

Pages: ◉ All ○ From: [] To: []

Animation: [Layers ▼]

Frame rate: [15] fps

☒ Autoplay
☐ Full screen playback

Publish

Compatibility: [Flash 4 ▼]

☒ Protect from import
☒ High quality printing

(Cancel) (OK)

FIGURE *The Flash export screen.*
2.29

THE TELEVISION SET

The video page of the site will show clips, or teasers, from the stage production. The video will play inside a stylized 1960's style television set and will run approximately 10 seconds. To make this video load quickly, after it's been created in a program like Adobe Premiere or Apple Final Cut Pro, we will compress it in Media Cleaner Pro and save it as a streaming file. This isn't the book to go into details on that aspect. Suffice it to say that you can create some great video pieces that load very quickly using these products, as well as use them in conjunction with Adobe AfterEffects.

While this video plays on the page, links with a still frame from the video will act as remote rollovers that will reveal a quick synopsis of the clip. Each video will run no more than 20 seconds. Under promotional rules and regulations, an audio or video clip shorter than 30 seconds can be considered a promotional clip. I don't condone lifting music or clips from a videotape and try to say it's being used for promotional purposes unless it really is—which, in the case of this site is true. There are specific rules that govern what is considered promotional and what is considered otherwise. Before using any type of copyrighted music or video, you'll want to do a search for Internet copyright laws to make sure you're not illegally reproducing the material.

So, let's build the television set.

Use the Pen tool and draw a box that is slightly wider than it is tall. Make the top and right side bow a bit. Then use the Skew tool to angle it slightly as shown in Figure 2.30. This will be the back portion of the television that, as would be expected, is made of wood. Assign a dark-brown color to the Stroke, and then copy this rectangle. Paste it behind the first one and, before deselecting it, assign a light-brown fill to it so it appears as shown in Figure 2.31. I know it looks rather weird now, but it will look better in a moment.

Next, choose Paste in Front (the copied rectangle is still on the clipboard). Move this rectangle down and to the left slightly as shown in Figure 2.32. Assign the same brown color to this Stroke as you assigned to the fill of the back rectangle.

Leave the front rectangle selected, and then activate the first rectangle you made. Choose Modify > Combine > Blend, and leave the Number of Steps at 25. The television cabinet is now complete, and should look similar to Figure 2.33.

Time to create the screen and the frame around it. Use the Rectangle tool to create a square inside the front area of the cabinet and give it a light-gray/silverish fill (see Figure 2.34).

FIGURE *The skewed rectangle that is the back of the television set.*
2.30

FIGURE *The duplicated rectangle with a fill assigned to it.*
2.31

FIGURE *The front of the television in place.*
2.32

FIGURE *The television cabinet.*
2.33

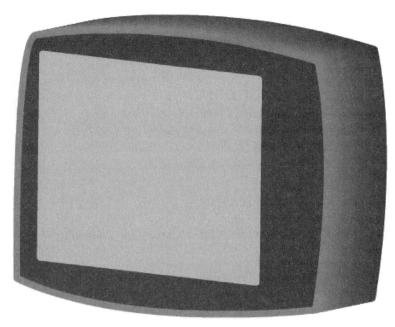

FIGURE *The television screen.*
2.34

Duplicate this screen, remove the fill, and assign black for the Stroke. Change the width of the stroke to 4 point. Then duplicate it, move it slightly down and to the left, and change the Stroke to the same color as the screen interior. There's no need to blend this, because with such a small area and the stylized look of the set, we have a nice dimensional feel without adding undo size to the file (see Figure 2.35).

Our television set needs some dials. Add elongated ellipses with a radial fill the same color as the screen blending into white, and place them on the right side of the cabinet (see Figure 2.36).

There are still two things missing: an antenna, and legs for the cabinet. Televisions in the 1950s and 1960s were on legs. Use the Pen tool to draw out the legs as inverted pyramids, and then create caps for the legs. The legs themselves should have a gradient added that uses the same two browns as the cabinet. The caps should have a gradient as well, with the same two colors as the dials. Figure 2.37 shows the legs and caps duplicated and placed into position.

Finally, create an antenna using the Pen tool, drawing a semicircle with a screen gray and black gradient fill. Create two rabbit ears with a 3-point black stroke. Your television is now complete (see Figure 2.38).

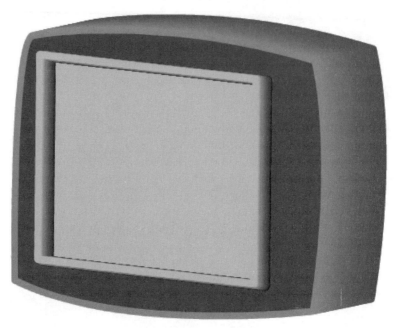

FIGURE *The finished screen and cabinet.*
2.35

FIGURE *Dials added to the television set.*
2.36

FIGURE *The legs are added to the cabinet.*
2.37

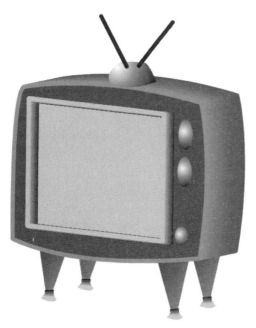

FIGURE *The completed television.*
2.38

This'll be pretty far out once the video is sized and the files are placed on the Web page. Since you've come this far, it's no fair skipping ahead to see what we'll do to accomplish this. You have to stay with me for this final portion of the chapter—creating elements for the jukebox.

ADDING SONG SAMPLES

There are over 30 hits featured in *The Summer of '66*, so any site for the show would be remiss if it didn't include an area where samples of some of the songs can be heard. We're talking classics like *Good Golly Miss Molly*, *Unchained Melody*, *I Cried*, *Birds and the Bees*, and many, many more. I'm sure that many of you may be thinking that these are nothing but crusty, moldy old songs that only old fogies like me could enjoy. However, from experience—having seen the show at least a dozen times—by the third song, kids as young as two or three, teenagers, adults, and seniors are tapping their feet and clapping their hands to the beat.

I know that sounds like a sales pitch, but isn't that what you're doing with any site you build? You sell yourself, your company, your views, and opinions. It doesn't matter if you are building a site to discuss your favorite hobby, show off your artwork, or to let people know your Web design prowess—the Web is one big sales sheet. Therefore, while you're building your site(s), you need to remain in that sales mode; otherwise, some of the focus and potential power could be inadvertently lost.

Because this show has acceptance from such a wide age range, and since some of the titles of the songs might not ring a bell with some visitors, there will be a page where people can download audio files in both PC (.wav) and Mac-readable (.aiff) formats. Graphically, there are a few different ways that we could go. We could create a turntable or a record album jacket. However, a jukebox fits more with the theme of the show and decade. The next question is, what should the jukebox look like? Should it be one of those tall, stand-alone jukes, or the tabletop type that was found in restaurants? The latter is cool, but kind of boring if we're creating a Flash animation. The former can be great for animations, but too large to fit on the screen and have the viewers see the different song title selections.

How about a compromise? I really like the idea of the stand-alone jukebox because of all the lights and motion that can be created. The dimensions would force us to do one of two things, though. The first would be to only create a portion of the jukebox. This could work, but it's not quite what I want for the overall feel. The second would be to start with a wide

shot of the jukebox, and then zoom in to the area where the song selection buttons are. This is a good way to do it, but for what I want with this screen, this would take unnecessary time and make the file larger than it really has to be. Therefore, the compromise would be to design a jukebox that combines the stand-up juke with the booth juke. This will give us a jukebox with dimensions that fit on the screen and still allow us to create some of the frills of the larger console.

What are those frills? The jukebox I envision has three rows of neon tubes shaped in a half-circle at the top. Those neon tubes will have bubbles floating from the bottom left to the bottom right. Song selections, of which there will be 12, will be lined up in two rows of six, with red push buttons as the download selector, one to the left of the title for the PC version, and one to the right of the title for the Mac. These buttons won't be large, only about a half-inch in diameter.

STARTING CONSTRUCTION

The first thing we'll create is the bottom center of the jukebox; a decorative area whose only purpose is to add to the ambience of the design.

Switch to Flash Anti-alias so you get a clean display (for right now). Using the Rectangle tool, create a square and fill it with a gradient. This should be a linear gradient going from a dark version of a color to its lighter cousin. Figure 2.39 shows the gradient assigned and its angle.

As you add more elements, you will more than likely begin noticing some redraw slow-down. Switch back to Preview mode at that time to help speed your work.

Now it's time to create the grid that is situated over the rectangle. First, zoom in to at least 400%. The elements we're creating should be fairly small. Move to another area of the workspace and, using the Pen tool, create a diagonal line going from top left to bottom right as shown in Figure 2.40. Copy this and rotate it 90 degrees to create an X. Use either the key combination of Command/Control +G or Modify > Group to turn this into one object like the one shown in Figure 2.41.

Note the width of the line in Figure 2.40. It gives an indication of the size the jukebox will actually be when it is completed. The finished size will be "revealed" at the end of this section.

FIGURE *The gradient assigned to the rectangle.*
2.39

FIGURE *The first diagonal line that will become the*
2.40 *screen in front of the rectangle.*

FIGURE *The grouped X.*
2.41

Copy this group and Paste in Back. Make the width of this element about twice as wide as the original. Next, select that first grouped object and assign a light-gray color to it. Figure 2.42 shows what this should look like. Move it up one notch by clicking on your keyboard's Up arrow key, and then select Modify > Combine > Blend to create the look of a fence link. Figure 2.43 shows what this should look like.

Move the link to the upper-left corner of the rectangle. Now start duplicating this element and linking up the duplicates in a horizontal row until you fill in the first row. Select all these links and group them, and then duplicate down until the entire rectangle is filled as shown in Figure 2.44.

FIGURE *The second diagonal line.*
2.42

FIGURE *The master link. (Hope you*
2.43 *didn't think I was going to*
 call it the Missing Link!).

FIGURE **2.44** *The screen is placed in front of the rectangle.*

I guess now would be a good time to give you that reminder that you get in almost every computer program book on the market, as well as almost every tutorial ever conceived. This is a good time to

SAVE YOUR FILE!

You knew that was coming, didn't you? It's one of those reminders that just never grow old. How many times have we all worked hard on a project, gotten lost in the creative process, and suffered some unexplainable crash—Alllll gone. So, let's head that possibility off at the pass and, with a hearty Hi-Ho Silver Away, get back to building our jukebox elements.

The screen is now complete. Create a new layer and name it Juke_Sides. These are made with three simple rectangles that are positioned against the left, right, and top of the screen. You can either give these the look of wood, as in Figure 2.45, or a metallic feel as in Figure 2.46.

The metallic cabinet would blend with the tabletop jukeboxes. If you want it to appear more like the stand-alone unit, use a flat black type of surface, almost like a countertop.

FIGURE
2.45 *A wooden jukebox cabinet.*

FIGURE *A metallic jukebox cabinet.*
2.46

YOU LIGHT UP OUR LIFE...

I have no idea why I would think of a Debbie Boone song from the 1970s for a section title. Sorry about that. It does kind of fit with this next portion of the chapter, though. We're going to create the neon lights, using thick strokes and blends. When imported into Flash, we'll assign a transparency to give it a tube-like look. To help speed the process, switch to Preview mode so that all you see are the strokes and outlines of the elements already created.

Using the Pen tool, draw a semicircular path starting from the middle of the left upright cabinet and ending at the middle point of the right upright cabinet. This path should be very tall, because the tune choices will be positioned in the open space between the finished tubes. Figure 2.47 shows the positioning and size of the path.

FIGURE *The first neon tube path and guidelines set*
2.47 *up to help in their uniformity.*

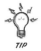

Use the Rulers and Guides to help you create the path for the neon tubes.

TIP

Choose whatever color you like for this first tube, and then experiment with the size of the stroke until it reaches the edges of the cabinet. If need be, select a point and then widen the path itself until the edge of the stroke is flush with the edge of the cabinet. Copy the path and assign a smaller stroke to it. Change the color to white, move it left a short distance, reduce the stroke size until it's extremely thin, and create a blend.

Create a second tube by following the previous procedure, assigning a different color to the wide stroke. After you're finished, move the layer beneath the Cabinet layer in the Layers panel. Your tubes will look similar to Figure 2.48.

Create one more rectangle on a different layer to fit behind the neon lights. Move the layer all the way to the bottom of the layer list so that it's behind the neon lights, and, as you see in Figure 2.49, you're finished with the main portion of the jukebox. We will build the rest of it in Flash 5.

FIGURE *The neon tubes bring the jukebox to*
2.48 *life.*

FIGURE *The finalized jukebox ready to be*
2.49 *imported into Flash 5.*

LEAVIN' ON A JET PLANE

Well, actually, we're leaving this chapter now and moving on to the next. You've built the elements that we will use on the Web pages themselves, as well as for importing into Flash. Now it's time to look at some ways of creating exciting effects with some add-on programs that work directly with Flash. These programs allow you to expedite your workflow so that you don't spend inordinate amounts of time creating effects that could take you mere minutes.

Get your tickets for the Saturday matinee at the counter, and I'll see you in Chapter 3, "Adding Dimensional Power to Flash."

CHAPTER

3

Adding Dimensional Power to Flash

More Hit Tunes of 1966

Help Me Rhonda—The Beach Boys
Get Off My Cloud—The Rolling Stones
I Hear a Symphony—The Supremes
Ticket to Ride—The Beatles

FLASH EFFECTS IN A SNAP

OK. Show of hands. How many of you want to get your work done faster so you aren't spending 26 hours a day 14 days a week at the office? How many of you want to have the opportunity to make more money? How many of you would like both? I can tell you this, my hand has been raised since I typed the first question (which made the time it took to type the follow-up questions twice as long, thus negating what I'm about to discuss). We're all looking for ways to create quality Web sites, but for the most part, the more cutting-edge we make our sites, the more time it takes from our schedule. At some point we all face the dilemma of creating the ultimate site or cutting something out to meet our deadlines. Unfortunately, ten times out of nine, the latter wins.

Recently, some programs that work as value-added extensions to all the cool Macromedia applications have been released—although one is an update to a program that has been out for a number of years now. Within a few minutes, all of these programs perform operations that would take hours to create in programs such as Flash or Director—if they could be created at all.

I'm taking the time to talk about these programs that hitch a ride on the Macromedia applications now so that we can create files to bring into Flash in the next chapter. In this chapter, you'll learn about new programs that give you the ability to make high-quality effects such as fireworks and waterfalls; convert video files to Flash format (no more having to create links to a separate file since Flash doesn't allow video to be included in its final output); and programs that let you create 3D text and humanoid and animal animations.

Refer to Appendix A to find out more about the programs discussed in this chapter.

WHAT DIMENSION ARE YOU CREATING IN?

Creating three-dimensional objects in Flash is one of the hottest topics among Web gurus these days. 3D is not exactly the easiest thing to do in Flash. For those who have accomplished it using various work-arounds, I'm sure they'll all say that, while it was worth the effort, the time it took was pretty intense. Enter the first of the three packages we're going to look at: Swift 3D. Swift 3D gives you the ability to create 3D text and objects

FIGURE *A frame from a Swift 3D animation.*
3.1

that can be saved as .swf files for inclusion in your Flash or Director pro-
jects. Combining text and primitive shapes such as balls, hoops, and pyra-
mids, you can build some really crazy files like the one in Figure 3.1.

 *You can work with an online demo of Swift 3D, and find
out more at www.swift3d.com.*
NOTE

Working with Swift 3D (Win/Mac) is basically the same as working in
any program that gives you the ability to animate. Using keyframes, you
can move your text and individual elements around on the workspace.

There are some points to be aware of when working with Swift 3D.
Complicated text such as fontdinerdotcom seen in Figure 3.2 can use up an
awful lot of memory. You can easily reach the memory limits of the

FIGURE *Complicated fonts such as this can really slow down the render time.*
3.2

program with even the simplest copy. This is because, as the dimensional aspects of the text are being drawn (including bevels and back faces), the number of polygons can easily become astronomical. Therefore, if you plan to create any type of text animations, it's a good idea to use a simple font family such as Helvetica, Times, and Arial. Use the primitives (or import your own vector art) to add extra interest.

Let's take a few moments to look at how Swift 3D works.

Figure 3.3 shows the basic workspace. At the top of the window is a row of buttons that give you the ability to create a new document or open an existing file, and place Text and the basic primitives. On screen left, various controls appear that are intrinsic to whatever element you place on the workspace or choose when there is more than one element on the workspace. Initially, this area gives you the ability to set the document size, background color, and more by clicking on a particular selection as shown in Figure 3.4.

Clicking the T button at the top of the screen brings up the text editor. The word "TEXT" appears by default (which really helps old folk like me remember what we just selected). I'll use a good old '60s term that has become popular again: Cool!—with the exclamation point. The subsequent

FIGURE *Swift 3D's screen at start-up.*
3.3

FIGURE *The initial selections for setting up your workspace.*
3.4

animation will be used sparingly; I'll place it next to particular elements—mostly downloadable files—to make them stand out and to create extra interest.

Notice in Figure 3.5 that you can access a number of controls. Bevel gives you choices between the type of bevel that is assigned to the text, the z-depth (which is how thick the letters will be), and more. Figure 3.6 shows "Cool!" with three different bevel effects assigned.

There are three control options at the bottom of the screen (see Figure 3.7). On the left is the rotational positioning controls that allow you to rotate your text or primitive on a horizontal or vertical plane, as well as in freeform mode. Immediately to the right of this is the lighting control. You can move existing lights to different locations and add other lights as needed. Finally, on the right are two control groups, animation and color. Swift 3D comes with about 100 different color effects that can be assigned to the various faces of your objects, and numerous preconfigured animations. As you create new animations, you can save them and retrieve them in this area. You can do the same with new colors.

Once you have the text set up as you want it, it's time to animate.

In the case of "Cool!", I want it to rotate in from screen left, stop when it's facing forward, and then rotate off screen right. This will take place

FIGURE *The various controls available to*
3.5 *you when using the Text tool.*

FIGURE *Cool! to the 3rd power.*
3.6

FIGURE *The Rotation, Light, and Color/Animation controls.*
3.7

over a span of 30 frames, or :01 second. Again, animation within Swift 3D is the same as keyframe animation in any other similar program—including Flash. Make sure the play head is at Frame 0.

Click on the vertical constraint in the Rotation control section and move the mouse onto the ball icon immediately to the right. Click and drag to the left to rotate the text to the left until the edge of the exclamation point is facing you.

Move the cursor over the text to highlight it as shown in Figure 3.8. Click and drag the text off screen left.

Front - Active

FIGURE *The text ready to be moved off screen.*
3.8

Move the play head to Frame 15. Move and rotate the text so that it ends up in the center of the screen. The keyframe, as you can see in Figure 3.9, is automatically created.

Finally, move the play head to Frame 30, and rotate and move the text off screen right. Time to animate.

The controls under the animation frame emulate the standard VCR. Click the right-pointing arrow to see the animation played back. If you need to modify anything, move the record head to the appropriate frame and make your changes. Then go to File > Export to save your file as a .swf for importation to Flash or Director, or to place directly on your page design in DreamWeaver 4.

The Cool! .swf file, and a couple variations on the theme are
ON THE CD *included on the companion CD-ROM for your perusal.*

So, there you have a really neat animation using 3D text that only took a few minutes to create. You could get really fancy and (to use an oft-forgotten term) create a *cherry* animation where "Cool!" moves through a rotating donut that is balanced on top of a pyramid. You could also create your own original vector art, import it into Swift 3D, and extrude it into a 3D object ready for animation.

FIGURE *When animating in Swift 3D, keyframes are automatically created when you make a change.*
3.9

REALLY COOL, MAN (OR WOMAN OR CHILD)

How many of you have wanted to add a 3D character to your Flash animations? The way to do that up until now was to create an animated character in a 3D modeling program such as LightWave [6], 3D Studio Max, Pixels:3D, Ray Dream Studio, Poser, or another 3D application, save it as an image series, and import the frames as a sequence. Well, now you can actually create 3D character animations in .swf format, thanks to the latest update to Curious Labs' Poser 4.

Poser 4.2, known as the Poser Pro Pack, was released in January, 2000 and includes a long-awaited feature that saves the animation as a .swf file. This is probably the coolest advance in 3D programs in a long time. In its simplest terms, it is a figure animation program that comes with almost 100 prebuilt and preconfigured models and props—from men, women, children, and babies, to cats, dogs, dinosaurs, and fantasy creatures. Figure 3.10 shows the Poser 4 interface, with a high-resolution figure on the workspace.

FIGURE *The main Poser Pro Pack workspace and Zygote's high-resolution Michael and Victoria models.*
3.10

 You can download a demo version of Poser 4 from the Curious Labs site at www.curiouslabs.com.
NOTE

 There could be some differences between the Poser Pro Pack screen seen in this chapter and the final release. The Pro Pack was still in beta form during the writing of this book.
NOTE

Creating an animation in Poser is a fairly detailed process, since you have control over everything from the eyebrows to each knuckle of each finger. In addition, with the newer advanced models like the ones seen in Figure 3.10, you can even age them over the course of the animation. Because of this, I'll skim over the posing of a Poser character and move on to preparing it for exporting as a .swf.

I'll use the aging process; only in this file, I'll pull a Merlin and reverse the tides of time. Merlin, as you probably remember, was born old and lived his life moving backward in time, growing younger each year. Michael and Victoria will start out old and revert to their youth when they were in their early twenties back in—you guessed it!—1966.

To do this, we'll use the camera controls to zoom in on Michael and Victoria's faces. Notice the basic animation controls at the bottom of the screen in Figure 3.11. You can also open the Advanced Animation control panel shown in Figure 3.12 for more precise tweaking of each element in the

FIGURE *The basic animation controls are located at the bottom of the screen.*
3.11

FIGURE *A look at the Advanced Animation controls.*
3.12

scene. Go to the base Animation panel at the bottom of the screen, and move the slider to Frame 29. Click on the Key icon to set a keyframe. By doing this, you don't have to worry about remembering all the base settings for the model. All you need to do is go back to Frame 1, change the parameters, and watch your model become youthful again.

 You cannot recreate this project with Poser 4's base models. The ones used in this demonstration are not included with the Poser program, but are for sale at www.zygote.com.

Clicking once on the head brings up the numerous controls for the head of that character. In Figure 3.13, you're looking at the controls for Victoria. Each control is set up like a dial. Clicking and dragging left or right on the dial changes the setting (seen in the numeric screen just above that particular dial). You can also double-click on the dial to bring up a numeric screen (see Figure 3.14) where you can type in a new parameter. For the first frame of this animation, we'll change the Age setting from 0 (the base) to 1.0. As you can see in Figure 3.15, this gives Victoria a good wrinkle base.

Add some crow's feet, thin the lips slightly, and make Victoria's nose and ears a bit longer. It's natural that the ears and nose droop a bit as age sets in. You can also lower the eyes some to give them some droop. Figure 3.16 shows the settings for each of these parameters if you are creating this older woman with me.

Repeat the steps you performed on Victoria on Michael's head, and then select the main camera (Figure 3.17) and zoom out until you see only Michael and Victoria's heads. Go to Animation>Make Movie, and select Export as Flash (Figure 3.18). Your animation will be saved as a Shockwave file ready for use in combination with other elements you create later in this chapter, or to put directly on your Web page.

Head

AfAmerHead	0.000
AsianHead	0.000
NatvAmerHead	000
Old	0.000
BigFoot	0.000
BeardFull	0.000
BeardFLong	0.000
BeardGoatee	0.000
BeardVandyke	0.000
BeardVLong	0.000
BeardFork	0.000
Mustache	0.000
FaceFlat	0.000
FaceHeart	0.000
FaceLong	0.000
FaceRound	0.000
FaceSquare	0.000
Dimple	0.000
ForeHeadFlat	0.000
BrowsHeavy	0.000
CheekBones	0.000
ChinCleft	0.000
ChinReced	0.000
JawFull	0.000
EyesCloser	0.145

FIGURE **3.13** *Some of the many controls for the head parameters of the model.*

Parameter Settings

Value:	0.000
Min Limit:	-100000.000
Max Limit:	100000.000
Name:	Old
Sensitivity:	0.01142

Graph Cancel OK

FIGURE **3.14** *This screen is opened by double-clicking on a parameter dial.*

Face Camera

FIGURE **3.15** *Victoria is beginning to age.*

FIGURE
3.16 *The various parameters and their new settings that make Victoria age naturally.*

FIGURE *The way to select elements in your scene.*
3.17

FIGURE *The Export as Flash screen.*
3.18

A REASON FOR BEING

It's one thing to create a cool humanoid 3D Shockwave file, but without having a reason for being, it's merely that—a cool humanoid 3D Shockwave file. To use that file as is would be analogous to what nearly every television station in the country has been guilty of doing at one time or another. You can always tell when your local stations have purchased new production control boards that contain tons of new effects. All of a sudden, you'll see dozens of really cool effects packed into a 30-second promotional spot, whether they need to be there or not. Those effects may be hot, but when you break it down, most, if not all, of these effects do nothing to enhance the message. Unfortunately, this often happens on the Web. A designer gets a new software program and starts using every effect he or she can generate. Do these effects have anything to do with the overall theme of the site? Like those TV stations, you can usually say "no, they don't." Are they neat? You bet. However, I want to avoid throwing in something like Victoria and Michael reverting to their youth on the site just because I can. There has to be a reason to use it in order to keep the continuity of the site.

So, what's my reason for even creating an animation like this? Let's dissect it. We have a show that features the hits of 1966. Many of the people who will initially be interested in it are now in their mid-40s to low-70s. The bulk of the target audience is in their 50s and 60s, since they would have been in their extreme late teens to early 30s in 1966. They'll remember what they were doing and where they were when *Wild Thing, Leader of the Pack, Boy from New York City, Unchained Melody*, and all the other tunes first hit the airwaves. They'll remember Wolfman Jack's gravelly voice, Dick Clark's *American Bandstand*, and *Hullabaloo*. Good old upper-middle-aged Michael and Victoria are designed to represent the target audience as they are now. However, we want to give the message that by attending this show, they'll be transported back to their youth. The years will fall away. The memories will flood back and, for a few brief hours, they'll see themselves as they were—young, innocent, and full of big dreams. Hence, the youthenizing of our models.

At this stage, that animation would possibly work on a subliminal level, but I really don't think that it will work as well as I would really like it to. There needs to be something else added; some sort of explanatory text so that we don't have two heads reverting to their younger days.

What will the text say? I know we can all think of at least a dozen oneliners that would be appropriate. One could be "Return to the days of your youth." Another could be "Step back in time." However, what I want to use is the title from one of the songs featured in the show; a song that perfectly

fits the tone for the Poser Pro Pack animation: Be Young, Be Foolish, Be
Happy.

WILD THING

This is where the third program I'm going to discuss comes in. Wild-
form's SWfX (PC only) is a lifesaver for everyone who wants to create in-
tricate text animations for Flash. It comes with 100 presets that are
compatible with either Flash 3 or Flash 4, including effects that include key
areas that reveal elements on other layers of your Flash movie.

 A demo version of SWfX is included on the CD-ROM.
ON THE CD

Figure 3.19 shows the SWfX workspace. The left side of the screen
scrolls to reveal the various preset effects. On the upper right is the typing
window where you assign the text you want to animate. The rest of the
controls, from font and font size selection, window size, alignment, and
previewing of the animations, are beneath the typing window.

FIGURE *The SWfX workspace.*
3.19

It would be easy enough to create static text; however, there are some nice, subtle effects within SWfX that will enhance the overall feel of the message without being overpowering or overly showy. Of course there are some fancier, more complex effects as well, but many of these are a bit too showy. Remember, we want to enhance the message, not make one effect overpower the other.

This could be one file with all three lines included on it. You need to be aware of one thing, though. SWfX views each space as an element. In other words, if I typed in "Be Young, Be Foolish, Be Happy" as you see in Figure 3.20, the animation would be affected adversely. Why? I had to add spaces in front of each of the lines to give them that stair-step appearance. Each of these spaces is read as an element, so the program sets them up as part of the animation, and the first letter of each line will appear after the literally invisible animated spaces are played back. I don't want this to happen.

The way to get around it is to create three files. One for Be Young, one for Be Foolish, and one for Be Happy. I can have more control over the

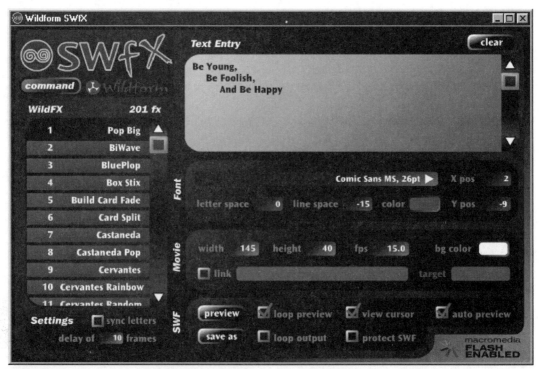

FIGURE *The text laid out to be created as one file.*
3.20

placement of these files, giving me extra design opportunities because I can place them in various positions around the Poser animation.

SWfX is an extremely easy program to use, belying the power lurking under its hood. If it was a car, it would be the perfect one with which to cruise the beach. Basically, type in the text you want to animate, make sure the Preview button is checked, and choose an effect. That's all there is to it.

The effect used for these animations is called Matrix. It's listed in alphabetical order (out of 200 available). If it is not part of the selections you have, the SWfX site has an update with more effects; it will be included in that.

One of the secondary reasons I chose the Matrix animation is because of the color scheme; it matches the overall color scheme of the site: green and purple. This just happened to be a nice, unexpected feature. The Matrix effect has each of the letters falling from the top to the bottom of the screen as shown in Figure 3.21, with the falling letters in green and the static letters in purple. Moreover, with loop output turned off, what you get is a file with the message remaining on screen while the various letters continue to fall behind it.

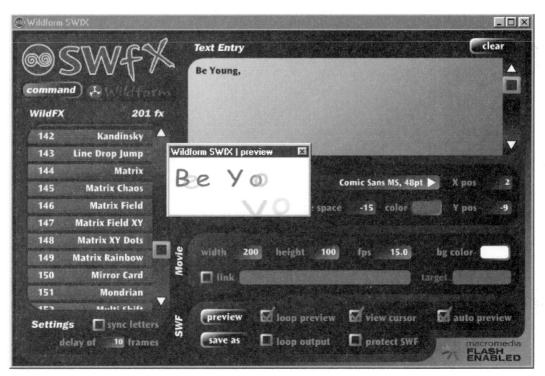

FIGURE *The Matrix effect at the halfway point of revealing the message.*
3.21

GETTING DIGITAL

One thing about Flash: it doesn't let you work with digital video (MPEG, AVI, MOV, etc.) and save it as a Shockwave file. You have to create a link to that footage. Just recently, Wildform introduced Flix (Figure 3.22) for Windows-based computers that converts digital video into Shockwave files ready for inclusion inside Flash or to put directly on the Web. You don't have to pin me down to say that this product is the must-have program of the year if you have been, or plan to create, video files in Flash.

As you can see in Figure 3.23, Flix's controls are pretty simple to work with. Most of the time, the default start-up screen is all you need to deal with. If you want more control over preparation, however, you'll want to use the other areas to make more precise export selections. Figures 3.24, 3.25, and 3.26 show these more specific workspaces.

FIGURE *The Flix splash screen.*
3.22

FIGURE *The main workspace for Flix. For the most part, this is the only screen you'll*
3.23 *need to set up your file conversion.*

FIGURE *The Flix SWF screen.*
3.24

FIGURE *The Flix Audio screen.*
3.25

FIGURE *The Flix screen.*
3.26

AN EXPLOSIVE FINALE

So now we have some cool, animated 3D text, two people who go from upper-middle age to their early twenties, and a fantastic animated text message, all ready for inclusion in Flash or directly on your Web site. All of this brings us to an explosive conclusion of this chapter featuring hot programs that enhance your Macromedia workflow. Although this program doesn't save in the Shockwave format, the PICT, TIFF, or JPEG files can be imported as a sequence, or the files can be saved in .avi format for easy inclusion in Director or directly on your Web page. Flash, as you may already know, doesn't allow the inclusion of AVI or QuickTime video in its final output. It creates a link to the video file, which, when played back, gives the appearance that it's embedded (or a part of) in the animation. To do more than just play back a video file, to really be able to add in some special effects that interact with the video, you have to save it as sequenced images—and that's what you have to do with this program you are about to discover.

What is this program? It's called Illusion from Impulse, Inc. (www.cool-fun .com), which, at the time of this writing, is in v2.0. Illusion is the only one of its kind. It creates particle system effects in a 2D environment, allowing you to create some fantastic effects for buttons or featured items on your site. Figure 3.21 shows four stills from one of the basic built-in particle effects.

 Illusion is a PC-only program at this point, although I wouldn't be surprised if a Mac version is near completion. You can download a PC demo of Illusion at www.coolfun.com.

Particle effects are a staple of cinematic entertainment these days; everything from exploding planets to the fire shooting out from the back of a spaceship is created using particles. Particle systems are even used to create large crowd scenes where detailed characters aren't necessary. They are also rather difficult to create because of the highly technical nature of producing the effects. Thanks to this program, though, you can provide some fantastic eye candy—anything from waterfalls to lava flows to fireworks. Which is exactly what we're going to create right now.

I don't know why, but when I think of summers at the beach, I think of bonfires and fireworks. The bonfires are pretty much a given. If you wanted to, you could create a beach scene using a program such as Vue d'Esprit, Bryce 4, or World Construction Set, and create a fire in Illusion to

meld onto the scene using a program such as Apple's Final Cut Pro, Adobe Premiere, or Adobe AfterEffects. Fireworks, on the other hand, may not be the first things to pop into your mind when thinking of the beach, but they work perfectly, in the timeframe of *Summer of '66*. *Summer of '66* concludes with the final concert performed by The Villagers, which took place on Labor Day weekend, so fireworks must have been a part of the holiday weekend.

The best use of the fireworks animation here will be as a Featured button. That means the image files will be approximately 50 × 50 pixels. I also had to consider Illusion's one downside (which is not a downside at all): the effects don't show up well on a white background; they're really made to be seen against black. Since each of the *Summer of '66* pages will have white backgrounds, I couldn't effectively create a larger file to feature on the page. Nothing else has a black background in any of the elements we're creating. However, since fireworks fit so well with the overall beach party feel of the site and the show, I'd hate to bypass the chance to have a hot animation just because the backgrounds don't match.

What exactly do I mean by a Featured button? I plan to update the site fairly regularly as the show travels or changes. Unlike shows on Broadway that can have a life decades long, a show such as this playing in the Myrtle Beach area needs to be freshened every so often—new songs need to be added; the cast, as actors get too old to play their parts, will change. We might add an online store where visitors can buy the CD, a video of the show, or apparel. The trivia game will need to be changed every so often to keep it fresh. To make it easier for visitors to know what's new, I'll use a Featured button next to the link. Animated fireworks, in my humble opinion, will be eye catching.

First, let's look at what the Illusion screen looks like; follow along with Figure 3.27. All the controls are located on the bar at the top. Below this, screen left, is the Layers window. You can add layers to your file, each containing different effects and paths. The main workspace is at the center of the screen, and just below that is the frame control. This latter area is where, using the same keyframe setups as with other programs, you can design paths along which your effects travel. On screen right is the Preview window. When you select an effect, you can see it in this area. Below that are the various folders with the prebuilt effects. You can modify and save these effects for use in later projects.

To create the fireworks, I'll start with a base effect and then modify it. Open the Sparkles folder by clicking on the small plus symbol to the folder's left. Click once on Super Colorful. This effect is then shown in the Preview window. Move your cursor over to the main workspace and double-click at the center of the screen. This brings up the Emitter Proper-

FIGURE *The main workspace of Illusion.*
3.27

ties screen where you can modify ever aspect of the effect. Figure 3.28
shows the Emitter Properties window.

The Super Colorful effect lasts too long and, while it looks pretty much
like an exploding firework, it needs some modifications to meet my
needs. Look at Figure 3.29. This figure shows the Life settings, which is
the first parameter I changed. Notice how it starts out at 100%. Click on
the indicator line at approximately the 12-frame mark, and drag this line
down to zero. Notice how the effect now appears in the Preview window.
Now we have some exploding fireworks that die out pretty quickly and
look more realistic. What's missing, though, is how the sparkles from the
exploded fireworks float downward. We'll fix that next.

Move to the Colorful area and expand the options. This is the area
where we'll modify the effect so that the particles fall downward. Click
once on Weight to pull up that selection's parameters. Move the entire set-
tings line upward so that it's between 0 and the first line above it as shown
in Figure 3.30. You can now see that this slight change has made Super
Colorful look like a rather realistic firework explosion.

FIGURE *In the Emitter Properties window, you can modify all aspects of your effect.*
3.28

FIGURE *The parameter controls for the Life setting.*
3.29

FIGURE *A weighty change makes realistic fireworks.*
3.30

Our fireworks are now complete. Click Add to Library in the lower-right corner and, in the Emitter Name screen that comes up, give the emitter a more descriptive name. In my case, I called it Super Colorful Fireworks. Pretty original, huh!

Now we'll set up the workspace and add some fireworks to it. In the toolbar, select Project Settings (its location is shown in Figure 3.31). In the Stage Size area of the Project Settings window, type in "50" for both width and height. Click OK. Select the fireworks you created and double-click on the middle of the resized workspace. The Emitter Properties screen will come up again. Just click OK. You now have your first firework instance set.

Move the timeline bar to 15 and add another firework emitter. Then move to Frame 30 and place a third. Figure 3.32 shows the location of the emitters on my screen. Your animation should run approximately 92 frames. Click the red button on the right side of the toolbar to save your file. In my case, I chose to save it as a JPEG image sequence. Once finished, you're ready to bring the sequence into Flash to create the final animation.

FIGURE *The Projects Settings screen.*
3.31

FIGURE *The locations of the three fireworks emitters positioned on the workspace.*
3.32

HANG TEN

Those are some pretty groovy programs, aren't they? With very little effort, you can now add depth, complex text motions, and 3D humanoids to your Flash files. And notice how I ended with the creation of fireworks. Think that was just by accident? Nope. That's because we're now going to return to our regularly scheduled book to prepare image files for the Web using Fireworks.

So, as a tribute to what the announcer would say at the end of each week's episode of *Batman*: "What dastardly plans does Authorman have up his nefarious sleeve? Find out on the next page." OK, so he never said that, but it is my prerogative to use some literary license—I think.

See you in the next chapter.

CHAPTER

4

Explosive Sites Using Fireworks

More Hit Tunes of 1966

Mr. Tambourine Man—The Byrds
Eve of Destruction—Barry McGuire
Eight Days a Week—The Beatles
A Lover's Concerto—The Toys

EXPLODING ONTO THE SCENE

If you are new to Web site creation and are fumbling around trying to maximize your images for quick access by visitors, then this chapter is for you. If you have used other programs that do what Fireworks does, but use other Macromedia products for layout and design, then this chapter is for you, too. If you're an intermediate designer who is looking for a way to increase your image productivity and offer site visitors a more sophisticated experience, then this chapter is for you. And, if you're a power user who hasn't upgraded to Fireworks 4 but wants the inside dope on what this latest version offers, then this chapter is for you. Amazingly, this chapter is for everyone!

Here's a quick historical rundown on the program. Introduced in the first quarter of 1998, it was the first program of its type, designed expressly for creating graphics for the Web. Not only did it introduce a new way to slice images more efficiently, now we had a program that allowed us to assign links, rollovers, and optimize without leaving the program. As the program evolved from v1 to v2 to v3, new features such as the History panel were introduced, as well as ways to export vector files into other applications such as Freehand, Flash, and other similar programs, while retaining paths and other information assigned to a file in Fireworks.

This most recent version of Fireworks takes it a step further.

- The interface seen in Figure 4.1 more closely resembles the updated GUI (Graphical User Interface) of its sister programs.
- A drag-and-drop rollover feature allows you to drag and drop from one image slice to another.
- Simple animations can now be repositioned and reworked across multiple frames.
- This version includes enhanced masking capabilities.
- You now have expanded thumbnail views in the Layers panel.
- Selective JPEG compression lets you assign different settings to a specific area of your image, rather than just creating one setting for the entire file.
- Batch processing makes your life a whole lot easier.
- Customizable export controls allow you to prepare your files to export to other programs.

As you can see by this list, there are many improvements to the overall package. This gives us the ability to create rather than figure out how to prepare files to be imported to other programs to finish up. But enough of the sales hype—that's not what you came here for. You want to start working with Fireworks to see what it can do.

IN THE BEGINNING...

Before we begin working with some of the new aspects of Fireworks, let's take a moment to look at some of the basic effects that are at your disposal. You're probably familiar with most of these from competitive programs. Since we're dealing with Macromedia products, though, and building a site using only those products (plus a few third-party applications discussed in Chapter 3, "Adding Dimensional Power to Flash"), if you're not familiar with Fireworks you might think you have to go somewhere else to achieve basic effects. I'll give you a look at some of the most commonly used tools here; otherwise, I'd have to write an entire book just on this program, thereby negating what we're trying to accomplish in this one. In other words, I'm going to keep this extremely brief, but there are in-depth books on Fireworks available if you need a more thorough review of the program.

CROP TOOL

I don't know anyone who doesn't think this is one of the best discoveries since the splitting of the atom. The crop tool is invaluable when it comes to cutting your image down to size, be it to crop out unwanted dead space or to simply reduce the actual size of the image to eliminate extraneous download times on the Web. Select the Crop tool, drag it across the portion of the image you want to use, as in Figure 4.1, and then double-click inside the border to get rid of all the nonselected image information. Figure 4.2 shows the modified file.

FIGURE *The selected area of the image that is to be*
4.1 *saved.*

FIGURE *The cropped image. Notice the difference in the size of the file in relation to*
4.2 *Figure 4.1.*

THE LASSO TOOL

The Lasso tool is invaluable when it comes to outlining and selecting particular elements within the image, as shown in Figure 4.3. It is recommended that you use a drawing tablet for more precise control over the outlining process.

FIGURE *The subject of the image selected by using the Lasso tool.*
4.3

MODIFIERS

Fireworks gives you all the modification commands that you find in competitive programs; everything from what you see in Figures 4.4 and 4.5, to sophisticated layer effects.

FIGURE *One set of modification tools to help you create special image effects.*
4.4

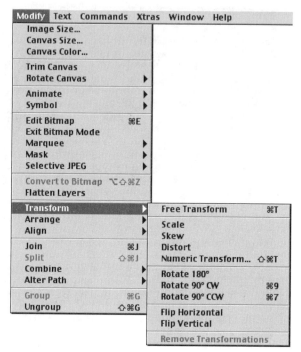

FIGURE *A second set of what are probably some very*
4.5 *familiar modification tools.*

OTHER RECOGNIZABLE TOOLS

There are dozens of other recognizable image modification tools inside Fireworks, including:

- The Rubber Stamp tool
- The Paint Bucket and Brush tools
- The Scale tool
- The Magic Wand tool
- The Pen tool

In addition, Fireworks has such a strong familial relationship with its sister programs, Flash and Dreamweaver 4, that many of these will take on a new level of purpose in your work. In Chapters 5, 8, and 9, you'll discover just how closely Fireworks files integrate with the other programs. For now, suffice it to say that whatever you want to accomplish with your photographic imagery, you can do it directly inside of Fireworks without the need for an outside program to be added to the design mix, and, in many cases, more efficiently.

Here is the reason this is the case. First and foremost, Fireworks should be used to optimize your images—whether GIF, JPEG, or PNG—for the Web. Optimization lets you modify the quality of the image without affecting its look so that it will load faster on the Web. Figure 4.6 shows the Optimization screen (called Export Preview), which is found by going to File>Export Preview. At the bottom of this window, you can switch between a single view, double view, or quad view, which is the one I selected.

Each of these views has pop-up menus that let you set different parameters for the image so you see how a particular setting affects the look of the image, and the time it will take to load onto a page depending on modem speed. Click once on each screen to activate it, and then use the controls on the left to change image settings. This way, you can compare quality and speed of download.

Fireworks is also excellent for creating rollover buttons for your Web site, whether standard rollovers where the button changes appearance when a cursor is moved over it, or advanced/remote rollovers where,

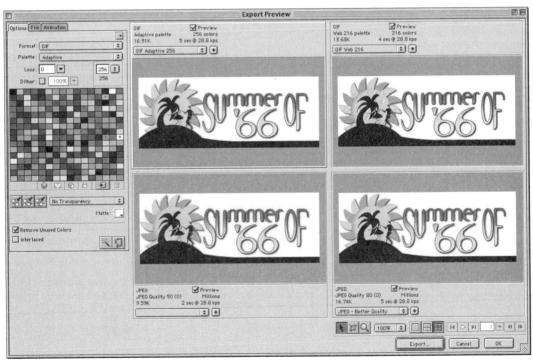

FIGURE *The Export Preview screen, the area where you can set optimization levels so your files look as*
4.6 *good as they can while loading as quickly as possible over the Internet.*

when the cursor rolls over it, something else appears in another part of the Web page.

You can create other types of animations as well. And, of course, you can import an image and modify it much as you can in programs such as Photoshop.

But what is really cool is that you can assign Fireworks to be the external image editor of choice from within Dreamweaver 4. You must do this inside of Dreamweaver, so you might want to take a moment to open that program and assign Fireworks as the external image editor now. Here's how to do that.

In Dreamweaver, go to Edit>Preferences, and choose File Types/Editors as shown in Figure 4.7.

Select a file extension such as .gif, .jpg, or .png and, if necessary, go to the Editors window, click the + (plus) button, and navigate to the Fireworks program to select it.

Once selected, click the Make Primary button to make Fireworks the external image editor assigned to Dreamweaver.

When you place a file with any of these extensions into a Web design and you want to make some modifications to the image, hold down the Command key (Win) or Control key (Mac) and double-click on the image.

FIGURE *The Preferences panel inside of Dreamweaver with File Types/Editors selected.*
4.7

Fireworks will open and you can make your changes. Then, when you save the modified file, it will automatically be updated on your Web page.

That's a quick rundown of what Fireworks can do, plus a look at how it can interact with Dreamweaver to help speed production of your sites. Let's move along and explore Fireworks 4 more fully.

USING FIREWORKS TO CREATE A POP-UP MENU

In the course of creating any Web site, if you're anything like me, after a while you really want to provide something different. You want to expand your creativity. This means not repeating your designs from site to site. Rollovers are hot. Advanced rollovers that make things magically appear at a different location on your page are *really* hot. The mouse follow command, where an image chases after the cursor as the visitor moves it from spot to spot, is the effect du jour. Creating the latter is definitely a scripting challenge, and we'll get into scripts in the Flash and Director chapters. For now, though, I want to look at a new feature in Fireworks that gives you the ability to create rollover pop-up menus.

I believe I mentioned earlier in the book that I personally dislike it when I go to a site and am bombarded with links. That's another of those designs du jour—provide every link known to mankind right on that first page. What this means for visitors is that they have to put on their Indiana Jones garb and begin the quest to find the specific link they are searching for. You can make things much easier for visitors to your site by using the new Pop-Up Menu Creator, which gives you the ability to build multiple levels of submenus and attach URLs to each. Therefore, instead of having to list each site you want to link to under a given header—Books, for instance— you can create one graphic and have a pop-up menu appear listing each of the sites you want to feature.

 *You will need to have a Web browser specified in Fireworks'
Preferences so you can monitor how this effect looks. You
cannot see the pop-up effect inside of Fireworks.*

Let's go ahead and create a basic pop-up that is assigned to a button you'll create in Fireworks. This section doesn't follow along with the design of the *Summer of '66* site; that will come in the next section of this chapter. We'll also look at the advanced elements of this feature.

Here comes my "Boy, He Has a Firm Grasp on the Obvious" statement: Go ahead and open Fireworks. Now, create a document that is 200×50 pixels. Make sure you have the following windows open:

- Layers
- Behaviors

Any other windows are superfluous to this demonstration.

Select a red color and, with Layer 1 selected, draw a rectangle on the workspace. Select None for Stroke, so that you completely fill the workspace. Create a second rectangle, this time filled with black. Switch to the Ellipse tool, create an oval inside the second rectangle, and fill it with white so that your button looks like Figure 4.8.

We don't have any identifying text assigned. For this demonstration, I'm going to make the button a link to online bookstores (so you can purchase more copies of this fantastic book you are holding in your hands right now). Using the Text tool, type "Books," and assign whatever font style and color to the text that you want. Figure 4.9 shows the button ready and waiting for fame and glory on the Web.

You'll need to do one more thing before you create the pop-ups: You must have an area assigned as a Slice or a Hotspot in order to make the pop-up. Use the Slice tool to draw a slice inside the red rectangle. You can draw it to encompass the entire area, or just a portion of it. As you can see in Figure 4.10, I did the latter. Notice that bulls-eye in the center of the screen? We'll discover what that's used for later in this chapter.

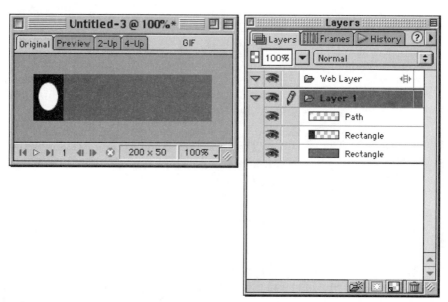

FIGURE *The base look for the button.*
4.8

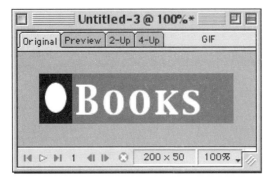

FIGURE *The finished button image.*
4.9

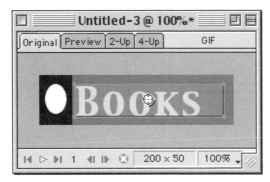

FIGURE *A slice assigned to the button.*
4.10

Now we'll move over to Behaviors. This is the area where we assign the pop-up values for the button. Click the Add Action to Hotspot/Slice object (or the + button for short), and select Set Pop-Up Menu from the list. This brings up the Set Pop-Up Menu screen like the one in Figure 4.11 where we'll give each pop-up section a name, a target, and a link. Yes, I said each section. You can create as many links to the pop-up as you like by clicking the Add Menu button after you finish creating the link.

For the first pop-up field, let's link to Amazon.com. Fill in the appropriate information for the Text, Target, and Link fields, and click the Add Menu button (the one with the plus sign above the Text field). You can also select a target from the pop-up menu associated with that field. Click the Change button when you're finished. Figure 4.11 shows how the changes are reflected in the large window. Click the Add Menu button again, and type in another online bookstore and fill in the required information. Continue

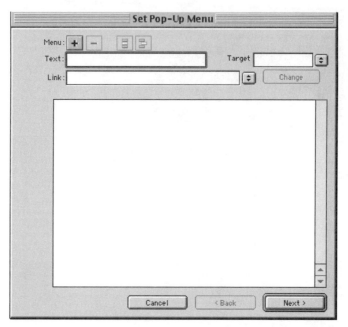

FIGURE *The Set Pop-Up Menu screen.*
4.11

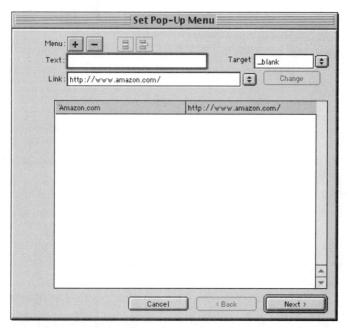

FIGURE *The first pop-up link is completed.*
4.12

with this until you have three or four selections assigned as shown in Figure 4.13.

Click the Next button to go to the secondary setup screen shown in Figure 4.14. Here you can assign text and menu bar rollover information, the type of file the button will be saved as, and fonts. For now, leave the settings as they are, and click Finish. That's all there is to it. Again, to view what you have done, you have to preview your work in your Web browser. Go to File>Preview In Browser. When you place the cursor over your button, you should see a pop-up menu appear much like the one in Figure 4.15.

That's a pretty nice option to know about when designing your sites—unfortunately, it looks pretty boring. Pop-up menus are pop-up menus, right? They're gray and they're ugly; however, they're functional and play their role without much fanfare. Luckily, we don't have to fall into that same old trap. With Fireworks, you can assign different looks to the pop-ups to give them unique looks.

Let's go back to the Behaviors window and double-click on the pop-up event to bring the Set Pop-Up Menu screen again. The links are still applicable, so don't change those. Just click the Next button to go to the second menu screen.

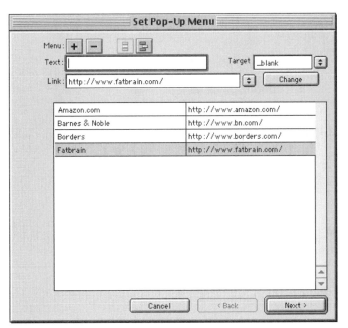

FIGURE *All pop-up links are now assigned.*
4.13

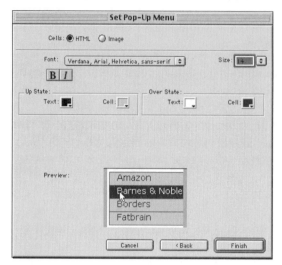

FIGURE *The secondary pop-up setup screen.*
4.14

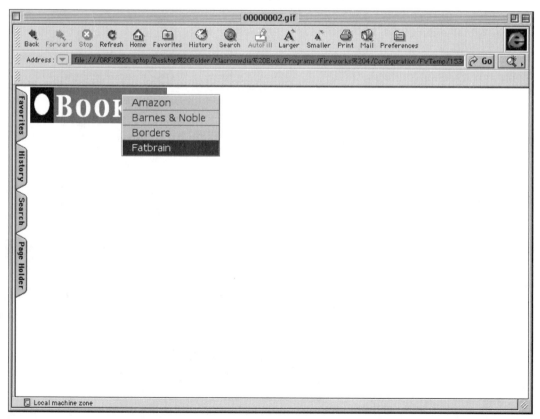

FIGURE *The effect as viewed inside an assigned browser.*
4.15

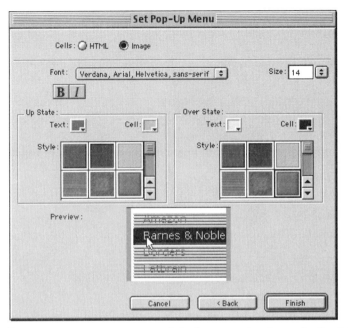

FIGURE *Button images are revealed when you select Image for the Cells.*
4.16

In this screen, change Cells from HTML to Image. Figure 4.16 shows the choices that are now revealed in the Up State and Over State areas. Here you can assign different styles to the pop-up segments themselves, both when the mouse is over a line and when it's away from it.

In Up State, choose the last button image shown in Figure 4.17.

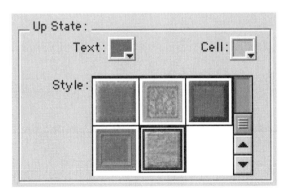

FIGURE *The selected Up State button image.*
4.17

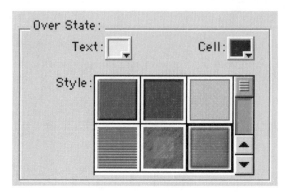

FIGURE *The selected Over State button image.*
4.18

In Over State, choose the third button image in the second row, as shown in Figure 4.18.

Finally, change the Up State text color to Red, and the Down State text color to Yellow. Click Finish, and then preview the file in your browser. It will look much like what you see in Figure 4.19.

FIGURE *The new look as seen in the Web browser.*
4.19

TAKING CONTROL

You will have noticed by now that the pop-up screen appears over the button image or, depending on the size and positioning of your slice, it could be off to the right in a totally different area of the screen. That isn't going to work most of the time. How do we fix that? Pretty easily, actually.

Look closely at the workspace. Notice the squiggly blue line extending from it? It's attached to a blue-outlined rectangle. It can be easily overlooked, but it's there. Move your cursor over this rectangle and move it to the position that best suits your fancy. You can move it anywhere on the screen and, by expanding the workspace window to show the "dead

space" around it, you can make the pop-up list appear anywhere on the screen.

This can be dangerous, as I'm sure you're well aware. If you create a pop-up list like this and position it in a remote location, you must remember where it's placed so it doesn't cover other elements on your Web page. This is definitely a feature that works best where there are wide open spaces.

Outdents and Indents

You may have noticed those two buttons just to the right of the Cells selection buttons. What are those for? And what does Outdent mean? Well, these are the controls that are used to determine a parent topic in the pop-up and the child topic associated with it. Let's make one more modification to the pop-up menu so you can see how these two buttons work.

First, the Outdent button—the one with all the bar images lined up flush left—is the default selection. That's what you want when you're making a pop-up like the ones we just made. However, what if you want to supply more precise links to the four main links? You'll use the Indent button to do this.

Go back to the Pop-Up Menu screen. Click once on the Amazon topic to highlight it. We'll add some subtopics for it, and we need to let Fireworks know that these subtopics are related to Amazon. Click the plus button for each of the following sublinks:

- Computer
- Web

Repeat this process for each of the other main bookstore links so that the preceding topics are listed underneath each one as shown in Figure 4.20. Make sure that you know the exact URL so these new links don't all go to the same Web page when accessed.

Now, highlight each of these subtopics in turn and click the Indent button. When you're finished, your screen will look like Figure 4.21.

Click Next, then Finish, and preview your button in your browser. The pop-up will now have submenus where specific topics can be selected as shown in Figure 4.22.

What's really great about this is that you can create submenus to the submenus (see Figure 4.23) to specify more precise links. The pop-up menu is a great feature when you have many different links that are somewhat related, or for e-retailers to specify sizes or colors for clothing or hats. You no longer have to have dozens and dozens of text links cluttering up

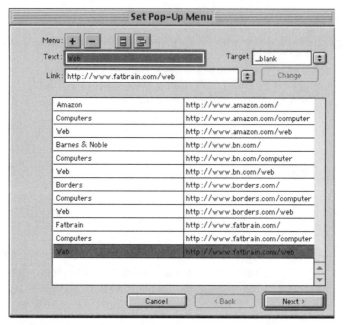

FIGURE *The new additions to the list.*
4.20

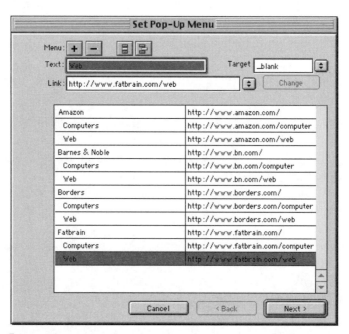

FIGURE *The topics indented.*
4.21

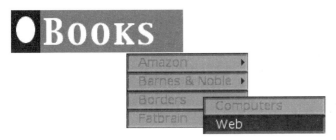

FIGURE *The new topics are now part of a sub-menu.*
4.22

FIGURE *The submenus now have submenus.*
4.23

your design. A few simple master topic buttons with pop-ups assigned are all you need to give your site(s) an original look.

You'll see how I incorporate this look in the *Summer of '66* site at the end of this chapter.

EVE OF DESTRUCTION

Yep, I finally found a way I could incorporate one of the hits of 1966 into the heading for a chapter section. I'm not talking about destruction like you'd see at a demolition derby or when a building is blown up—nothing so violent. I'm merely talking about the cutting up of images and how you can control the appearance of each slice when it is accessed on the Web.

Why would you want to do this? If you have a photographic image to display, why not assign the same compression settings to each slice? Most of the time you will want to do this. However, there are other times when you will want to highlight a specific portion of a larger image to make it stand out. Maybe that's because it's a link to another area of your site or to a remote

site. Maybe it's an area of the image that pertains to the topic, while all the other sections are eye candy. If the latter is the case, then why not just cut out all the unwanted areas and only use the portion that illustrates your topic better? Again, there's no reason not to. But then, there's no reason not to give an image an interesting and unexpected stylistic appearance.

Figure 4.24 shows the base image I'll use to give you an idea of what different stylistic approaches we can create. This is a rather later image, approximately 400 × 300 pixels. As mentioned earlier, it's always best to set up a Web page for the lowest common denominator, those with a 15-inch

FIGURE *The base image with which we'll be working.*
4.24

monitor set at 800×600 pixels. That being the case, our image will take up approximately half the screen, and will take some time to download on a 56.6Kbps modem.

Of course, the first thing that we could do is slice the image into manageable chunks. That way, even though it won't necessarily cut down on the overall download time (remember that the overall size of the sliced files still comes out to the size of the original, nonsliced file; hence, the download time would be approximately the same), it will give the impression of loading faster because each of its parts will load more quickly. Figure 4.25 shows the way this image was sliced.

FIGURE *The image sliced for the Web.*
4.25

The images used in this section of the chapter are available
in the appropriate chapter folders on the CD-ROM.

Then again, we could always create a vignette effect similar to Figure 4.26 using Fireworks or a program such as Photoshop, thereby forcing the focus on the image's subject.

This is a good time to point out that Fireworks 4 has been improved to import and export Photoshop files more efficiently. Text, layers, and masks have all become more user friendly when imported from, or exported to, Photoshop. This really helps when you work in a collaborative atmosphere. It also helps most of us who have Photoshop (in one incarnation or another) in our toolkit.

FIGURE *A vignette imported into Fireworks.*
4.26

I personally like vignettes. I think they look fairly classy when done correctly—meaning that the subject fits with the effect and that the vignette is framed correctly. I also like the use of violating the edges of a vignette—Figure 4.27 shows what I mean. Basically, it allows a portion of the image that would normally be cut off to appear as if it is coming out through a hole.

FIGURE *An example of a vignette with its subject violating*
4.27 *the border.*

You saw the basic sliced image in Figure 4.25. This merely set up the slices in equal-sized parts. However, notice how the subject of the photograph is cut in half. This definitely won't do, not for what we want to do to the image. Now look at Figure 4.28. Here you'll see the slices set up so the subject is unaffected.

With the image sliced correctly, let's go ahead and assign an effect to the slices. Since the theme of this book is set in the mid-1960s, it would be

FIGURE *The correct way to slice the image in order to keep the subject whole.*
4.28

appropriate to set up the surrounding slices to emulate the psychedelic posters of that time. This won't be a truly psychedelic effect, though. It's going to use the GIF compression technology to lower the number of colors in the slices.

Remember that you can hold down the Shift key and select multiple slices. Select all the exterior slices and, in the Optimize window, select GIF from the pop-up menu. Keep the Index Palette set to Web Adaptive, and change Colors to 8. Never thought you'd allow a photograph to look like

FIGURE *A posterized GIF effect along the edges of the image.*
4.29

Figure 4.29, did you? In this case, though, it gives a rather interesting pos-terized effect that fits with our theme.

Finally, select the slice that contains the subject and set it up as a higher-quality JPEG image. Click the Preview tab on the workspace when you have finished with the setup to see how the modified image appears. You can also do Preview in your browser to see how the sliced files will look. Figure 4.30 shows the finished image.

It would be good to note at this stage of the discussion that you will want to have as many browsers as you can in your system. There are dis-play differences for each. Therefore, to have Internet Explorer and

FIGURE *The finished image with GIF and JPEG compression combined.*
4.30

Netscape Communicator (at the least) accessible by all the programs we're looking at, you will be able to fix any problems that might be inherent to a particular browser's display before putting the site up on the Web.

There are a number of smaller browsers available that, while not actually competitive with the "Big 2," do have some users. You can check the World Wide Web Consortium's site for information on their browsers (www.w3c.com), and sites such as MacOrchard (www.macorchard.com) for competitive Macintosh browsers.

If possible, find someone you know who has a WebTV unit attached to their television set. Because of the dimensions and resolution of the standard television screen, as well as the fact that WebTV uses Windows CE as its base operating system, you'll see massive differences in many of the Web sites. While WebTV only commands approximately 2 percent of the Internet market, it's a good idea to know what your designs will look like via every possible connection. Note that WebTV, at the time of this writing, cannot read .swf files.

COMPLEX ROLLOVERS

Complex Rollovers are also referred to as Advanced Rollovers or Remote Rollovers. Bottom line, these are the type of rollovers that, when activated, make another image appear at a different location on the page. They could appear immediately next to the activating element or in a totally different area of the screen. Fireworks is the perfect tool to create these types of rollovers, because everything can be accomplished directly inside the program and easily imported into Dreamweaver.

For this section, we're going to create one rollover button that incorporates the sun logo image you built in Chapter 2. If you didn't create it, or you if didn't save the file when you finished, you can find the logo on the CD-ROM in the Chapter 2 folder located inside the Images folder—Images>Chapter 2>Sun.

The first thing to realize about this project is that it will not appear in this form on the actual Web site. You'll see in the next section that the button would be much too large for a real site. This button would basically be large enough to be used as title art, so don't be concerned about that.

This is also our first taste of a really cool, multiple rollover that offers the visitor a unique way of accessing different areas. It's designed to give you an idea of just how powerful—and how easy—it is to create an interactive element with many levels.

A MULTIPLE ROLLOVER BUTTON

First, create a document that is 300 × 50 pixels and, of course, 72 dpi. You want the background to be white since that will be the background color of the site. Create a rectangle and fill it with black, approximately the size you see in Figure 4.31.

FIGURE *The first portion of the rollover button.*
4.31

Open—don't Import – the Sun image (Command/Ctrl + R). Once you've located and selected the file, a new screen will appear. Since this is a Freehand file, the screen you see in Figure 4.32 will come up. Leave everything at their default settings, making sure that the Preserve Layers is selected in

FIGURE *The Vector File Options screen that appears when you open an*
4.32 *image containing vector artwork.*

the pop-up menu about halfway down the screen. Then click OK to open the file.

There are three layers to this file, two of them being the rays of the sun, and the sun itself. Group them (Command/Ctrl + G) and drag the image onto the button workspace. You can now close the Sun file, because all our work from here on will be on the button workspace.

Since the sun much too large for our button, select Modify>Transform> Scale and, while holding the Shift key to constrain the proportions, scale the sun down so it fits into our black box. Move it into the position shown in Figure 4.3. Once in position, ungroup the layers using Command/Ctrl + Shift + G. In the Layers window, name each of the sun's layers so they are more easily selected.

Now add some text to identify the button. For this project, we'll call the button Tunes. I'm using a font called Sand for this demonstration, but you can use any font you wish. Sand, though, is an interesting font that doesn't conflict with the rest of the fonts we discussed in earlier chapters, so it could be used in the actual site. In fact, for certain elements, it very well might. You can see the completed first frame of the button in Figure 4.34.

FIGURE *The sun is scaled and positioned on the workspace.*
4.33

FIGURE *The main Tune button.*
4.34

GETTING FRAMED

Frames are an important part of designing a site that has a more complex layout, whether for controlled placement of different elements such as text and images, or for advanced rollovers. To build any type of rollover in Fireworks, you need to work with frames, adding elements at different levels that will appear when the visitor does something, which, in this case, is move his or her mouse onto the text. In the most basic terms, you are creating an animation. This type of animation is extremely controlled, and is activated by specific actions assigned by you.

If it isn't open already, open the Frames window (Window>Frames). You will see the first layer, the one containing the elements you just created. You could create a new frame by going to the Panel Options pop-up in the upper-right corner and selecting Add Frame. To do it that way, though, means that you will have to select all three elements (the black box, the sun logo, and the text) in Frame 1, copy them, and paste them into a new frame. Why? If you didn't do that, as soon as the visitor's mouse moved onto the button, that information would disappear to be replaced by the text we're about to create. Sometimes you'll want something like that to happen—for this project, you don't. You want the elements to remain on screen at all times. Therefore, select Duplicate Frame from the Panel Options. This will duplicate everything from the selected frame and place it on the new frame.

Select the Text tool and add the following text to the new frame:

Hear The Boss Tunes!

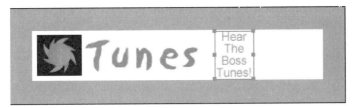

FIGURE *Text added to the second frame.*
4.35

Figure 4.35 shows the position of this text.
Duplicate this frame and add the following text:

Select A Hit:

After you have done that, your button should look similar to Figure 4.36.
Now comes the fun part: It's time to add the rollover effects.

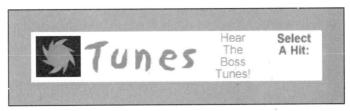

FIGURE *This is what the button will look like after all three frames are revealed.*
4.36

Activate the Pointer tool. Select Frame 1. Activate the Slice tool and sur-
round Tunes. Next, select the second frame and, using the Slice tool again,
surround the Hear The Boss Tunes text. Go back to Frame 1, activate the
Pointer tool, and click once on the slice. Notice the bulls-eye that appears
in the center of it. This is another new feature that makes it easier to create
links, and here's where, as I promised, you'll discover what it's used for.

If you are used to other versions of Fireworks, you know you had to use
the Behaviors window to assign a behavior to a set of slices. In v4, you
don't need to do this. Just drag the bulls-eye to the slice you want it linked
to, and everything happens automatically. It's a real time saver.

So, drag the bulls-eye until you see it attach itself to the slice you cre-
ated on the second frame. Figure 4.37 shows what this will look like. As
soon as you release the mouse button, the Swap Image screen comes up
and asks you which frame you want to change to. Make sure Frame 2 is

FIGURE *When you place the bulls-eye over the target slice, you'll see the link being*
4.37 *created.*

selected, and then click the More Options button. Deselect Restore Image
onMouseOut so that the button doesn't revert to Frame 1 as soon as the
cursor is outside the Frame 1 slice area.

Now select Frame 3. Create a slice around the text in this layer. Go back
to Frame 2 and link the second slice to the newly created one. This time,
when the Swap Image screen appears, go directly to More Options (do not
pass go, do not collect . . . well, never mind). Select Frame 3, and deselect
Restore Image onMouseOut.

Now would be a good time to save the file and then make sure that
everything is working correctly.

THE TUNE TITLES

Here is where we will add a pop-up list with a selection of songs your vis-
itors can access. Using what you learned earlier in the chapter, add these
song titles and (false) links:

Wild Thing	http://www.summerof66.com/wt.html
Boy from New York City	http://www.summerof66.com/bfnyc.html
Leader of the Pack	http://www.summerof66.com/lotp.html
Sweet Talkin' Guy	http://www.summerof66.com/stg.html
Carolina Girls	http://www.summerof66.com/cg.html

Set _blank as the Target. In the next screen, activate Image and change
the font size to 9. Choose a look for the pop-up menu, and click OK. Move
the pop-up indicator so that it is immediately adjacent to the colon after
Hit.

Save your file again, and preview your work in the browser. The final
look in the browser window should be similar to what you see in Figure
4.38.

That's a pretty awesome look; one that will really make your site stand
out. It would definitely need to be modified before it's ready for public

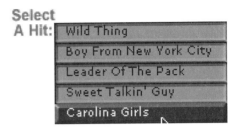

FIGURE *The multiple rollover's final appearance.*
4.38

consumption on the Internet, because it really doesn't fit in with the over-all site design (as you'll discover in Chapters 8 and 10).

GET YOUR MOTOR RUNNIN'

Now, it's probably best that we head out on the highway to get some more ideas before we actually buckle down and build our Web site. But, as you discovered here, there are some vast improvements to Fireworks that can really make your work flow smoothly.

In the next chapter, we'll look at Flash 5, discover some of its new features, and begin to create some animations for the *Summer of '66* Web site.

5

Animations in a Flash

More Hit Tunes of 1966

Wooly Bully—Sam the Sham & The Pharaohs
Like a Rolling Stone—Bob Dylan
Treat Her Right—Roy Head & The Traits
I Got You (I Feel Good)—James Brown

YOU HAVE CONTROL

"Do not adjust your television set. We have control of the vertical. We have control of the horizontal." Almost 30 years later, the opening lines from the classic science fiction show *Outer Limits* has a new meaning. Just substitute "monitor" for "television set" and you have the modern-day version of this series—and it's all made possible with a program called Flash. I can say with almost complete certainty that there is virtually no one who has been accessing the Internet for more than a couple of months who has not heard of this program. With millions upon millions of free Flash players in use around the world, it is, by far, the most popular program for fast-loading, high-quality animations on the Web. Flash developers literally have control of your vertical and horizontal when creating their files, because Flash seems to be able to do anything you want it to—as long as you take the time to learn how.

It's important to understand the genesis of Flash because it gives some insight as to how it has evolved to what we have now. Flash was originally created as an animation tool, capable of doing cel animation for cartoons. As the Web began to expand and technology started to allow animation capabilities, Macromedia added the capability to save files for viewing on the Internet. It was the perfect melding of program and presentation, since it had already been honed to create vector-based graphic animations for cartoonists.

What are vector graphics? Unlike photographic images that are pixel-based and dependent on resolution (dots or pixels per inch—dpi/ppi) for clarity, vector graphics rely on mathematical equations to produce clean, crisp images, no matter what size they are. You can create a 1-pixel × 1-pixel drawing and it will print as cleanly at that size as it will if you expand it to outdoor billboard size.

What is also nice about vector graphics is that the resultant files remain small, which means that for Web purposes, they load extremely quickly—in most cases, almost instantaneously. The same size JPEG or PNG image file could take up to 100 times longer to load on a page.

One of the smartest moves ever made was to provide the Flash Player—the browser plug-in—for free download. At this writing, approximately 95 percent of all Web surfers have this plug-in installed, which means that virtually everyone surfing the Internet can view Flash files you create.

As with other sophisticated applications, learning to develop in Flash is not something that will happen overnight. While that won't stop you from opening the box and creating a cool animation quickly, to get the most out

of Flash you'll need to add or create your own action scripts, called ActionScripts. Pretty appropriate, huh?

Another thing you should realize about Flash is that it is not overly forgiving. This means you really need to have a game plan, whether a sketch as in Figure 5.1, or a listing of the various elements you'll need to have, before attempting to build your Flash file. You need to know what element is going to be a graphic, button, or a movie. It's difficult to go back later and change a movie to a button, or a button to a graphic. Therefore, knowing what is going to be what before you open the program will save you a lot of time and headaches. Although the program has gotten better about this aspect, it really will behoove you to have your plan laid out before starting to create.

What I just discussed could well be thought of as a negative, but it really isn't; it's an aspect of Flash that can only make your design work that much better. By getting into the habit of preplanning, the amount of time it takes to create the file you envision will be reduced dramatically. If you aren't

FIGURE *A sketched idea of the design for a Flash file, showing buttons, input fields,*
5.1 *and graphics.*

familiar with Flash, or are fairly new to the program, your biggest challenge will be in determining what element should be used to generate your effects. Get in the habit of asking yourself what specific elements would work the best in any given situation. Would X be best assigned as a straight graphic, or would it ultimately be more effective as a button or movie?

In this chapter, you'll get a better feel for what your next project should include. As with Chapter 4, there is so much to cover in Flash that one chapter wouldn't do it justice. What you should come away with here is a good idea of how to plan your animations and then create the final file. I'll be looking at different ways of creating some great files, as well as how I'll go about creating files for the *Summer of '66* site. I'll also discuss why it would be more effective to create certain files inside of Flash, and why it might be better to create them in Director. Of course, Director is not exactly an inexpensive program, and its native programming language, Lingo, differs from ActionScript. However, Director does work with certain types of files more efficiently than Flash does. I can tell you with some authority (I have this badge, see, that I wear under my street clothes that says I have authority—although it doesn't say authority over what) that you'll be hard-pressed to really find much in either program that would make you throw out one for the other—especially when it comes to Web site creation.

MULTI-TALENTED PROGRAMMING

You can use Flash to create intricate rollovers, animated elements, and entire Web sites without the need for any other program. Yes, it can take a little extra work to do this, but a full page or full site has such great rewards. A Flash site has a fluidity and form unlike any other. Check out www .extremeflash.com as one example of just how different a Flash site "feels" in comparison to other sites. It's fascinating. I can't think of any words that accurately describe the experience of visiting a Flash site. The best analogy I can come up with is that the difference between a site that contains Flash elements and a site created entirely in Flash is like playing under a sprinkler versus swimming in the ocean.

NEW IN 5

Before we get started with all the fun stuff, let's look at some of the new features in Flash 5. For those of you who have worked with version 4, you'll find these new features well worth upgrading.

New panels (Figure 5.2). There is a slew of new panels to help you organize your workflow. These include panels for Color, Actions, Instances, Frames, Type, and Movies. The latter gives you the ability to modify elements in a Flash movie.

FIGURE *The new panels contain important controls such as color, actions, and instances.*
5.2

Pen tool (Figure 5.3). This is probably the most-requested element to be added to Flash (in my estimation). The Pen tool acts like its counterpart in programs such as Freehand and Adobe Illustrator.

Customizable shortcut keys. You're no longer limited to shortcuts provided with the program. Create your own commands and functions. Refer to the *User Manual* to learn how.

Shared libraries. You can create buttons, graphics, sounds, font symbols, and regular symbols, and share them between documents.

FIGURE *A look at the Pen tool in action.*
5.3

MP3 support. Now you can import audio that is already compressed. This reduces file size and the memory load while you're building your movies.

Enhanced ActionScript gives you more scripting capabilities. This lets you more easily create greater interactivity in your movies.

Print actions. You can assign actions for printing frames from Flash movies directly from the Flash Player. You can print out as vector or bitmap graphics.

Movie Explorer. Get the properties of the current movie for easier modification.

FIGURE *Connecting to the Internet using Macromedia Dashboard is a great way to quickly and easily*
5.4 *update your program, and get inside information from Macromedia and from power users*
worldwide.

> **Macromedia Dashboard** (Figure 5.4). A really cool way to connect to
> Macromedia to get the latest tips, tricks, updates, and more.

As you can see from this short list, there are many great additions to
Flash that really add to its creative functionality.

FLASH CARDS

It might behoove us to take a few moments to differentiate between a
graphic, a button, and a movie. If you don't have enough space on your
computer desk to keep this book or the *User Manual* open to use as a
refresher, make some Flash cards to help you remember what each term
stands for.

Get it? Flash cards for Flash.

But I digress.

Here's how I view this section. For those of you who are new to Flash, use this to refresh yourself with what you learned in the Flash 5 *User Manual*. For those who have been using Flash for a while, you might want to skip over this part; it will be pretty redundant to what you already know (unless, of course, you really love my writing style and want to see what strange things I might say about these elements). Of course, no one has ever accused me of being the Isaac Asimov of software-related writing—yet. More of my readers have likened me to Stephen King because of the scary way in which I look at graphic design and e-life.

TERMS AND CONDITIONS

First, the main workspace is called the *Stage* (Figure 5.5). You can look at the Stage as being the area where all your actors (graphics, buttons, movies, etc.) perform for their audience—the visitor of the site. It is also the place where events are staged, such as rollovers, animations, and more.

The *Timeline* (Figure 5.6), as with the timelines in other programs, determines where an element will appear, where an event will happen, and what elements are positioned where.

FIGURE *The Stage, where your designs will come to life.*
5.5

FIGURE *The Flash Timeline, which is identical to the timelines in other Macromedia programs.*
5.6

Other terms to know:

Events. Actions created with ActionScripts or by other methods that determine the look, interactivity, or animation of an element or elements on the stage.

Graphics. These are most often nonanimated images, although you can save animations or portions of animations as graphic symbols for later use. The one thing about graphic animations is that interactive controls will not work on or with them. These elements are tied to the Timeline of the main movie.

Buttons. This is pretty self-explanatory when it comes to Web site elements. You use these to build interactive buttons and rollovers. You can place a Movie inside a button to create animated buttons.

Movies. These symbols are reusable animations that have their own Timeline. This means they will play independently of the main movie's Timeline. One way you can look at these is like a television's Picture In Picture (PIP) feature, where one screen shows one channel and another screen laid over the main one shows another channel.

These are the main terms that you need to understand and recognize for Flash success, because they are used extensively throughout the *User Manual* and all the books on the market dealing with the program. Moreover, they're explained in each of the books, so who am I to break from the norm? Not knowing what these terms mean will hinder your growth in Flash.

ACTIONSCRIPTS

There is also an impressive upgrade of the ActionScript feature. If you want to provide any type of interactivity for visitors, you will have to use ActionScripts in your files. Otherwise, you will be creating a movie for people to watch—and only watch, like seeing a movie in the theater. Interactivity is the key when dealing with the Internet. A movie is fine, but the payoff had better not be the hero riding into the sunset; it has to be something with which the visitor can interact.

Flash 5's ActionScript is a full scripting language, whereas, in prior versions, it was a small set of actions that you plugged in to your buttons or

movies. There is still point-and-click placement of preset terms with the addition of drag-and-drop placement, but now you can do much, much more in this area. The ActionScript editor now includes both a Normal and an Expert mode. In Normal mode, you can select elements by double-clicking on them, clicking on the + sign, or dragging the element onto the script. In Expert mode, experienced ActionScripters can type their scripts directly in Flash, yet still have access to functions, options, operators, and actions. Basically, when you know how to create scripts "by hand," working with Flash 5's updated ActionScript will give you the best of both creative worlds. Figure 5.7 shows the ActionScript window in Normal mode. Figure 5.8 shows it in Expert mode.

FIGURE *The ActionScript window in Normal*
5.7 *mode.*

FIGURE *The ActionScript window in Expert mode.*
5.8

Flash uses an Object-Oriented Programming language (or OOP) that al-lows you to plug in actions like fitting a puzzle piece into a puzzle to cre-ate the entire image. Each of the code modules stands alone, yet all work in conjunction with each other. It's an interesting concept; one that makes for easy learning and implementation, yet retains a power found in all of the non-OOP languages. For beginners, all you have to do is work with the

ActionScript you actually need without having to learn vast batches of arcane language. As you become comfortable with it, practice plugging in more code and watch how it interacts with the various blocks. That's what you will do when working in Normal mode.

Experimentation is the key, and ActionScript allows you do to that with very little effort.

In Expert mode, you have the added benefit of using OOP to place the basic code, but then you can get in there and add whatever you need to really make your files sing. Hopefully not like a *Fat Lady* (which is a term, I believe, that is not politically correct in this day and age), because that would mean the whole thing was over—which is as far from the truth as you can get. In Normal mode, the active portion of the code is already placed in its container—the portion of the code that signals Flash that this is what should happen. In Expert mode, the containers are left blank to allow you to build your scripts as you see fit.

Talk about the best of both worlds.

5 IS ALIVE

Flash 5, after becoming comfortable with it (whether it's the first version of the program you've ever used, or if you're an experienced Flash maestro who's getting used to the differences in the user interface), almost feels like it has a life of its own. As you delve further into its almost limitless potential, you'll find yourself being driven to do increasingly intricate work. Check out sites such as www.stanlee.com. Stan Lee helped create such comic book characters as Spiderman, The X-Men, Fantastic Four, Iron Man, and many more. He's now turned his attention to streaming comics on the Web, and his site has some superb examples of storytelling with Flash. Figure 5.9 shows the Stan Lee home page.

Another site to look at that uses a simple Flash animation that is effective because of how it portrays its subject is www.williamleegolden.com. William Lee is the long-haired, long-bearded member of the long-lived country music supergroup The Oak Ridge Boys. There's a lot of "long" to that and absolutely no "short," isn't there? Figures 5.10, 5.11, and 5.12 show three frames from the William Lee Golden animation. These two examples show the diverse quality of Flash creativity.

When you visit www.extremeflash.com, you can also sign up for their newsletter, which is sent on a weekly basis via e-mail. It's a great way to keep up with what Flash developers are doing and how these people are pushing the Flash envelope. You'll discover an awful lot of "ooh and ahh" material; stuff that will make you want to spend every waking hour working

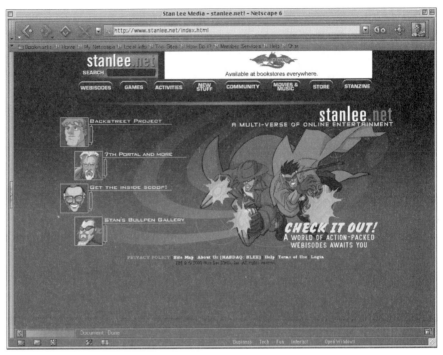

FIGURE *The home page for Stan Lee's Web site.*
5.9

FIGURE *A frame from William Lee Golden's Web site.*
5.10

FIGURE *A second instance of the William Lee Golden opening animation.*
5.11

FIGURE *A third frame from the same opening graphic.*
5.12

in Flash so you too can develop awesome files. Of course, for most of us, to do that would mean giving up all creature comforts because our bosses wouldn't stand for it very long.

STAGING AN EVENT

From this point on, I'm going to assume that you have a working knowledge of Flash and creating basic Flash files. If you're new to Flash, it would be best to work with the program for a while until you're familiar with building animations. The first project we'll work on can be considered appropriate for intermediate users.

While Flash creates files that load very quickly, an intricate animation can take a while to download and then view. However, at various sites, some people create screens or animations that remain on the page until the actual file is ready. Figure 5.13 shows one example. These screens are called pre-loaders, and that's what we're going to create right now.

The *Summer of '66* site won't use a pre-loader, because none of the animations will be large enough to have to worry about using one. It seems, however, that on various e-mail lists and newsgroups, wanting to know how to create a pre-loader is pretty much an ongoing topic. Let's now look

FIGURE *An example of a pre-loader, which you're about to build.*
5.13

at how to do this, because you can use many of the events you use to build a pre-loader for other animations as well.

This upcoming project is designed to help you get used to using the ActionScript window in the Normal mode.

WHICH COMES FIRST?

It's important to remember to place the pre-loader before the actual movie file. Why do I say something that seems so basic? Since you can add a pre-loader to an existing file, you want to make sure that no other elements except those associated with the preloader reside at the same spot on the Timeline. If you want to add a preloader, choose Insert>Scene at the appropriate spot. In our case, however, we will create an entirely new document, so select File>New (Command/Ctrl + N).

The reason for not adding this pre-loader to an existing file at this point is so you can get used to working with the Actions window and adding scripts. There are some differences in the way you assign such things as Label identifiers (Layer Styles in the Actions window) in respect to how it was done in Flash 3 and 4. This section, therefore, will help you get used to where the commands are now located.

All the elements of the preloader will be positioned on Layer 1 in the Timeline. Usually, when working with elements on different layers, you would assign an identifying name to the layer by double-clicking on the layer name. Since you won't have that option here, you'll want to create segments that are long enough to help you keep track of each element. At the end of this, you'll shorten each segment to make the animation run correctly. For now, right-click or Control-click (on a Mac) on Frame 10 in the Timeline. This brings up a Selector screen as shown in Figure 5.14. Choose Insert Key Frame. Repeat this at Frames 20, 30, and 40. Your Timeline window will look like Figure 5.15.

You can also use F6 to insert a keyframe.

Take a look at the Timeline. You'll notice that Frame 40 is a single frame, and all the others are nine frames apiece. It would seem that you created 10 frames for each segment—no, you didn't. You assigned a new keyframe at the tenth frame of each, which means that the ninth frame is the last for the preceding element. Also, since there is no keyframe being

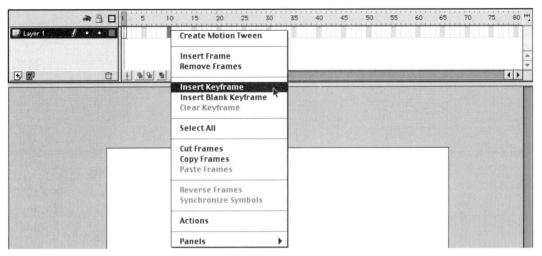

FIGURE *The Timeline Selector pop-up window accessed by right-clicking or Control-clicking on a frame.*
5.14

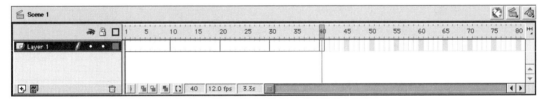

FIGURE *The Timeline with frames inserted.*
5.15

created after Frame 40, you have a one-frame element. This is what you want to have; why will become apparent shortly.

Now, the reason why we created nine frame segments: We need to name each of these elements and, if you don't add enough frames to them at the beginning, you will have to remember what each of these are because there won't be a visual cue to remind you.

BUILDING THE FIRST SCRIPT

Select Frame 1 by clicking on it once in the Timeline. Access the Frame window (go to Windows > Frame if the window isn't open already). In the Label text field, type "StartFrame." Figure 5.16 shows the Frame window. This tells Flash that it is the first frame of the animation. Leave Tweening set to None.

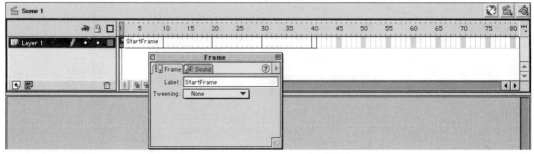

FIGURE *The first frame is given a label. This image shows how important it is to have some visual*
5.16 *breathing space when creating an animation such as this.*

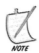

Refer to the Flash 5 User Manual *for an explanation of tweening if you don't know what it means.*

Assign names to Frames 10, 20, 30, and 40. The following are the Labels you need to create, in order:

Frame 10: IfEndFrameLoaded
Frame 20: GoToStartFrame (or feel free to put GoToSF)
Frame 30: StartMovie
Frame 40: LastFrame

Frame 40 is the perfect example of why you wanted to stretch out the other frames. Imagine trying to remember what each of the other frames is as you work through the rest of the project. By giving yourself the ability to easily see what frame you're working with when assigning actions, you won't accidentally assign an action to a wrong frame.

. . . and speaking of Actions, it's time to start assigning them.

Select the first frame of IfEndFrameLoaded.(Frame 10). With Flash 5, assigning Actions is even easier now. Double-click on Frame 10 to bring up the Actions window as shown in Figure 5.17. Open the Actions folder by clicking on the arrow-in-a-book symbol next to it, and select ifFrameLoaded from the exposed Actions list.

Move down to the pop-up menus at the bottom of this window—for this project, just Scene 1 in the Scene field. In the Frame field, choose Frame Label. Then, in the Frame field, choose LastFrame. Figure 5.18 shows the Actions window, the path to the action, and the assigned Action parameters.

We're not finished with this frame. You created the first part of the action associated with it, but you still need to tell Flash what to do when the

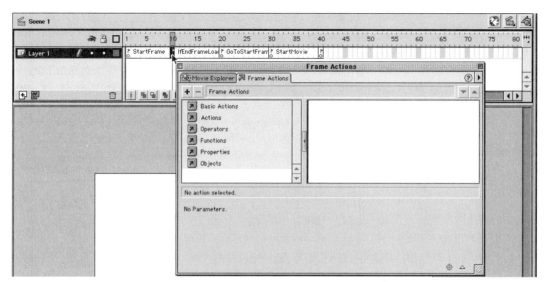

Open the Actions window by double-clicking on a frame in the Timeline.
5.17

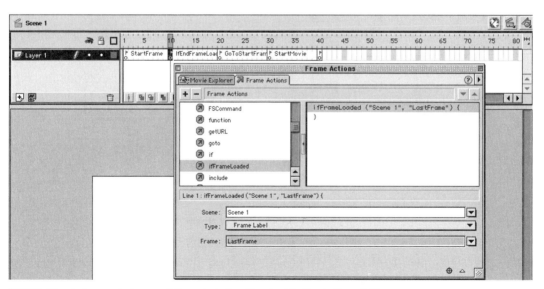

FIGURE *The Actions window and the selected action inside the Actions folder.*
5.18

frame is loaded. All you've accomplished so far is to give Flash something to look for.

Make sure the action is highlighted in the rightmost screen in the Actions window. Double-click on goto so that the Action gotoAndPlay is added to the script. This is a pretty obvious command for the script, because you want to goto someplace and have that new element begin playing. However, you're not finished yet. Set up the action's parameters as follows. Refer to Figure 5.19 to see how your Actions screen should look.

Scene: <current frame>
Type: Frame Label
Frame: StartMovie.

Once you have set these parameters up, close the Actions window.

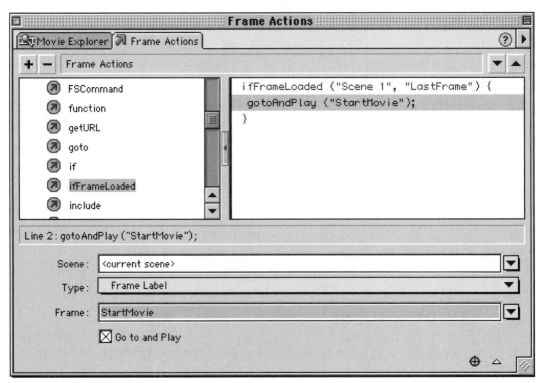

FIGURE **5.19** *The Actions window parameters for the FirstFrame element.*

THE STARTFRAME SCRIPT

The next script we'll build is the GoToStartFrame script. This tells the program that, if the actual animation file has not completed loading, a loop will occur that will return to the first frame of the preloader. Double-click on the first frame of this section to bring up the Actions window. Set up the parameters as follows, referring to Figure 5.20 as necessary):

Actions: goto
Scene: <current scene>
Type: Frame Label
Frame: GoToStartFrame

Finally, make sure the Go to and Play is active by click in the check box, if it isn't active already.

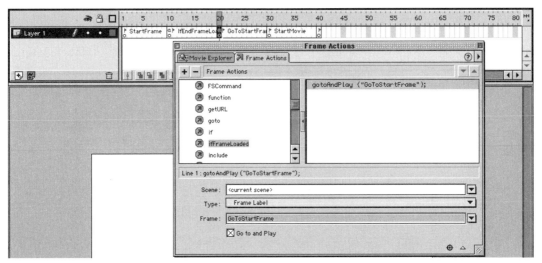

FIGURE *The StartFrame Actions window. Use this as a reference as you build your*
5.20 *action.*

THE STARTMOVIE SCRIPT

When the movie loads, you need to have a command that tells the preloader to go ahead and play the movie rather than remain on the screen. Therefore, double-click on the first frame of StartMovie (Frame 30) and select the following parameters:

Actions: goto

Scene: <Scene 1> (or the Scene name for the movie itself that would show up as <MainMovie>)

Type: FrameNumber

Frame: 1

Make sure that Go to and Play is active by clicking in the check box if it isn't active already. Figure 5.21 shows how this Action window should appear.

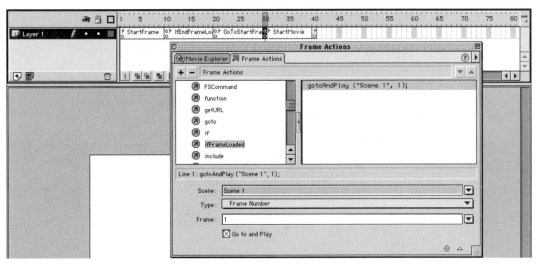

FIGURE *The StartMovie Actions window. Use this as a reference as you build your action.*
5.21

Now what's left is to remove the extraneous frames. Use either Shift + F5, or click on a frame and right-click or Control-click on a Mac until all that's left is what you see in Figure 5.22.

There you go. You just created a series of actions that, when combined with a movie, will act as a bookmark of sorts while the main movie loads. I'm sure you noticed that we didn't create artwork for the pre-loader. What you should do is take some time, add some graphics to the Stage, and practice assigning preassigned ActionScripts to your files. As with anything in life, the more you practice, the better (and in this case, the faster) you'll become.

FIGURE *The final look for the Timeline.*
5.22

INTERACTIVITY

Forms have become almost an integral part of today's Web sites. It seems that everyone is adding forms to their sites. You might want to keep a log of who visited your personal site. Maybe you have decided to collect world-wide locales, keeping a list of the countries represented by your visitors. If you're a business, you might want to use a form to build a database of potential customers.

In this project, we'll create a form for the *Summer of '66* site using the artwork that's quickly becoming infamous, the Sun. This file will be used as both a graphic and a button. As discussed earlier, the graphic cannot have any ActionScripts assigned to it because it's only a piece of art on the Stage. The buttons, though, will have ActionScripts assigned to them.

Before starting, you might want to view the So66Form.swf file located in the Chapter 5 folder on the CD-ROM. It shows the finished version of the file you're about to create.

THE SO66 FORM

First, create a new file and then modify the workspace. This will be a full-page form, so we need to make sure the Stage is set up to reflect this.

Go to Modify>Movie, or use Command/Ctrl + M to bring up the Movie Properties screen.

Change the Dimensions to 640 × 480, and then select Inches for the Ruler Units.

After clicking OK, use Command/Ctrl + - (dash or minus, depending on how you refer to it) to zoom out so you can see the entire Stage.

Turn on Rulers (View>Rulers).

Save the file as SummerForm.

THE SETUP

Position the Stage so that you can see the upper-left corner as shown in Figure 5.23. To do this, hold down the Space Bar on your keyboard. The cursor will turn into a hand. Hold down the Space Bar and the left mouse button (or the main mouse button if you are using a standard Mac mouse) and drag the workspace until the Stage is in position.

Double-click on Layer 1 in the Timeline and name it Background.

Select a dark sky-blue color. From the Fill Color pop-up, I chose the one that is in the fifth row from the top, third to the left. Refer to Figure 5.24 to see exactly where the selected color is located.

FIGURE *The first element for the design will start at the upper-left corner of the Stage, so*
5.23 *position the Stage as you see here.*

Use the Rectangle tool and, starting just outside the upper-left corner of
the stage, create a rectangle that is 75 pixels wide and 480 pixels high so it
fills the left side of the screen as shown in Figure 5.25.

You also want to remove any border that may be assigned to the rec-
tangle.

FIGURE *The chosen color swatch for the*
5.24 *element about to be created.*

Right-click or, if you're using a Mac, Ctrl click, on Frame 10 to bring up the selection panel. Choose Insert Frame to make the overall animation length 10 frames.

Create a new layer, and call it Rotating Sun.

Before importing the Sun artwork, open the Libraries panel (Command/Ctrl + L). I've gotten into the habit of creating groups in this area where I'll store artwork that has a common theme, such as the Sun graphics we're about to add to the Stage. Click the New Folder button at the bottom left of the Libraries window (it looks like a brown expandable file

FIGURE *This is how the Background layer should look.*
5.25

folder). Rename the new folder Sun Art by double-clicking on the folder title.

Make sure the Frame indicator is back at Frame 1 on the Timeline. Go to File>Import and navigate to the Sun file. When the Freehand Import window opens, choose Flatten. Also make sure all Options are deselected. You certainly don't need a background for this second layer. When your Freehand Import screen looks like Figure 5.26, click OK.

Make sure the Background layer is locked. Use the Command/Control + A key combo to select all the Sun elements, and then use Command/Control + G to group the elements.

With the Sun artwork selected, go to Insert>Convert To Symbol, or use the F8 key to change the artwork into a symbol. Name this symbol Large Sun, and make sure to select Graphic as the Symbol type. Refer to Figure 5.27 for a look at this symbol setup. Once this has been set up, click and drag the newly created Large Sun graphic to the Sun Art folder. Figure 5.27 shows how this looks in the Library window.

Save the file.

FIGURE *Flatten the Sun image file before placing it onto the Stage.*
5.26

FIGURE *By using folders, you can group elements in ways that best fit the way you*
5.27 *work. In this case, a folder named Sun Art was created, and the first instance of sun artwork was placed inside the folder.*

POSITION AND ANIMATE THE SUN

Before doing anything else, let's go ahead and position the sun where it needs to be. Using the interior edge of the frame you created for the background, move the sun so that its center point is aligned with the interior edge of the blue rectangle. The top edge of the sun should be approximately 15 pixels down from the top of the Stage. Position a guideline at the third marker down from 0 to help with your positioning.

To place a guideline, move your cursor inside the ruler and hold down the mouse button while dragging either downward (from the horizontal ruler) or to the right (from the vertical ruler).

Each marker along the ruler when pixels are displayed represents five-pixel increments.

With the sun artwork in position, go to the Timeline. Create a keyframe at frame 10. Then create a Motion Tween (the first selection in the Timeline pop-up menu as seen in Figure 5.28).

Go to the Transform controls (Window>Transform if it's not already open). With Frame 10 selected, change the rotation of the sun to 168 degrees.

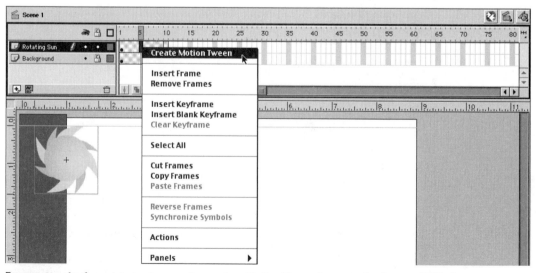

FIGURE **5.28** *Use the frame's pop-up menu to create a Motion Tween between the first and fifth frames.*

Hey! What's going on? What's with this 168-degree stuff? That's not even a full half-circle. Well, let me explain.

First, look at the sun image closely. If you split it in half horizontally and fold the upper and lower halves together, they are identical. This means you can do a 168-degree rotation and it will look the same as if we rotated it 360 degrees.

Second, if we set up for a full 180 or 360 degrees, the first and last frames of the animation would be exactly the same, which would create a hitch in the playback when the two frames played back to back. That would be undesirable.

Third, optimum playback on today's Web when it comes to Shockwave animation is 12fps (frames per second). This means we have to do some basic math to make a smooth transition between frame 10 and frame 1. By subtracting 12 from 180, we come up with 168. Therefore, a 168-degree rotation would, in essence, create a very smooth transition between frame 10 and frame 1 during the loop. That transition would be the same as the transition between the first and second frames, the second and third frames, and so on.

I could have done a 248-degree rotation, but I wanted the sun to spin more quickly. I have, therefore, doubled the speed of rotation. Because of the playback rate, this speedier rotation will create a blurring effect between the different flames coming out of the sun, masking any defects that might be in the rotating elements. It also gives a more interesting feel to the look of the rotation, a more stylistically realistic (if that makes sense) representation of heat.

There you have it, the reason why we assigned a 168-degree rotation rather than 180, 348, or 360.

LOCK AND LOAD

We're finished with that layer. It's time to add another sun into our Sun Art folder. I don't want this sun image to have any type of relationship with the Large Sun we just worked on. This second Sun instance is going to be part of the Select button that will send the information from the text fields to your e-mail. Lock all the layers except this new one.

Create a new layer, and name it Send Button. Repeat the previous steps to import the Sun image again, only this time make it a button when prompted. Select the three sun elements by using Command/Control + A and grouping them (Command/Control + G).

Go to the Transform window and make sure Constrain Proportions is checked. Reduce the size of the sun by 50 percent, and then turn it into a

symbol. You can name this one Small Sun Send or anything else you'd like (only don't call it late for dinner—sorry, I couldn't resist). Make sure Button is still selected.

Open the Library window and drag the Small Sun Send image into the folder you created. Now, double-click on the sun to bring up the Button controls. It's time to create the rest of the button.

Choose the Pen tool and make a stylized rectangle like the one shown in Figure 5.29. With the rectangle selected, go to the Swatches window and change the color to a bright shade of green. Refer to Figure 5.30 to see which swatch I chose. Also, double-click the border to select it and then press Delete to get rid of it. Once you have it drawn, move the rectangle so that it's positioned behind the Small Sun element as shown in Figure 5.31.

Insert a keyframe in the Out frame. Changes that you make in this area will appear when the cursor moves over the button.

Select the Type tool, and type "Send." Make it a color that will be easily seen against the green rectangle, which will be its final resting place. After positioning the text, increase its size to better fit in the rectangle, as shown in Figure 5.32.

Before moving on, click once on the Small Sun image and rotate it 180 degrees. Next, select all of the elements of the Over frame and Group them. Repeat this for the Up layer, and then test your animation. Do this by going to Control > Test Movie, or use the Command/Control + Enter key combination.

FIGURE *Create a stylized rectangle like this.*
5.29

FIGURE *The green color swatch that was selected for the rectangle.*
5.30

FIGURE *The stylized rectangle in its final position.*
5.31

FIGURE *The Send text in position over the stylized rectangle.*
5.32

Repeat this process, name the new layer Reset Button, and create a new button with a purple rectangle marked Reset instead of Send.

Position both of these buttons at the bottom of the Stage as shown in Figure 5.33.

FIGURE *The two buttons are now in position.*
5.33

HEY, HEY, WAIT A MINUTE MR. POSTMAN

It's nice to have Send and Reset buttons, but what's going to be sent? What is there to reset? Time to create our form and the input fields.

Select the Background layer, and create two new layers above it. Name the first layer Join, and the second layer List. We'll be placing the *Summer of '66* logo between them. Refer to Figure 5.34 for the placement of these two lines, but be aware that they will need to be repositioned once we place the logo on the Stage. Here's what the text should be:

Line 1: Join The
Line 2: Mailing List

Align the right edge of the second line of text with the right edge of the Reset rectangle. Use a guide to help with the alignment.

FIGURE *The positioning of these two lines of text is temporary. The final positioning will*
5.34 *be determined once the* Summer of '66 *logo is placed on the Stage.*

With the Header layer still selected, make a new layer and call it Body Text. This is where we'll add some copy to tell people what they'll get and what to do. Here's the copy to put on this layer.

> Fill out the form below with your e-mail address to get the latest information on our show schedule and to receive valuable discounts on *Summer of '66* Merchandise.

Make sure the text is centered, and the text block is centered in the white space of the Stage as shown in Figure 5.35. Again, you'll need to reposition this block of text once the logo is put in place.

Now it's time to build the form itself. This will be made up of titles and text input fields. First, the titles.

Create a new layer and name it Input Field Titles.

Have you noticed that I like to use layers a lot? Since you can have a virtually unlimited number of layers, there's no reason not to. Moreover, it really helps to keep everything separated into its own space for easier

FIGURE *The Info block of text in position on the Stage.*
5.35

modification. If, for example, putting "Join The" and "Mailing List" on the same layer would mean extra work for us to move the two lines into position, because, once they're placed on the layer, they are merged together. If you then selected that layer, both lines of text would be selected. Therefore, unless there's a reason to have all the elements of a design on a single layer, it's best to create a new layer for each element. In the case of our Titles layer, we can put them on the same layer. The positioning issue will come up with the input fields, which, of course, will be on a separate layer.

With the Text tool, type the following:

Name:
City and State:
E-Mail Address:
If you know anyone else who would be interested in the *Summer of '66*, please add their e-mail addresses here:

Figure 5.36 shows the Stage as it should now appear.

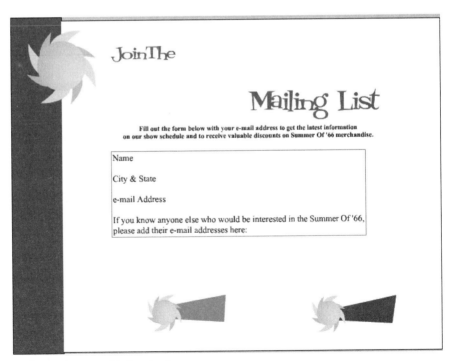

FIGURE *Titles are added to the Stage.*
5.36

Can you guess what's next? That's right. Create another layer, and call it Input. Time to make the input fields for the form.

Choose the Text tool and drag out a rectangle (or block, if you prefer) to the right of Name:. Now, open Text Options (Window>Panels>Text Options) and choose the following:

Change Text Type to Input Text
Assign Single Line to the Line Type pop-up
Make sure Border/Bkg is active

Select the Arrow tool and move the new input field into the position shown in Figure 5.37.

Create a text field for both the City and State and E-Mail Address titles that use the same settings as the Name field. Then, create a field for the additional e-mail addresses title, only this time, select Multi-Line as the type. Figure 5.38 shows all the input fields in place.

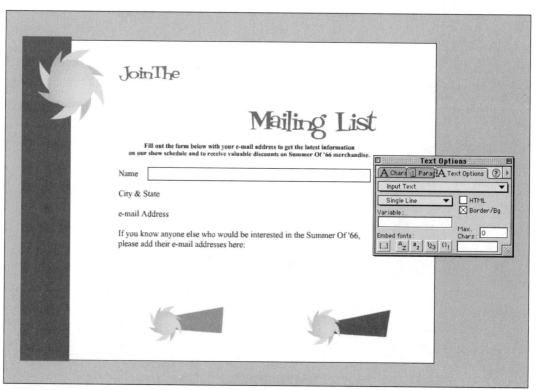

FIGURE *An input field is created and positioned next to Name.*
5.37

JoinThe

Mailing List

Fill out the form below with your e-mail address to get the latest information
on our show schedule and to receive valuable discounts on Summer Of '66 merchandise.

Name

City & State

e-mail Address

If you know anyone else who would be interested in the Summer Of '66,
please add their e-mail addresses here:

FIGURE *All input fields are in place. All that's left to do now is add a little design work, and the overall*
5.38 *layout will be complete.*

*Use the small sizing box in the lower right-hand corner of
the text field to resize the last input field.*

NOTE

One of the nice things about laying out the text input fields like this is
that visitors filling out the fields can simply tab from one to the next; they
won't have to click on each field to activate it.

Remember that logo that needs to be added? Time to do that, placing it
between the file headlines. Once that's in position and you have reposi-
tioned the header lines, all that is left to do is create some artwork to fill
out the page so it isn't so barren. Figure 5.39 shows the final look for the
screen, but you can add whatever elements meet with your design sense.

You could also enhance the overall flavor of the file by adding some
music to play underneath. The only problem that occurs—and this is defi-
nitely a pet peeve of mine and you might like this fact—is that the music

Join The

Summer Of '66 Mailing List

Fill out the form below with your e-mail address to get the latest information
on our show schedule and to receive valuable discounts on Summer Of '66 merchandise.

Name

City & State

e-mail Address

If you know anyone else who would be interested in the Summer Of '66,
please add their e-mail addresses here:

FIGURE *The final look for the informational screen that you just created.*
5.39

will become extremely monotonous after a while. I have yet to find any
type of music that, when played over and over ad nauseum, doesn't be-
come a detriment to a great design. Especially when the music is that elec-
tronically produced, quasi-Muzak-like reproduction of such classic tunes as
Feelings or *You Light Up My Life*. Even such great songs as *Wild Thing* or
Louie Louie would start getting on your last nerve very quickly.

Finally, we didn't add the script needed to send this page to its destina-
tion—we'll discuss that in Chapter 9 as we build the site. So, no, I didn't
forget! You didn't catch me in some writer's faux pas, or suffering from sun
poisoning after hanging out at the beach trying to catch some waves.

Now, what you want to do is save this file as both a Flash and a .swf.
The latter is so you can go ahead and view it any time you'd like. The for-
mer is so we can come back to it in Chapter 9 and finish it up.

CRUISIN'

In the next chapter, we're going to look at Flash's big brother and the daddy of all animation software, Director 8. We'll explore the differences between it and Flash so you have a better idea as to which program might work best for you. So, take a few minutes and head down to the local drive-in, grab a malt and a dog, and then come on back to the *Summer of '66*—Director-style.

CHAPTER

Using Director

More Hit Tunes of 1966

The Birds and the Bees—Jewel Akens
Love Potion Number 9—The Searchers
The Name Game—Shirley Ellis
Let's Hang On—The 4 Seasons

THE DESIGN GAME

You've now worked with Flash a little bit, setting up a form allowing people to join a mailing list. Although we haven't written the script needed to actually send or reset the form, we will soon. As you know, Flash is an extremely powerful program for Web site creation, either as an entire site or for elements appearing on a site. However, Flash, to me, is the baby brother (or sister or, to be politically correct in this day and age, sibling) to another of Macromedia's program family. Director is to Flash what DVD (Digital Video Disk) is to VHS. And the latest version of Director—Director 8 Shockwave Studio—is truly the crème de la crème of multimedia authoring tools.

How do I talk about a program in one chapter that literally takes up thousands of pages in other books? Director is so vast, so all-encompassing, that the experts—those who have been using it since its infancy—are still discovering new and exciting tricks and techniques. The best that can be accomplished is to give a working overview of the application, trying to put into new, fresh words just how important a tool that program can be. Understanding the concepts that make up a working relationship with Director is as important as spending hours delving into its myriad intricacies.

Director has long been used to create high-end interactive programs and animations. Most DVD interfaces are created in Director, as well as games and interfaces on CD-ROMs for various computer systems. The high-tech look of the computers and controls on the Starship Enterprise in the *Star Trek* series (both TV and movies) was designed and animated in Director. In other words, when you work with Director, you work with the best.

Another aspect that makes Director extremely different from Flash is its ability to accept digital video. Flash won't allow that unless, of course, you have the Flix program discussed in Chapter 3, "Adding Dimensional Power to Flash."

There is also speculation on future uses of Director. One of these was recently noted by Bob Lewis, a contributing writer to *InfoWorld* magazine. In this article, he discussed what came about in the computer industry in Y2K based on predictions made by technology industry insiders. One of these predictions was that Macromedia would turn Flash, Shockwave, and Director into a full-fledged software development tool. Well, as we all know, it didn't happen in 2000. However, as Mr. Lewis pointed out, at least one test application has been written using Macromedia products. If you really think about it, it's a fascinating idea and not that unrealistic. To create applications, you need a base program (or set of programs) that gives programmers the tools they need to write specific interactions. Director houses such

FIGURE *The Director 8 splash screen.*
6.1

a powerhouse programming language. So who's to say this idea won't find its way onto the desktop of your computer in the very near future?

With the changes that have been implemented in version 8, it's not too hard to see how something big is happening. Here's a list of some of those changes. You'll need to refer to the *User Manual* for a total list of the changes.

Zoomable Stage. Every Director user has wanted this since the beginning. Prior to version 8, the Stage was a fixed ratio on screen, and you had to scroll around if your movie was larger than the viewable window.

Guides. On top of the grid, you can also place guides for even more accurate placement of objects.

Lockable Sprites. This lets you make sure you won't edit any elements you don't want to.

Scalable Shockwave. Shockwave files can now be stretched to fit the browser window. While doing this, the Shockwave file can be set to retain its aspect ratio.

Multiple Vector Curves. Prior to this, you could create vector curves, but only one at a time. Now you can create and edit multiple curves segments.

Because of this power, Director is probably one of the hardest programs you will ever have to learn. This is because, like Flash, it relies on the use of programming language to bring the most out of your work; and it's not the same language that Flash uses. On the other hand, it's got to be one of the most satisfying programs, because once you've created your first full-fledged, fully functional Director file, you'll be hooked forever.

That was one heck of a sales pitch, wasn't it?

WHAT DIRECTOR DIRECTS

Before starting, let's get a better feel for terms intrinsic to Director.

First, you'll find the term *Movie* used extensively. A Movie is the file you create in Director. It's made up of all the elements that will make up your final product, be it for CD-ROM, DVD, television, movies, or even the World Wide Web.

Here are other terms associated with Director files:

Stage. As in Flash, this is the workspace on which you place the various elements that make up your file.

Score (Refer to Figure 6.2). This is the timeline, the place where the elements in your file are organized.

Cast (Refer to Figure 6.3). This refers to the elements that will be placed on the stage. Each element is called a Cast Member. A Cast Member can be a visual or aural element, or an Xtra.

Sprites. This is a control element. It tells Director when, where, and how a Cast Member will make its appearance.

FIGURE *A look at the Score. It retains a very familiar look while adding many extras to*
6.2 *help in high-end file generation.*

FIGURE *The Cast window, where all your Cast Members are stored.*
6.3

Sprite is a term you really need to understand. Sprites are Cast Members that have been moved from the Cast window onto the Stage. Upon placement, the Cast Member becomes a Sprite. Sprites can have separate properties, but if a property is added to the Cast Member from which that Sprite was created, that change will affect all instances of the Sprite.

Let me try to make that a bit clearer because, no matter how many times I wrote that previous paragraph, it still seems rather convoluted. I'll use the Button image we created in Chapter 2 as an example.

When you bring it into Director as a Cast Member (Figure 6.4), you can assign a master action to it that will affect every appearance it has when put on the Stage. That action could be making the colors change throughout its tenure on the Stage, or playing a specific sound or music clip when a cursor moves over it.

Now, let's say that no action has been assigned to the image while in the Cast window. When you put the image on the Stage, it is merely that—an image on the Stage. You can now assign actions to each of these instances, and they will only be assigned to that particular instance. This way, each instance of that art can have a different effect, making them appear as if they are totally different pieces.

FIGURE *The Button artwork in the Cast window. Any action assigned to it while in here will affect every*
6.4 *instance of that artwork on the Stage.*

UNDERSTANDING DIRECTOR'S LINGO

Flash uses ActionScript, an Object Oriented Programming (OOP) language. Director, on the other hand, uses a programming language called Lingo. This language uses specific terminology and grammatical rules and punctuation to which you must adhere in order for Director to work. Unlike Flash, which allows you to plug in terms to help create actions, Director wants you to really *know* your stuff. There are plug-ins called Xtras that act as plug-and-play scripts that are assigned to different elements in your file. You can find them on the Macromedia site or at numerous sites on the Web.

There is one company that makes some great Xtras that I should mention here—MediaLab (www.medialab.com). Included on the CD-ROM are demos of their Effector Set Xtras. These Xtras, listed in Figure 6.5, add

FIGURE *A look at the Xtras included in MediaLab's Effector Set 1.*
6.5

some great functionality to your work. There are two Effector sets: Set 1 Libraries and Set 2 Behaviours. In addition, MediaLab has created a special effect add-on called AlphaMania (now in version 2) that gives you the ability to work with alpha channels that are assigned to your image files and save them as separate Cast Members (Figure 6.6). PhotoCaster, another special effect add-on, lets you import layered Photoshop files (Figure 6.7). Add to this their SetFX plug-in to add animated special effects to your image files, and you have a wonderful set of tools that add easy functionality to your Director files.

While the plug-ins add quick functionality, no one can write one to meet every particular need. Think of it this way: If you're a movie buff and have been following such cinematic offerings as *Stuart Little*, you'll know that they used specific 3D modeling and animation programs to create Stuart. However, they needed the programs to do more than they allowed; hence, new scripts were created to meet the needs of the producers. More

FIGURE *The AlphaMania import screen, which lets you import layered files*
6.6 *that contain alpha channels.*

FIGURE *The PhotoCaster import screen. PhotoCaster allows you to*
6.7 *import layered Photoshop files directly into Director.*

than likely these scripts will soon become a part of the basic program, but suffice it to say there will still be effects that will have to be written to create that new level of animation sophistication. Moreover, just as with 3D applications, no matter high end, learning Lingo is an essential part of effectively working with Director.

Of course, learning a programming language takes time and patience. You'll make mistakes. You'll create scripts that are 99.9-percent correct, but that .1 percent can undo all your hard work. And until you're really used to writing Lingo scripts, finding that one word or line that is fighting your overall script will be like finding that oft-lost needle in the proverbial haystack. Plus, consider this: The *Lingo Dictionary* that comes with the program is thicker than the *User Manual*, so that should give you some idea that you aren't necessarily going to learn Lingo overnight—even if you are an experienced programmer.

THE NAME GAME

Before we move on, let's look at some of the terms that make up the Lingo language.

Events. Events are actions that happen when a movie is playing. An example would be having a text input screen appear in which a site visitor enters his or her e-mail address. This would appear after a certain frame of the movie was reached.

Commands. – Commands are terms that control what happens while a movie is playing.

Constants. Constants are elements that never change.

Handlers. Handlers are sets of Lingo code inside a script that run when a specific event happens in the movie.

Arguments. Arguments are placeholders that let you assign values to scripts.

Properties. Properties are attributes that define an object.

Variables. Use variables to store and update values.

Messages. Messages basically tell Director to do something if all parameters are met; for example, going to a specific frame of the movie if Director finds the enterFrame command.

The other Lingo scripting terms are:

Expressions
Functions
Keywords
Operators
Properties
Statements

You'll want to refer to the *User Manual* to gain an understanding of what these specific terms mean, and how they are used in your design process.

THE DIRECTOR VIDEO

Now that we've spent all that time going over some of the Director and Lingo lingo, it's time to get to work. In this section, we'll create an introductory video that can be used for numerous things—from a CD or DVD opening, to a Web site opening.

 You can find all the files for this project in the Chapter 6
ON THE CD *folder on the CD-ROM.*

The finished project, titled So66Open, is also provided in the Chapter 6 folder of the CD-ROM. You will probably want to view this to get a feel for what you will be creating.

As you'll soon find out, you reallywant a dual monitor setup when working with Director, because the screen can get filled up awfully quickly. You might want to go online to price dual-monitor video cards for your PC or Mac; it's well worth the investment.

The screen captures you'll see from here on are from a dual monitor setup. I have the controls on a 15" monitor, while the Stage and Timeline are positioned on a 17" Pivot Display monitor.

PREPARING THE THEATER

Yep, I said "theater." Hey, if the workspace is the Stage, and we have cast members who perform on that stage, I view the overall monitor and controls as parts of a theater.

Anyway . . .

First, we'll resize the Stage. Go to Modify > Movie > Properties to open the Properties window shown in Figure 6.8. Change the dimension of the Stage to 6040 × 480 pixels. This is because, as I mentioned in a previous chapter, I want the dimensions to fit easily on a 15" monitor. You'll also notice that, with the larger monitor (on the right), you are able to position the Properties window immediately inside the expanded Stage area so all the controls are close by.

Save your file as So66_Video.

Next, we'll create a new Cast window. Go to Modify > Movie > Cast to open the Cast selector screen (seen in Figure 6.9). Click the New button, type "SummerOf66" for the name, and leave Internal as the Storage selection.

What is the difference between an Internal and External Cast? The Internal Cast stores elements for use in that particular project. An External Cast is saved to a folder. The Cast Members stored in it can then be accessed by any and all projects you create in the future.

Click Create when you're finished. You're then returned to the Cast creation window, where you'll see your new Cast name added to the list of available ones. To open the newly created Cast window, go to Window > Cast and select the SummerOf66 Cast window from the expanded list. The path is shown in Figure 6.10.

The Properties panel, located to the immediate right of the Stage. This image shows how a dual-
6.8 *monitor setup can benefit your workflow by giving you extra room for open windows.*

FIGURE *The Cast creation window.*
6.9

FIGURE *In this conglomerate image, you can see the windows in the lower left where*
6.10 *you can create a new Cast window. After creating this Internal Cast, you can select it from the Window menu, seen toward the upper center of this image.*

CREATING CAST MEMBERS

The first thing you'll do to prepare the Stage is change the color to black. In the Property Inspector window, select the Movie tab, and change the Stage Fill Color to black.

Now you'll make the first Cast Member, a gradient-filled rectangle. Select Window > Vector Shape, and draw a Filled Rectangle. It makes no difference what size you make this rectangle because you'll resize it on the Stage. You can either keep the border—as long as you make sure it's a black border—or change the border width to 0. Then select the Gradient fill option either on the Vector tool set or in the Vector Properties window so your rectangle looks like Figure 6.11.

Beneath the fill color selector options in the tool set (refer to Figure 6.12), you'll see two color chips bordering a gradient symbol. These are

FIGURE *The gradient-filled rectangle has no border. You can keep a border around the*
6.11 *rectangle as long as you assign a black color to it.*

FIGURE *The highlighted area in this picture is the color selector located in the Vector*
6.12 *Shape workspace. The gradient color selector chips are directly beneath the fill*
type selectors.

the chips to assign the gradient colors. In the leftmost chip, assign a gold-ish color, and on the right chip, select a sky blue.

Just above the Vector Shapes workspace is a pop-up menu with Linear already selected. Select Radial from this menu, because we want to simulate the sun in the sky. When you do this, your filled rectangle will look like Figure 6.13.

The only thing is, we want the "sun" in the upper-left corner in order for the bulk of the color to be blue. To the right of the gradient type pop-up are a series of numeric inputs. Leave Cycles at 1 (although you may want to change this number just to see what happens). Then change the other values to the following so that your fill ends up looking like Figure 6.14.

Spread: 50
Angle: 0
X Offset: −200
Y Offset: −110

Finally, assign a name—such as SunBKG—to the rectangle Cast Member. When you close the Vector Shape workspace, your rectangle will appear in the SummerOf66 Cast window.

FIGURE *Radial has been chosen for the gradient fill type.*
6.13

FIGURE *After changing the values for the various gradient settings, your filled rectangle will look like this,*
6.14 *with the sun in the upper-left corner.*

FIGURE **6.15** *Resize the placed rectangle so that a portion of the black background borders the edges of the rectangle.*

Drag the rectangle onto the Stage and resize it so that the selection border aligns with the edges of the Stage as shown in Figure 6.15.

We need to add the numerals 0–9 to the Cast. These will be used to create the floating 1966 you saw in the finished project.

First, go to Window > Inspectors > Text to open the text options window. Select an interesting font. In my case, I used one called Techno that I found on the Web at one of the free font download sites like Fontdiner.com. Starting with 0, set the size of the font to 48 and make the text bold. As you can see in Figure 6.16, each numeral is added to the Cast window as you create it. Also, make sure you choose white for the text color. Delete the numerals from the Stage as you create them.

Yes, I know that with a white background you can't see the white numerals. That will be fixed in just a moment.

FIGURE *The numerals represented in the SummerOf66 Cast window.*
6.16

SETTING THE BLEND

Now, here's what needs to happen to make sure you see the number and not some large white block. Basically, what has happened is that a background has also been created when you assigned these numbers (or any text for that matter), and you need to tell Director to make that background go away.

To do this, place your number Cast Member back on the Stage and go to the Sprite Property Inspector. Notice the pop-up menu? This is the selection link for setting the Ink style, which is basically Director's version of a blending mode. Select Background Transparent from the list as shown in Figure 6.17. This will remove all instances of white background, leaving

FIGURE *The selections in this pop-up menu assigns different effects to your Cast Members.*
6.17

just the number. Do this for each of the Cast Members and for the text blocks you'll build in the next section.

There are also four text blocks that need to be created. Make a separate Cast Member for each of the following using the same size and color for the font. I used a font style called Fifties for this text.

- Get ready for a journey back in time…
- To a time of sun and sand…
- To a time of discovering who we were and finding out who we would become….
- To a time filled with bittersweet memories that will remain with us forever…

Now that those elements are in place like in Figure 6.18, it's time to add the visual that will make up the rest of the animation.

FIGURE *All of the elements created directly in Director are now in position to be led*
6.18 *onto the Stage.*

HIRING CAST MEMBERS FROM OTHER LOCATIONS

It's time to import the files that will become our animation. Go to File > Import and navigate to the folder that contains the *Summer of 66* files you copied onto your hard drive from the CD-ROM. When prompted, change the bit depth to Stage to help make the final file size more manageable.

In the Score, click the Hide/Show Effects Channels button, the location of which is shown in Figure 6.19. This will expand the upper portion of the Timeline so you can add audio tracks and other effects-based elements. Since the length of the animation will be based on the length of the music Cast Member, that's what we want to add first. Locate the audio file from

FIGURE *To reveal extra channels in the Timeline, click on the Hide/Show Effects Channels button in the*
6.19 *upper right of the Timeline window.*

FIGURE *The audio track is placed into the audio channel of the Timeline.*
6.20

the Cast window and drag it onto the Timeline in the audio track (seen in
Figure 6.20).

> *You're going to need to extend the audio track in the Time-
> line so that the entire clip plays.*
>
> NOTE

You'll notice I started the music at Frame 10. This gives a little extra time
for the files to load. What's nice about Director is that, when you save your
file for streaming over the Web, you can tell it to automatically add a pre-
loader to it. This pre-loader uses a standard bar that fills up, and the Shock-
wave logo. Visitors will also be warned if they need the plug-in, or if their
current plug-in is too old and should be updated.

ASSIGNING ROLES TO THE CAST MEMBERS

OK. All the elements are now in place. They are waiting anxiously to make
their grand entrance on stage. As we move through this section, refer back
to the finished file so that you can use it as a template for your Director
file.

The SunBKG Cast Member is (or should be) located at Frame 1 as
shown in Figure 6.21. Make sure to extend this Sprite (remember, as soon
as it was placed on Stage, it became a Sprite while its appearance in the
Cast window is still a Cast Member) to the end of the music file. Figure 6.22
shows what I mean by this. Extend the Sprite by clicking and holding
down the mouse button on the last frame of the Sprite in the Timeline and
dragging it to the frame you want.

Now it's time to have some fun. We'll create the numeric countdown
that will finally reveal the date "1966." Move the Playback Head (that red-
dish bracket that surrounds the frame number) to Frame 10 so your Time-
line looks like mine in Figure 6.23. When you do this, any Cast Member
you place on the Stage will appear starting at that frame.

FIGURE *The music file starts at Frame 10, and the SunBKG Sprite is positioned on the first frame.*

6.21

FIGURE *Here you see the SunBKG Sprite extended to match the length of the audio file.*

6.22

FIGURE *Move the Playback Head to Frame 10.*

6.23

Start with the number 0, and place it at Frame 10 on line 9. You can also place Cast Members directly onto the stage as you did with the SunBKG image; however, when you want to make sure your elements are being placed on the correct line (for organization's sake), drag them directly onto the Score in the Timeline. With the 0 in place, compress the Sprite's length to 1 frame so it looks like Figure 6.24.

FIGURE *After placing the first number, decrease the length of the Sprite to 1 frame.*
6.24

You also need to set the percentage of the blend to 10% so the numerals have a ghostly appearance. Do this for all subsequent numbers as you go through this project.

Place the numbers 1 through 9 after the 0, repeating what you just did to make each of them 1 frame in length. Select the 10 numbers by clicking on the frame containing the 0, holding down the Shift key, and selecting the frame containing the number 9. This selects all 10 frames. Refer to Figure 6.25. Copy these 10 frames using the Command/Control + C key combination.

With these 10 frames copied, click once on Frame 20 (Figure 6.26) and paste them behind the first set of numbers (Figure 6.27). Paste the numbers one more time directly behind these numbers, and delete every frame after the number 5 (Figure 6.28).

Drag the number 1 directly behind the last single-frame number, and extend it to Frame 185.

Now, copy everything on line 3 up to the final number 1 (the one you extended). Paste the copied frames in this order:

FIGURE *Select the 10 frames you just placed and copy them.*
6.25

FIGURE *Frame 20 is selected and ready to have our copied numbers pasted onto the Score.*
6.26

FIGURE *The numbers have been pasted onto the Score.*
6.27

FIGURE *The numbers 0 through 5 have been left on the Score following two occurrences of the full*
6.28 *number set.*

Frame 36 on Line 10
Frame 60 on Line 11
Frame 90 on Line 12

Refer to Figure 6.29 to see how this lays out. Following the last frame on each of those lines, add the following numbers in this order and extend them to the indicated frames:

Line 4: 9 Frame 195
Line 5: 6 Frame 205
Line 6: 6 Frame 215

FIGURE *The number frames have been pasted onto the next three Score lines in the Timeline. Use this as a*
6.29 *reference as you paste your copies onto the Score.*

FIGURE *The placement for the number effects.*
6.30

What you have done is created an animation where the numbers cycle
and then lock in to read "1966." Now, refer to Figure 6.30 to see their
placement on the Stage. The only thing to worry about at this stage is the
location of the numbers along the horizontal plane of the Stage.

THE DISAPPEARING ACT

As the numbers cycle, they remain in place. Once they lock in, you need
to build an animation starting from this point and moving upward approx-
imately 75 percent of the screen height. Here's how to accomplish that.

Select the last frame associated with the #1. On the Stage, drag the num-
ber straight up (holding down the Shift key to constrain the movement)
until it's about three-quarters of the way up the Stage. Then set the opacity
of the Sprite to 0%. Repeat this for the other number Sprites. What you
have effectively done is tell Director to start moving the Sprite at the very

FIGURE *The date, 1966, halfway through the entire animation of the numbers. You can see how they are*
6.31 *fading into nothingness from left to right.*

beginning of its appearance and dissolve slowly into nothingness. Figure 6.31 shows the numbers midway through their moves.

ADDING OTHER ELEMENTS

Let's finish this first part of the animation by placing one of the images and the first text block. We'll start with the latter.

On Line 13, place the first text block you made at Frame 1 and extend it through Frame 9—just before the numbers start to cycle. Place the second text block (Sun and Sand) on the same line, but at Frame 36. Extend it through Frame 84. Make sure that the Sprite opacity is set to 100% at Frame 36 and 0% at Frame 84. If it isn't already, make sure Background Transparent is selected so that the start of your text block looks like Figure 6.32. The text should be completely transparent on the last frame seen in Figure 6.33.

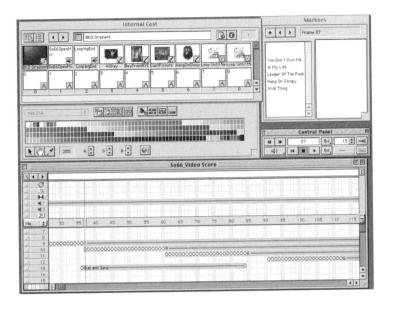

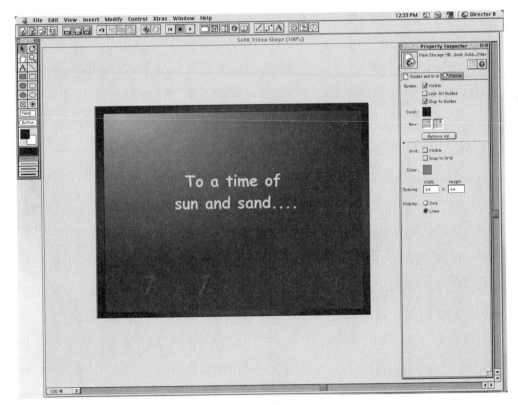

FIGURE *The text block pops onto the Stage at Frame 32.*
6.32

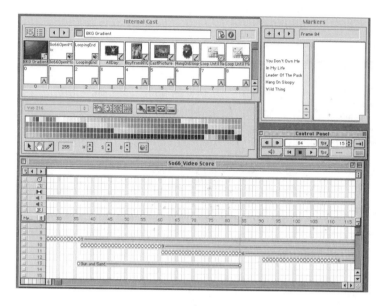

FIGURE
6.33
Throughout its life on Stage, the text block fades until it's totally transparent as you see here.

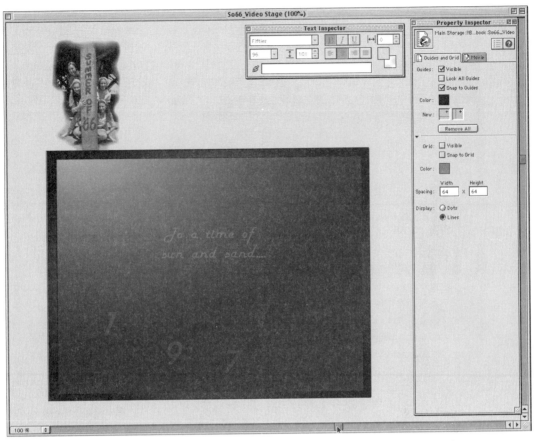

FIGURE *The starting point for the first image is off Stage.*
6.34

Select the Post Galsflt Cast Member. On Frame 67, place it to the left side of the Stage and outside of it as shown in Figure 6.34.

Extend this newly created Sprite to Frame 245. With this frame selected, move the Sprite straight down (again, holding the Shift key to constrain the movement to a straight line) and off the bottom of the Stage as shown in Figure 6.35.

Finally, set the Ink to Darkest, which will give the Sprite an interesting transparent look. Figure 6.36 shows how it appears against the background Sprite when assigned this setting.

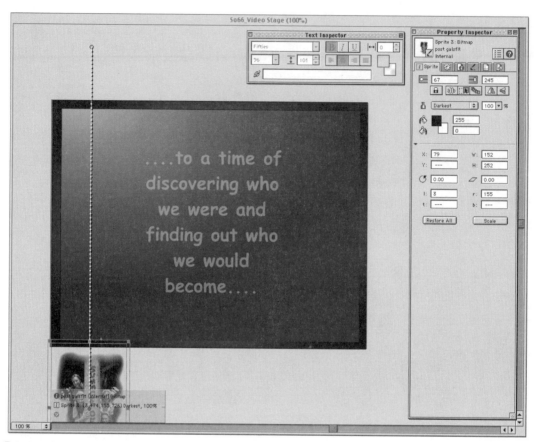

FIGURE *The ending point for the image.*
6.35

FIGURE *The Image Ink has been set to Darkest,*
6.36 *creating an interesting visual effect.*

ELEMENTAL, MY DEAR READER

Now it's time to put the other elements in their place. Again, refer to the in-cluded Director file in the Chapter 6 folder of the CD-ROM. This will give you the exact placement of each element. Plus, I have left the end of the animation open as you can see in Figure 6.37. I did this so you can make and place other Cast Members on the Stage where you see fit, experiment-ing with the timing and effects to make a more personalized file.

So, what was my thought process as I placed the Cast Members where I did in the Timeline? The images I used corresponded with songs; what you see on the stage are stills from the song that is playing. Figure 6.38 is a still from the song *You Don't Own Me*, where two of the Villagers are having relationship problems. Figure 6.39 shows the scene featuring the Beatles' hit *In My Life*.

FIGURE **6.37** *Room has been left at the end of the* Summer Of 66 *Director file for you to practice adding Cast Members to the screen and modifying their placement. Here you see the workspace and the Timeline at the frame where this starts.*

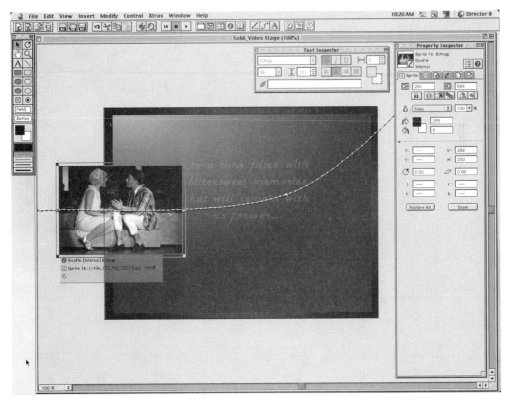

FIGURE *This still corresponds with the song* You Don't Own Me.
6.38

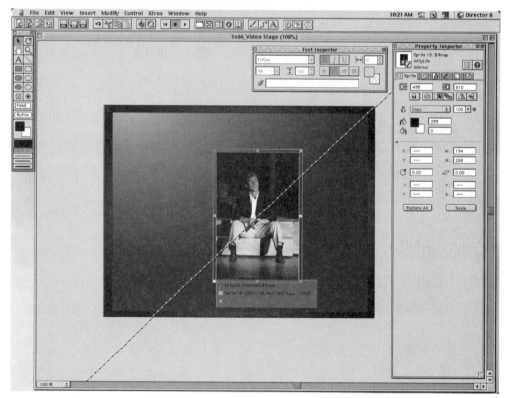

FIGURE *This still corresponds with the song* In My Life.

6.39

any still I wanted at any these points in the Movie,
ain as true to the production as possible. I've never
om a movie as part of the trailer that don't appear
have never liked seeing images that don't belong
dio being featured on a video. It's a little discon-
ovie poster that has the actors' names over their
visages are in a different order from the name

lf-aggrandizement regarding the design of the

IPS

Flash, can incorporate digital video into its files.
he way you would any other file (File>Import or
nd add it to your Cast. Place it on the workspace
ure 6.40 shows a black-and-white movie created
OM presentation. This file, called So66bw.avi) is
-ROM in the Chapter 6 folder. There is also a
video included on the CD-ROM.

*cks, you will need to extend the video Sprite
e so the file plays in its entirety.*

Wny did I include two different versions of the video? You actually have
more control over the control of QuickTime files in Director than you do
AVI files. This is because Director gives you the opportunity to add Lingo
control to QT files, and it doesn't for AVI. Lingo can control everything
from the volume of the audio to the way the video looks on the screen, as
well as rotation, scale, and other image properties. Moreover, if you're
using a QuickTime VR (Virtual Reality) file, Lingo can control user interac-
tivity by assigning hotspots in the VR file.

While you'll need to refer to the *Lingo Dictionary* that's included with the
program (there's just so much to working with Lingo that it's impossible to
do anything other than touch on the key points), let's take a moment to go
over some Lingo terms that are important to video and audio inclusion:

Audio

preLoadBuffer member. This loads part of a streaming audio track
into memory.

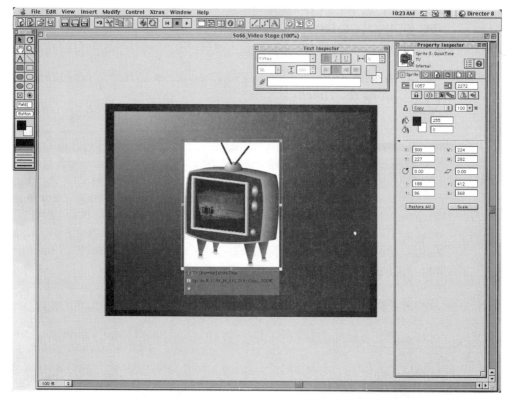

FIGURE *Digital video can be included in your Director files, making the inclusion of this type of Cast*
6.40 *Member much easier than in Flash.*

soundChannel. Specifies the sound channel (left or right) that the audio plays back on.

bitRate. Lets you determine the bit rate of streaming audio clips. This is very important for smooth playback on the Internet, as well as the sound quality.

volume. Gives you the ability to set a playback volume level.

copyrightInfo. Mucho importante! If your files are original works, you sure don't want anyone else to take credit for them. This allows you to set copyright information in streaming audio, as well as let the person listening to the file see that copyright info.

The preceding commands, although nowhere near comprehensive, are appropriate for both Shockwave and MP3 audio files.

Digital Video

movieRate. Use this to pause video by setting the property to 0 (zero). To start the video again, set the rate to 1.

movieTime. Lets you set a command to return the video to its starting point by setting the property to 0 (zero).

setTrackEnabled. Controls the playback of individual digital video tracks.

digitalVideoType. Lets you determine whether the video to be played is a QuickTime file or AVI.

trackStartTime. Let's you review the start time of a track in a digital video Sprite or Cast Member.

Again, the preceding commands are nowhere near comprehensive.

Lingo is so powerful and so important to Director that, if you want to get the most out of your movies, you will need to spend a lot of time learning the programming language. There are numerous Lingo User Groups that you can join to get help from people who are experts at Lingo scripting. Just visit the Macromedia site to find a listing of Director and Lingo Users groups.

TIME TO TRUCK ON

Once again, for more in-depth coverage of Director, you'll need to visit your local bookstore or check out the Macromedia site to find books dedicated to working with this program. It's literally impossible to do anything but give you a taste for this comprehensive, high-end application in the space provided here. What's cool, though, is the fact that you can still

create fun movies for Web presentations without writing a line of Lingo—as was proven here. Suffice it to say, you will want to learn Lingo if you have any desire to build highly involved movie files.

Now it's time to take a bit of a break and begin to look at the programs that will ultimately be your final stop before getting onto the Web: Dreamweaver 4 and/or Dreamweaver 4 UltraDev. Before working with the programs, though, it's important to know the difference between the two so you can choose the one that is most appropriate for your projects.

CHAPTER 7

Dreamweaver 4 and Dreamweaver UltraDev —

A Comparative Analysis

More Hit Tunes of 1966

Crying in the Chapel—Elvis Presley
Shotgun—Jr. Walker & The All Stars
Unchained Melody—The Righteous Brothers
King of the Road— Roger Miller

THE DREAMWEAVER ENVIRONMENT

In the early 1970s, a singer named Gary Wright released a song called *Dream Weaver*. There is no way he could have ever dreamed that a computer program with the same name would become one of the most popular Web design tools almost 30 years later. In fact, Mr. Wright probably couldn't have envisioned the World Wide Web back then, let alone computers that weren't the size of airplane hangers, or so powerful that the computers of that day's military would be like oversized calculators today. Yet, here we are with computers in our offices and homes that have more power than could even be imagined 10 years ago, let alone three decades.

So what is it about Dreamweaver that is so impressive to so many of today's Web designers? Is it its ability to work seamlessly with its sister products? Is it its plug-in architecture that allows users to develop additional functionality to the program? Yes, yes, and more. For those of us in the design community, when purchasing a program created by a company that has produced other programs you use, you expect it to work seamlessly with them. The ability to create and add functionality is definitely a plus, although it seems that almost every program now offers some form of development tool. What's really cool about Dreamweaver is the way it fits so naturally into what is probably already a natural workflow for you.

Working in Dreamweaver can be likened to working with a page layout program such as QuarkXPress or InDepth. I don't know many graphics people who don't commonly use one of these programs and know them inside and out. As you build your page, you're incorporating frames and image placeholders like those you see in Figure 7.1. These elements can be nested inside one another for added design potential. Nesting means that you can place a frame or an image placeholder inside another frame, turning the latter into a parent object. When you move that parent around the Document (what I always call the "workspace" out of habit), you also move the frame or placeholder that is inside it.

There are two flavors of the program—Dreamweaver 4 and Dreamweaver 4 UltraDev. It can be a bit confusing, especially if you are trying to determine if there is a need to change from one to the other. This chapter, while short, is meant to give you a feel for what the differences are between the two. This will hopefully give you the information you need to choose the right version for your needs.

I'll also use this chapter to give you an idea of the changes from Dreamweaver 3 to Dreamweaver 4. If you haven't upgraded to version 4 yet because you aren't sure you need to, this chapter will more than likely change your mind.

FIGURE *An example of frames and placeholders on the Document. Note the frames*
7.1 *"nested" within other frames.*

We'll actually work with Dreamweaver 4 in Chapter 9, when we bring all the elements together into the final Summer of '66 site design.

NOTE

Since I used the term *flavor* before, I might as well stick with the theme. If I had to assign a flavor comparison between Dreamweaver 4 and Dreamweaver 4 UltraDev, the former would be vanilla, and the latter a combination of vanilla and chocolate. That's because the two programs are almost identical on the outside, although there are differences that make one a better choice over another depending on your end product.

DREAMWEAVER 4

Let's start with the main Dreamweaver program. This is the upgrade to the application you have probably come to know and love, and offers a number of new features that will make your design life much happier. Most of the changes are within the coding engine of the program, but there are other improvements as you'll see.

CODE ENHANCEMENTS

- **Code View** (Figure 7.2). This area gives you an improved way to view your HTML code. The Code View can be seen directly inside the Document window.

FIGURE *The new Code View lets you see your HTML source code directly in the*
7.2 *Document window.*

- **Code Editors** (Figures 7.3 and 7.4). These editors are literally state of the art, giving you the ability to set word wrapping, syntax colorization, code indenting, and more directly from the Options menu.
- **Code Navigation** (Figure 7.5). Select JavaScript code functions through a new pop-up menu. This works within the Code View.

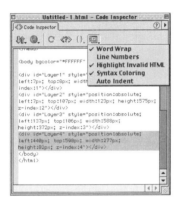

FIGURE **7.3** *The Code View, which is part of the new integrated code editing feature.*

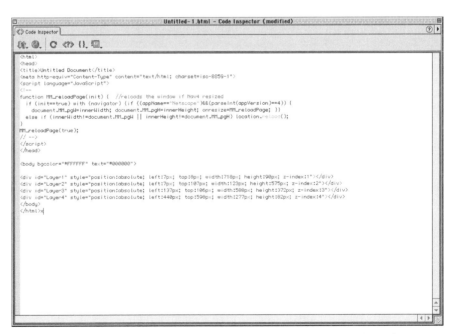

FIGURE **7.4** *The Code Inspector, which is part of the new integrated code editing feature.*

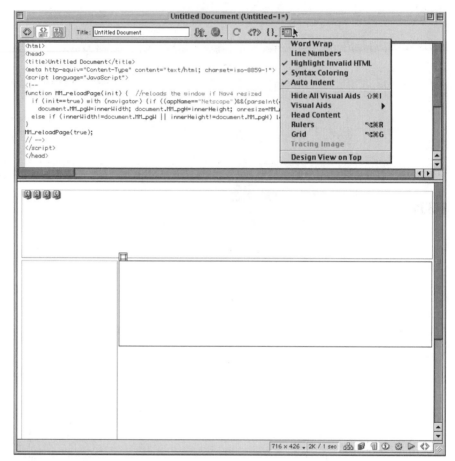

FIGURE *The Code Navigation pop-up menu.*
7.5

- **JavaScript Debugger** (Figure 7.6). Gives you the ability to debug your JavaScript while inside Dreamweaver, rather than having to go into another program.
- **Reference Panel** (Figure 7.7). Puts information on CSS, JavaScript, HTML, and reference information right at your fingertips.

Last but not least:

- **Toolbar**. Gives you the ability to manage numerous aspects of your document, including how you view a page, and gives you a central location to access all your most commonly used tools and features.

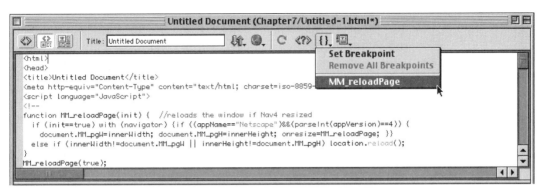

FIGURE *The new JavaScript Debugger window.*
7.6

FIGURE *The new Reference Panel.*
7.7

LAYOUT

- **CSS Stylesheets**. You can now define CSS style sheets immediately upon creating the new style, or attach an existing style sheet with the click of a button in the CSS Styles panel seen in Figure 7.8.
- **Layout View** (Figure 7.9). Now you can design your Web pages by drawing out tables and/or cells quickly and easily.

FIGURE *The CSS Styles panel with the button that allows you to attach an existing style*
7.8 *sheet.*

FIGURE *An example of the new Layout View that allows you to quickly design pages by*
7.9 *drawing out elements.*

FIGURE *Included in the template improvements is a name indicator for easier*
7.10 *recognition of different design element blocks.*

• **Template Improvements** (Figure 7.10). Now it's easier to identify editable areas in a template file.

INTEGRATION BETWEEN PROGRAMS

• **Web Safe Color Picker** (Figure 7.11). Choose colors from anywhere on your desktop, and the Color Picker will convert it to the nearest Web-safe color.
• **Flash Buttons and Text** (Figure 7.12). These elements are now included directly inside the program, so you can pick from a predefined set of buttons and place them directly on the Document.
• **Roundtrip Slicing**. This is the term Macromedia uses to describe being able to edit and update images and embedded HTML coding imported from Fireworks 4. You can edit these files directly in Dreamweaver or in Fireworks, and the master file is saved so either program will reflect the changes.

FIGURE *The Web-Safe Color Picker automatically corrects chosen colors to the nearest*
7.11 *Web-safe color.*

FIGURE *A set of Flash buttons on the workspace that were chosen from the predefined elements included*
7.12 *in Dreamweaver 4.*

As you can see, there are some impressive changes to Dreamweaver that give you the power to create rather than figure out a workaround to particular problems. You know what I'm talking about; they're those niggling little problems that always crop up, no matter how small and no matter how well you planned your design.

If the truth be told, Dreamweaver 4 would be considered the less powerful of the two versions. Not because it's any less of a program, but because it's produced with the majority of Web designers in mind who do not have to worry about large online infrastructures that require high-end Business-to-Business or Business-to-Consumer integration.

DREAMWEAVER 4 ULTRADEV

This flavor of Dreamweaver is geared toward the Web and Application Server site administrators and designers who need extremely intricate site structure development. UltraDev is designed to create Active Server Pages (ASP), Coldfusion, or JavaServer Pages (JSP) applications.

While Dreamweaver 4 is virtually identical on both the PC and Mac platforms, UltraDev differentiates between the Windows and Mac environments in very distinct ways. While the program itself—the site design portion, that is – is identical, the server interaction setup is very different and requires you to know exactly what type of delivery system your ISP or site host uses.

In short, you need to know if your Web server is a dedicated server, or if it doubles as an application server, such as Internet Information Server (IIS) or Microsoft Personal Web Server (PWS). In addition, the requirements are different depending on what type of application you're creating, such as ASP, JSP, or Coldfusion.

The main difference for a Mac user is that you will need to have access to a Windows NT server or a Windows 2000 computer to benefit from UltraDev's added functionality. Since most providers and servers do not currently support the Macintosh, you have to have Windows-compliant hardware to access all the necessary components. If you're a Mac user who does not have a PC, too, there is a workaround. You can purchase any of the Windows software emulators such as SoftWindows and install it on your computer. Be aware, though; SoftWindows, SoftPC, and others require a lot of disk space and they run extremely slowly. (I know this from first-hand experience before acquiring a PC for my office. Oh my, but it was painful! Almost as painful as my knee surgery back in the early 1970s.)

WHICH IS BEST FOR YOU

Since the two programs are virtually identical when it comes to basic site design, your decision process when upgrading from version 3 of Dreamweaver is dependent upon your ultimate use for the program. If you build basic, non-ASP/JSP/Coldfusion database sites, then the base Dreamweaver 4 package should fit the bill perfectly. If you design sites that include database information, UltraDev is the way to go.

THE DREAMWEAVER WORK-AROUND

What happens if you've upgraded your version of Dreamweaver 3 to Dreamweaver 4 and find the need to start creating ASP, JSP, or Coldfusion sites? Do you need to buy a copy of UltraDev, thus doubling up on the base Dreamweaver application? The answer to that is simple: no, you don't.

There is a product on the market called Lasso Studio for Dreamweaver by Blueworld seen in Figure 7.13 (www.blueworld.com). This cross-platform product adds database functionality to the base Dreamweaver package for Lasso-based Web sites. Again, there are different flavors for different needs, such as:

Lasso FMP. Lets you build high-performance FileMaker Pro databases.
Lasso ODBC. Gives you the ability to build high-performance ODBC-compliant databases.

Lasso Publisher. Lets you build basic FileMaker Pro or ODBC-compliant databases.

Lasso Studio Web Data Engine. Lets you develop and test Lasso-compatible data sources. This one is an exclusive with the Lasso Studio for Dreamweaver package.

As with UltraDev, you will need to have access to compliant servers; otherwise, the purchase is all for naught.

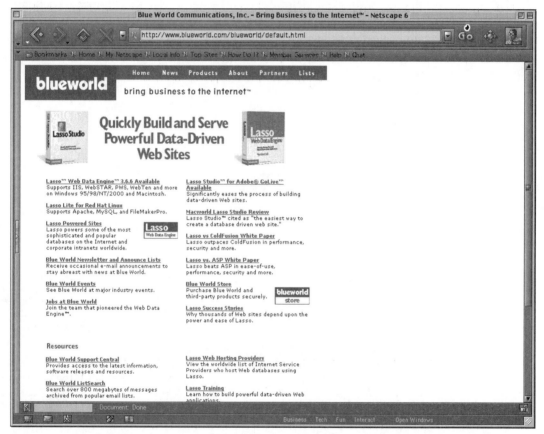

FIGURE *The Blueworld Web site, where you can get more information on Lasso (in all its configurations).*
7.13

WONDERLAND

As you can see in this brief overview, you have decisions to make when purchasing Dreamweaver, either for the first time or as an upgrade from a

previous version. If you feel that you'll potentially need the additional power of UltraDev, or want to start exploring database site building, then definitely upgrade to UltraDev. If you already have Dreamweaver 4 and don't want to purchase a second copy of the program to move up to UltraDevs' functionality, then you'll want to look at the alternatives.

There's another add-on you probably will need at some time, and that's Coursebuilder. This is a really cool application that works in both Dreamweaver 4 and Dreamweaver 4 UltraDev (as well as version 3 of both programs). And that's what we'll work with next as we return to the design process of the book.

Building an Interactive Game

More Hit Tunes of 1966

How Sweet It Is to Be Loved by You—Marvin Gaye
For Your Love—The Yardbirds
Seventh Son—Johnny Rivers
All Day and All of the Night—The Kinks
What the World Needs Now Is Love—Jackie DeShannon

INTERACTIVITY PERSONIFIED

This, my friends, is going to be one of the coolest, most far-out chapters in the book. If you haven't looked at the Dreamweaver add-on called Coursebuilder For Dreamweaver, then you're going to discover a fantastic addition to your design and content development.

What is Coursebuilder? Basically, it's designed to provide a way to create interactive online tests and learning content for your sites. While it is billed as being perfect for internal company use for employee evaluation purposes, there are limitless possibilities for incorporating Coursebuilder content in your Web sites. In my opinion, while the main purpose of the program is pretty explicit, I think that the targeted marketing of this program is hindering its utilization in thousands of Web designer's toolkits. However, I always try to look beyond the intended purpose of a program to see how I can make it work for my specific needs; in the case of Coursebuilder For Dreamweaver, that was one of the easiest mental conversions I've ever experienced.

Before this, earlier versions of Coursebuilder were called Dreamweaver Attain or Attain Objects for Dreamweaver, so if you used either, you have used Coursebuilder. Plus, if you're used to one of the former, the only differences you'll really notice are in the interface. Refer to the next section of this chapter to learn about these changes.

If you haven't used Attain in any of its two incarnations, you might be asking yourself exactly what can be done with this program. Here's a quick list:

- Create True/False quizzes
- Build Multiple Choice quizzes
- Design Drag-and-Drop games
- Build buttons, timers, and sliders
- Create quizzes with text input fields

These interactive elements can be used for educational purposes, and for interactive games that have no other purpose in e-life than to make visitors to your site smile and go "Wow, man! Far out!"—which is what we'll do in this chapter.

COURSEBUILDER BASICS

After installing Coursebuilder, a new button is added to your tool set. This button, shown in Figure 8.1, accesses the interactive design area shown in

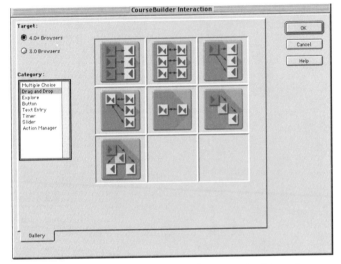

FIGURE **8.1** *The highlighted button is the portal to accessing Coursebuilder For Dreamweaver's design area.*

FIGURE **8.2** *This is the main design area for Coursebuilder, where you can easily create really far-out site content.*

Figure 8.2. Merely click once on the Coursebuilder button to activate the subprogram.

 Since Coursebuilder was made available for Dreamweaver 3 (it doesn't work with earlier versions of Dreamweaver), and hasn't been updated for Dreamweaver 4 as of the time of this writing, a little anomaly appears at the startup screen. Instead of the Dreamweaver 4 splash screen, it reverts to a Dreamweaver 3 splash screen after Coursebuilder is installed. That's the only aspect of Dreamweaver 4 that appears to be affected.

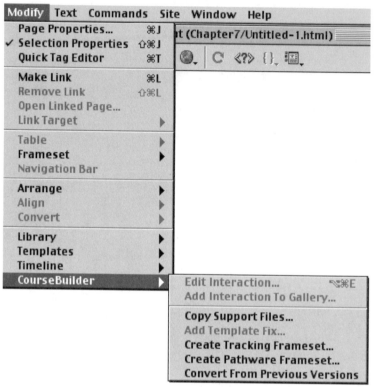

FIGURE *A new set of commands become available to you when you start working in*
8.3 *Coursebuilder.*

Once Coursebuilder is activated, you'll notice some differences in the Dreamweaver commands. Follow along with Figure 8.3 to see what these differences are.

a) **Insert Coursebuilder Interaction**. This is the main dialog box that gives you the insert choices.

b) **Add Coursebuilder Interaction To Gallery**. This is the control where you can save custom interactions for use in other sites you design.

c) **Edit Interaction**. Brings up the dialog box allowing you to edit Coursebuilder interactions.

d) **Copy Support Files**. Copies files you are using, such as scripts and images, to the same folder as your Coursebuilder document.

e) **Create Tracking Frameset and Create Pathware Frameset**. If you are creating a test site, these controls let you make framesets and de-

fine results for tracking the test-taker's performance. These results are saved in Lotus Pathware or other Computer Managed Instruction (CMI) tracking systems.

f) **Covert From Previous Version**. Pretty self-explanatory. This one converts pages you created in earlier versions of Coursebuilder.

g) **Insert Authorware**. Gives you the ability to insert Web-packaged Authorware pieces onto your site.

Now, here are some other changes that experienced Attain users will be interested in knowing about.

Live Updates. This feature is improved in this version. Any changes you make inside the Interaction dialog are immediately reflected in the Document window.

Undo Command. Instead of undoing all the changes you make to an Interaction, this affects individual changes.

Insert Layer. This places a Coursebuilder Interaction on its own layer, which fixes some problems that appeared when viewing Attain files in Netscape.

Customizable Pop-Up Menus. Now you can create customizable pop-up menus, as well as edit the order of the menu items.

Custom Behaviors. Now behaviors are dynamically generated, and visible both in the Action Manager pop-up and in the Behavior window.

While some of these changes may not seem like such big deals to new users, for experienced interactive page developers, they are exciting modifications that make the creation of this type of content much more pleasant.

GETTING IN THE GROOVE

I'm sure you're thinking that you can create interactive elements or pages in Flash or Director, which is true. Why, then, add Coursebuilder if it accomplishes the same thing that can be done in other Macromedia products that are already in your product stable? First, working with Coursebuilder is not an overly complicated process. However, in its simplicity lies the ability to build some exceptional pages that will have visitors returning over and over again—especially if you update the Coursebuilder elements every month or so. To accomplish the same thing in Flash or Director would mean writing a lot of ActionScript or Lingo code, which may not be the most advantageous thing to do if you're under tight time constraints.

Yes, with Flash or Director you can create some eye-catching animations to go along with the games. However, you need to ask yourself the following questions:

- Will the addition of "flashy" animations add to the content of the page or make the content more compelling?
- Will the addition of "flashy" elements detract from the content of the page?
- Will you lose visitors by using a program that in unavailable to some Web surfers? (Remember, the Shockwave player isn't installed on every computer, nor is it available to users of WebTV or other dedicated Internet access systems.)

These are hard questions without any right answer, except for what you ultimately want to convey. I believe I have said this before, but it's worth repeating: —Just because you have a certain "toy" that can do lots of intricate effects doesn't mean it has to be used all the time. Overuse of a specific software package can be as detrimental as not having the right content on your site. Overusing a program can lessen the impact of those elements because they quickly become redundant.

Again, you have to ask yourself what will better meet your or your client's needs, and will the presentation be worse by not using a program such as Flash to create pages such as this? Most of the time, the answer will be no.

THE COURSEBUILDER ENVIRONMENT

Time to get familiar with working with Coursebuilder.

Since Coursebuilder runs within Dreamweaver, you have to set up a site folder in which all your files will be stored. The root folder of the actual site will be created in the next chapter. For this section, though, the folder you create will be specifically for Coursebuilder and can be thrown away after you complete this chapter.

Here's what you need to do to work with Coursebuilder.

When you click the Coursebuilder button for the first time, you will receive the message shown in Figure 8.4. For the purposes of this project, click OK to set your link to the support files.

What support files is Coursebuilder talking about? These are specific image files that pertain to Coursebuilder interactions. You need to give a name to an HTML document and then assign a folder in which this document and linked files will be housed. Figure 8.5 shows the names I gave to these elements in relation to this chapter. Figure 8.6 shows these elements in the folder so you can see what support files are added. There are over

FIGURE *Coursebuilder won't open until you do what it needs you to do.*
8.4

FIGURE *The Save As screen and the New Folder assignment screen with this project's*
8.5 *titles.*

55 image files (you need to include the files inside the buttons folder) and 14 scripts associated with Coursebuilder interactions

Upon completing this, the Gallery section of Coursebuilder opens. Here, you assign what type of interactive section you want to build. Notice in Figure 8.7 the various styles of interactive elements you can assign to your page. For our project, we'll use the default choice, Multiple Choice, and the third layout in the top row. Make sure the 4.0+ Browsers is selected in the Target selection. Click OK.

Double-click on the layout choice to bring up the next screen.

FIGURE **8.6** *After assigning the links for Coursebuilder, these files will be added to the folder you just created.*

FIGURE **8.7** *A list of different interactive layouts is shown on the left of this Interaction screen.*

THE GENERAL SCREEN

Figure 8.8 shows this page and the new tab selections at the bottom of it. Let's take a moment to go over what the elements on this screen represent.

- **Interaction Name**. This is where you assign a name to your interactive file. Nine times out of ten, you can leave this as is.
- **Question Text**. This is where you type in the question you want the visitors to answer.
- **Judge Interaction**. Tells the browser to tell the participant if an answer is correct or not. Choose from one of the following:
 - **When user clicks a button labeled**. This creates a button that the participant clicks to submit his or her response(s). Coursebuilder tells whether the response is right or wrong immediately upon pressing this button.
 - **When user clicks a choice**. Responds immediately to the participants selecting an answer.
 - **On a specific event**. Lets you assign a time for responses to be judged. Depending on how you would set this up, a "score" might not be given until all questions have been answered.

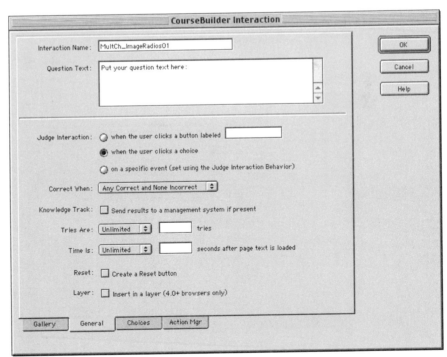

FIGURE *The General screen where you assign the question and other parameters for*
8.8 *your interactive page.*

- **Correct When**. This pop-up gives you two choices that tell Coursebuilder when to show a response.
- **Knowledge Track**. If this were part of an infrastructure such as in a school environment, you can assign a file to be saved and sent to a specific party.
- **Tries Are**. Assigns how many times a participant can try to get a correct answer.
- **Time Is**. Assigns a time-frame in which the answer must be chosen.
- **Reset**. Allow the page to be reset so a participant can try again.
- **Layer**. This is a must-have. It puts the interactive elements on a new layer so you can move it around to best fit your design. I don't know why it isn't a default setting.

Here are the settings for this particular project:

- **Question Text**: The Macromedia Web Design Handbook Is
- **Judge Interaction**: when user clicks a choice
- **Correct**: When All correct and none incorrect
- **Tries Are**: Unlimited

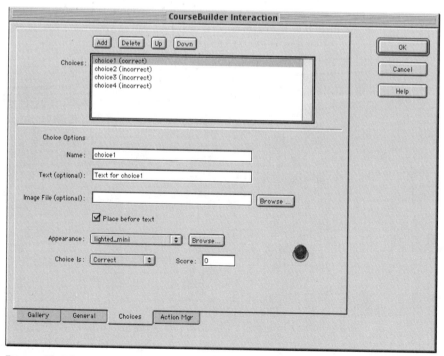

FIGURE *The Choices screen. Refer to this picture as you assign questions in the next*
8.9 *section of this chapter.*

- **Time Is**: Unlimited
- **Layer**: Selected

When you have this set, click on the Choices tab at the bottom of the screen. Refer to Figure 8.9 for the next section.

THE CHOICES SCREEN

By default, you have four choices that can be assigned. This can be reduced or added to by clicking on the appropriate button above the Choices pane. Four, by the way, will work perfectly for this project.

With Choice 1 selected in the Choice pane, move down to Choice options. Fill in the fields as you see fit, but here are my suggestions:

Choice 1:
- **Name**: Great
- **Text** (Optional): An invaluable and well-written book
- **Image File**: Leave blank. (If you had an image to assign, you could select it in this area to have it assigned to the page.)
- **Leave Place Before Text selected**: This means the image will be before the text. If unselected, the image will come after the text. This remains the same for all Choices.
- **Appearance**: Leave the button appearance in its default lighted_mini setting. Remains the same for all Choices.
- **Choice is**: Correct. Remains the same for all Choices. (Aren't I a sick puppy!)

Choice 2:
- **Name**: Superb
- **Text** (Optional): I have 12 copies and they're all dog-eared.

Choice 3:
- **Name**: Excellent
- **Text** (Optional): I not only have 12 dog-eared copies, I have bought copies for all my friends whether they own a computer or not.

Choice 4:
- **Name**: All Of The Above
- **Text** (Optional): All Of The Above.

When you've completed this, you can select Action Manager to reveal the Actions assigned to your questionnaire as shown in Figure 8.10. If you are a Code Warrior, you can use the pop-up menu at the top of this screen (Figure 8.11) to view and add different parameters.

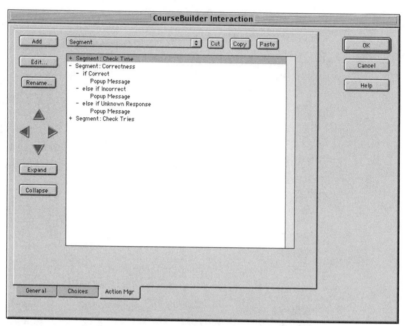

FIGURE *The Action Manager screen shows the code assigned to the interactive element*
8.10 *you created.*

FIGURE *The different parameters that can be added if you are a Code Warrior.*
8.11

When you're finished, click the OK button and you'll be taken back to your Web page. If you find that you need to modify any of your selections, go to Modify>Coursebuilder>Edit Interaction… Otherwise, select the Layer you just created and resize it to fit your design.

Just for the fun of it, let's go ahead and add a Shockwave animation to this page. Drag the Insert Shockwave placeholder onto the workspace. Select the TappingLip.swf file included in the Chapter 8 folder on the CD-ROM, and place the file immediately to the left of your Coursebuilder interaction as shown in Figure 8.12.

You can also modify the text inside the Coursebuilder layer just as you would any other text. This way, you can change the question into a Header and assign different text attributes for instance. You can also change the spacing between the answers to make the layer more readable.

Now, view how this looks and works by clicking the Preview/Debug In Browser button and viewing the page in your Web browser. Figures 8.13 and 8.14 show this layout, and Figure 8.15 shows what happens when an answer is selected.

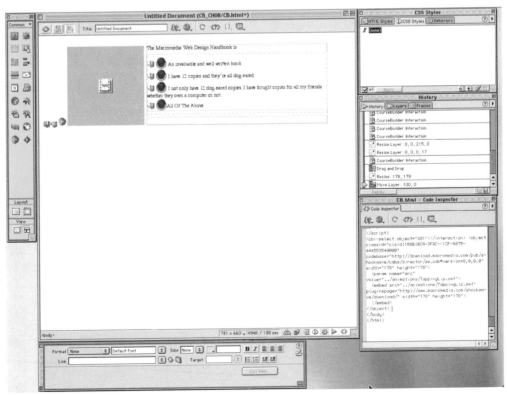

FIGURE *The Shockwave file in position next to the Coursebuilder layer.*
8.12

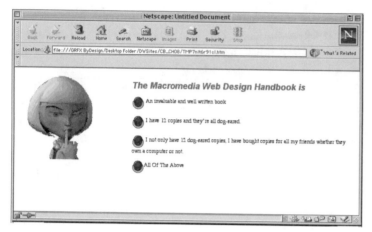

FIGURE **8.13** *The Coursebuilder page as seen in Netscape Navigator 6.*

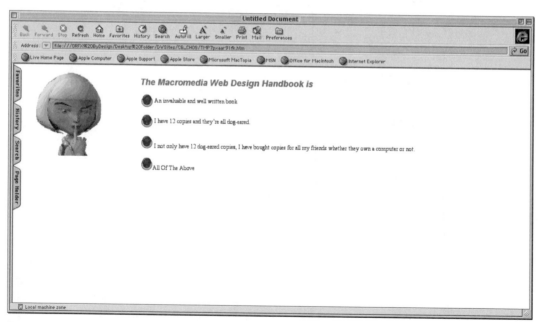

FIGURE **8.14** *The Coursebuilder page as seen in Internet Explorer.*

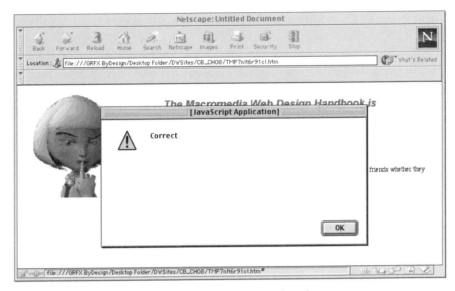

FIGURE *A look at what happens when an answer is selected.*
8.15

MOVING ALONG

OK. Enough of that stuff. Let's look at how we're going to incorporate Coursebuilder For Dreamweaver files into our site.

A section of the site will feature some games that visitors can play, and is there strictly for fun. This section will contain trivia questions pertaining to the 1960s and very early 1970s. Some questions will be multiple choice, and some will be matching games. We want the content of these pages to stay with the entire theme of the site.

At some point, if the client wants to do it, this section will also become a contest area. Visitors would be able to answer these questions, input their e-mail address and other information, and compete for prizes such as *Summer of '66* t-shirts, hats, the original cast recording CD, or possibly even a trip to the city of their choice to see the show. However, that's in the future, and at this stage is only an idea that is floating around in my addled mind.

The 1960s have a wealth of topics that lend themselves to some great trivia questions—classic television, fantastic songs by groups who are still popular today, and historical moments that shaped today's world. It seems that baby boomers like me have lived through some rather interesting times.

I don't want to delve into some of the darker moments of the 1960s—race riots, the Bay of Pigs, drugs, free love, and the assassinations. I want to tap into the fun, innocuous elements of that era—the music, the television shows (such as *Gilligan's Island*, *My Mother the Car* (ugh!!), *My Favorite Martian*, *Batman*, *Laugh-In*, etc), and the verbiage.

During this chapter, we'll create two different pages. One will be a multiple-choice page; the other will house a series of questions where the answer must be input into a text field. Here are the questions we'll be using. The answers, by the way, will be revealed in Chapter 9 when we create these actual pages for the site.

Oh yeah. No fair jumping ahead!

Page 1: Multiple Choice

- **Q1**: In what show did the host say "I see Tommy. I see Jane. I see Frankie. And I see you, too"?
 - a) *Sesame Street*
 - b) *The Big Valley*
 - c) Walt Disney on *The Wonderful World of Disney*
 - d) *Romper Room*

- **Q2**: What group sang *"I Think I Love You"* and *"C'mon Get Happy"*?
 - a) The Cowsills
 - b) The Monkees
 - c) The Archies
 - d) The Partridge Family

- **Q3**: What was introduced at the 1964 World's Fair and cost the exorbitant price of $2,368?
 - a) The first home computer
 - b) The refrigerator of the future with built-in ice-maker
 - c) An around-the-world flight on a jumbo jet
 - d) The Ford Mustang

- **Q4**: What was Thurston Howell's pet name for his wife?
 - a) Snookums
 - b) Lovey
 - c) Doll Face
 - d) Dingbat

- **Q5**: Finish this phrase: Up and at 'em, _____."
 - a) George of the Jungle
 - b) Will Robinson
 - c) Atom Ant
 - d) Speed Racer

Page 2: Fill in the Blanks

Q1: What group sang the song *Blowin' in the Wind?*

Q2: What is the name of Buffy and Jodie's older sister?

Q3: What did Agent 86 have in his shoe?

Q4: What did the astronauts drink while in orbit?

Q5: Coca-Cola wanted to teach the world to do something. What was it?

That's a good start to our Route 66 Trivia section. Now it's time to see how this is pieced together using Coursebuilder For Dreamweaver.

SETTING COURSE

Now you know what the questions will be for each of the Coursebuilder pages. It's now time to really begin building the site and incorporating these questions into the site using Coursebuilder. So, head over to Chapter 9 and we'll get started.

Completing the Site

More Hit Tunes of 1966

Do You Believe in Magic—The Lovin' Spoonful
Heart Full of Soul—The Yardbirds
Down in the Boondocks—Billy Joe Royal
Hold Me, Thrill Me, Kiss Me—Mel Carter

SO, DO YOU BELIEVE IN MAGIC?

It's easy to believe in magic after you have gone through all the preparation, sweat, and angst of idea generation, and then finally see your creation up and running on the Internet. There's no comparable feeling in the world. It's like seeing your baby give you that first smile, or being kissed for the first time by that boy or girl who you've had a crush on for the past umpteen months.

Well, maybe I'm overdoing the analogies a bit. Let's just say that there is an intrinsic pride of authorship that comes with a job well done. It doesn't matter if your site has so many visitors in the first 30 seconds of existence that the ISP locks up, or if you only have 10 visitors a decade; building and putting a Web site on the Internet is its own reward.

All the other chapters in this book have led to this one. This, my friends, is the culmination—the zenith, if you will—of your journey. This is where everything you have done before is put together. This is where the magic happens.

So far, you've practiced with all the different programs that Macromedia has to offer. You've delved into Director, fiddled with Freehand, Flash, and Fireworks, and created conundrums in Coursebuilder. Now you'll merge all of this knowledge, all of your repressed energy, into a cohesive whole that will be presented to everyone with Internet connections from Borneo to Bogota, from Utah to Uganda.

DREAM A LITTLE DREAM

As I just mentioned, it makes little difference if you create the ultimate site or a site that is voted as the dregs of the dregs on the Internet. What's important is that you have fun, you experiment, and you follow your dream.

Of course, there are rules you need to follow. This means if you're following your dream, your physical self is the third car on the creative train. First come rules, then come dreams, and then comes you. What am I talking about?

The rules to putting a Web site on the Internet are paramount. All your HyperText Markup Language (HTML) has to be correct. All your links and files have to be in place. All your JavaScript, Coldfusion, and ASP codes have to meet certain criteria to be read. If one thing is out of place, if one file is missing, then your site is going to suffer—no matter how good it looks or how much effort you put into designing it.

Your dream—your vision—can be as far out and fanciful as you want. However, if the dream forces you to break the base rules on which Web presentations are built, then your project won't see the light of a diode. You need to be know the limitations of the Internet and be prepared to modify your vision to make those limitations work for you.

"Your physical self" is somewhat self-explanatory. Without you, the page would never be put together—unless of course you're a sentient ball of gas that has trekked through the galaxies since time immemorial and can solidify yourself when needed to complete tasks handed down by your superiors. (I've been watching too much *Star Trek* lately. Forgive my transgression.)

Let's take a moment to go further into this "bringing your dream to fruition" discussion. As I said, the vision you have for your site can be as far out and fanciful as you want it to be. I'm a firm believer that it is much easier to make something smaller than to make a small thing bigger. Take movies for example. Probably the most widely regarded failure in modern times was a western called *Heaven's Gate* released in 1981. At the time, it was the most expensive movie ever made. It ran almost four hours, and it took down an entire movie studio. It was a project that got way out of control, with creative forces unwilling to cut back on their vision. Instead of stepping back, looking at it with an open mind, and seeing that the flow of the story could have been much better by cutting out at least an hour of footage (or more), it was a box office disaster. Your site could easily fall into this trap if you're unwilling to hone it to a fine edge, with the final result being visitors leaving your site wanting to see even more and coming back over and over again to see what new and exciting content you've added.

It may seem that a film such as *Heaven's Gate* was a bad idea. Ultimately, there are never any bad ideas. Some might work better for a particular project than others, but those ideas that are not used could well be the perfect solution for future projects. There is also no such thing as a bad design. A great design is one that works perfectly for the subject. However, if you take that same design and force it to work with subject matter that would fit better with a different layout, then you have created something that is extremely ineffective. This equates to being a bad design in modern nomenclature.

I know there are many of you who will disagree with this. Yet, think about it. If you look back at the history of modern design—be it print or electronic—accepted theories change. How does this come about? By someone being brave enough to break the rules, throw all the teachings out the window, and defy their peers. We have gone from the clean, straightforward ad designs of the 1940s and 1950s that showed happy,

smiling people dressed in their Sunday best, cleaning kitchens to raucous, multilayered imagery that doesn't necessarily pertain to the product that's being sold. If this latter style had been introduced in 1955, professional designers would have raised their voices in contempt. Yet, because of artists such as Peter Max who, in the late 1960s, began creating posters with flowing colors merging into fluid designs merging into what many thought was sensory overload, the ultra-layered looks of today would not be as accepted. Those artists broke, or, if you prefer, changed the rules, thereby opening the door for today's artistic expression and thoughts on proper design.

It was the same with two groundbreaking broadcasts—*60 Minutes* and *MTV*. *60 Minutes* introduced a visual style that, until that time, was considered a professional no-no—framing a subject so their heads were cut off at the top and sides. Prior to this *60 Minutes* style, if you didn't leave space at the top and sides of a subject (called *headroom* – no relation to Max Headroom, by the way), you were chastised by the boss, and your footage might very well not make it on the air. In the case of *MTV*, they introduced the quick edit. Sure, quick edits had been in existence since film-immemorial. However, look at the commercials and the majority of broadcast material prior to *MTV*'s startup and you will see many lingering shots, and lots of dissolves and fades—lots of calm. Now, because of *MTV*, manic presentations are de rigeur.

So, as you can see, your design ideas may be accepted by some, chastised by others, but could well become the norm—you just never know. All you can do is do you best and know that for every negative remark you hear, there will be an equal number of positive responses out there. It just seems that the negatives are more vocal than the positives.

Another thing you will want to do: Keep a notebook handy—one of those Reporter's pads you can get at any office supply store. Jot down notes as you surf the Web and as you take that allotted five-minute break from the computer to see if the world outside your cubicle or den is still there. When an idea comes to mind, write it down or draw it out. If you're as I, then you'll very quickly have dozens of such notepads filled to the brim with exciting ideas.

Finally, never, ever, be satisfied with your final product. I don't care if it's the best work you have ever done; there is always room for improvement. I can always take a few minutes to clear my head, come back, and find flaws in what I've created or things that could use some tweaking. Many people tell me that I do this too much (especially my publishers when the deadline has come and gone and I have fallen behind because of constantly changing things). Satisfaction is a double-edged sword; you can be satisfied with a job well done, but you shouldn't be so satisfied that you

can't find things to change. If you ever do, you might as well find something else that interests you because you will begin stagnating if you don't. So, beware complacency as you continue your foray into the wonderful world of Web design.

MORE PREPRODUCTION ISSUES

There is a great divide within the Web design community that deals with layout issues. How much is too much when it comes to content? There are those who believe that everything including the kitchen sink are perfect. Others believe that less is more. While I fall into the latter category, I believe there is definitely a middle ground that can be reached.

POINT 1: DOWNLOAD TIMES

Download time, in my opinion, is definitely the most important area to consider when putting your site together. Remember, the standard connection speed for the core surfer is 56.6Kbps. While you may be on a cable modem or connecting via DSL, most others aren't. This means that, when you connect to your site and see those pages load quickly, others are sitting patiently as your content loads. You might have created a page with very small image files that are used as static links (non-rollover type), or a set of small rollovers. The page might have a few JPEG or GIF images to spice things up. There might be a background image, streaming audio, and a banner ad or two. While each of these files might individually only weigh in at a maximum of 12K, when you have a few dozen on the page (or more, as is the case with some of the sites I've visited over the years), download time increases exponentially.

If you use cable or DSL, you really need to have a way to access the Web using a standard telephone line so you can accurately monitor the speed at which your page loads. There are plenty of companies offering free access to the Internet, some of which limit the amount of time you can be connected at any given time. Others force you to dial long distance to access their service because they don't have local dial-ups in your area. Since you won't use this secondary connection as your main method of surfing the Internet, you don't need to worry about using up too much time. All you want to do is put your site up, connect to it using a 33.6Kbps or 56.6Kbps modem, and see how long it takes for your page to load. If you've had your high-speed connection for some time, you'll be surprised at how much slower a standard modem is.

What you will quickly find if you are building a complex site is that the load time on a standard connection can be painfully slow. You need to

consider how many people will actually wait around for the page to be completely revealed. Moreover, how many of those impatient surfers may be potential clients or potential employers?

Yes, that's right. Your site, if done well, could lead to a new career for you, even if at this juncture you merely design sites for yourself, family, and friends as a hobby. A friend of mine put up a site that gives away free textures for placement on 3D models. A recruiter from a motion picture production company came by the site and literally offered her a job doing texturing on a major motion picture. It came right out of the blue. Now, she'll be one of the few, the proud, the artists on a motion picture that is to be released next year.

Her site is, by the standards of many of today's design houses, nondescript. There are no fancy remote rollovers, no mouse follows, no animations at all (except on one page that is specifically designated as the place to go for animation viewing). What she did was feature her work in a compelling manner, making it easy to find the content. Moreover, when a page is accessed that might have heavy visual content, surfers know that it might take some time to load and they're willing to wait because the environment this lady created has piqued the visitors' interest and made them feel at ease.

POINT 2: MAKE VISITORS FEEL AT EASE

This is another thing to consider when you are designing animations, effects, or, simply, your overall design. Making people feel at ease and feel comfortable where they are is a talent unto itself. If you create a site with tons of fast-paced visuals and heart-pounding music, visitors will feel hurried. It also gives them the idea that everything on the site is going to race toward them. They will think that images will load so fast that they'll be on the screen before the link button is actually pressed. You can equate this to how you feel when your house is nice and clean and everything is in its place, compared to how you feel when your house is in a shambles. Cluttered living space is uncomfortable to live in, and visiting a cluttered site is just as uncomfortable.

Unknown to your visitors, and often unknown to you as you're putting it together, is that your psychological—or subliminal—message is causing their adrenaline to pump a bit harder, their pulses to race a little faster. This leads visitors to feel as if everything is going to be fast, hard-driving, and intense—but then it takes a couple of minutes for an image to load or for a page to be accessed. They decide to download a MOV or AVI file, which leaves them enough time to go to the grocery store, get enough groceries to last a month, and come home and unload the bags before the download is complete. That's a pretty intense mixed message that's being sent.

This isn't to say not to do that; just be aware of the type of message you are sending to your visitors. If it isn't appropriate for your overall concept, then leave it out. Save it for another site, or for a different area of the site. Don't make it the first thematic element they see, because it will set the tone for the entire site.

Where is this leading? To let you know that if the overall design is pleasing to the eye, and the main pages download quickly, then people will put up with areas that take longer to load. It comes down to psychology: Give people a pleasant, affordable product and they will be more willing to put up with some of life's little inconveniences when they occasionally crop up.

POINT 3: TEXT

How much text is too much? There is no specific answer to that age-old question; however, there are some basics that you will want to consider.

First, think back on your Web travels. I'm sure you have encountered pages that had tons of links and visuals, and text that seemed to scroll on forever. Everything under the sun was laid out in extreme verbosity (much like this chapter, huh?). By the time you finished reading the first page—if you ever did finish reading that first page—you knew everything there was to know about the person, his or her immediate family, extended families, his or her pet's history, and the shoe sizes of every family member since the eighteenth century.

You need to be tough on yourself and ask if all this information is necessary. Ten times out of nine (yes, that's what I meant to say), it isn't. Think about this: Do you want to spend all your time reading what would, if transposed to a word processing program, equate to 10 pages of material? I don't think you would. With that in mind, you really need to edit yourself unmercifully, giving clear, concise information that will tease and whet the visitor's appetite for more.

POINT 4: VISUALS

While this may seem to fit with Point 1, it really is its own entity because I'm talking about visuals included on example pages. If you want to show off photographs you've taken, artwork you have created, or other Web pages you have designed, then you need to show the best and get rid of the rest. If that means that you only have two images instead of five or ten, so be it. It is better to show a couple of fantastic images that you are immensely proud of than a whole slew of images that you think are good but that don't add anything new to the visual experience.

You also need to consider how many files of a particular genre you need to show to get your point across. If, for example, you dabble in 3D

art and have created numerous images that run the gamut from science fiction to fantasy to photorealism, each of which has its own subcategory, you don't need to show numerous repetitive images to get your point across.

Let's flesh this out a bit. Say you have a number of science fiction images that include interstellar space combat scenes and a slew of interior space-station scenes. Looking at them closely, while you might see massive differences in the layout and feel of the images, you need to ask yourself if, even with their differences, they are redundant in their theme. How many spaceships does it take to show that you can model spaceships? How many hallways does it take to prove you can model high-tech interiors? Again, be tough on yourself. Show the ones that really stand out, and leave the others for later exhibition.

POINT 5: AUDIO

Here I go on a rampage.

Am I alone in thinking those ultra-repetitive, Muzak-wannabe music strings are the most obnoxious things to come along since pet rocks? To place an audio file on a site that automatically loads whether you want it to or not often causes undo mental anxiety, because the loading indicator on the browser continues on forever, even after all the information is loaded or, in the worst case, can cause your program to lock up completely. If you don't experience the latter—which, in many cases can be considered the preferable outcome—then you're faced with listening to some Mandy-esque love song repeating ad nauseum until you leave the site. What's even worse is that many of the people who include these songs on their sites have learned about the _blank_ code so, if you click on a link, a new page is opened, leaving that dag-nab-dang-ding (excuse my language) music blasting through the speakers. All I can say is, there should be an international law that provides severe penalties if this type of file is placed on a Web site.

Then there are the few (very few at this writing) who have discovered that their computers have an installed microphone and have decided they are now announcers. In forced bass voices, they over-ee-NUN-see-ate every syllable as they welcome you to their site.

'Nuff said.

If you got past my rant on that last point, suffice it to say that the bottom line when you put a site together is to live, eat, and breathe the acronym K.I.S.S.—Keep It Simple Stupid. No, I am not calling you stupid. That is what the acronym stands for and, try as I might, I couldn't come up with something that didn't sound derogatory. Seriously, though, keeping a site simple will help with download time and alleviate the problem of too

much content, which ultimately translates into a form of redundancy, making the visitor's experience a very pleasant and memorable one.

You know the ones I'm talking about: the sites set up by people who want to generate freelance work. All the previous points become even more important in this case, and there is another one to which you should pay attention.

If you are either interested in creating a way to bring in some extra money by doing some part-time freelance work, or if you are trying to build awareness for a startup company, the first inclination is to put your fees on the Internet so people know what you are charging for particular projects.

Bad idea. Doing this gives visitors no incentive to contact you. You want your site to encourage potential clients to call you so that you can sell yourself, to make them excited, and to close that deal. If they know what you charge, they can easily move to other sites to gather information. They can call your competition and hear a human voice answering their questions. By revealing your pricing structure, you have effectively closed the door on potential clientele because your main asset—yourself—has been taken out of the equation. Can your site sell your services better than you can? I think I can unequivocally say that no, it can't.

There's another aspect to this: Who's to say your competition isn't checking you out, discovering your prices, and lowering theirs to steal your thunder? Why give competitors an open door to your company?

Bottom line: It's not a good idea to quote rates on the Internet.

As you can see if you made it through all of that, creating a Web site entails much more than just putting some pictures on a page, writing scintillating text, and announcing that you're open for public viewing. Unfortunately, with the proliferation of low-cost, easily understood photo manipulation and Web design programs, the majority of the sites displayed on the Web continue to add to the "vast wasteland, " a title that, until the past decade, was solely reserved for television.

This means that planning will, ultimately, make or break a Web site. With the proper planning, you can make even the most static site stand out in a sea of commonality. I think you'll all agree that poor execution is the number-one destroyer of a good idea. You could use every high-end professional software package known to humankind, and create effects that— at first viewing—make the visitor's eyes widen in amazement. However, if there is no content, no meat to the flash (no pun intended), then there is no reason to return. There is nothing there to hold the interest of the audience or make them want to return. Using this theory, you can see that it's imperative that content becomes the starting point for everything else. After content comes layout. After layout come the effects you might want to include.

Again, I'm a firm believer that less is more. Don't throw everything including the kitchen sink into your site. Leave visitors wanting; make them come back to see if anything new has been added—which means, you need to keep materials in reserve. You need to have enough material (whether already created or in the works) so you can replace older content, refreshing the look not through a total overhaul of your site design, but through the offering of fresh product. Content is what brings people back, not showy effects.

Unfortunately, many Flash-driven sites trade content for show. Sit back and really dissect that impressive site you think is so great. Why do you think it's cool? More than likely, it's because of all the flashy animations that are triggered when you click on a link or when you roll the cursor over an area of the screen. Yes, it's impressive, and the people who created that animation should be given their due for a job well done. But then, look beyond the eye candy. Does the actual content live up to your expectations? Most of the time, you will probably say that it doesn't. Great effort was put into the interface, while the actual content was thrown in as an afterthought. This leaves visitors with the feeling that something isn't quite right. They might not consciously know what is bothering them, but it will leave them with the feeling that there is no reason to return to your site because it didn't live up to all the hype.

You can compare this with the promotional trailers for movies where the studio throws in every action-packed scene in the movie. When you go to see it, though, those scenes take up maybe 10 minutes, and you have to sit through 80 other excruciating minutes to get to them. You feel cheated and let down. So, avoid the hype and focus on content over everything else.

If you wanted to put this into list form for your creative construction process (also see Figure 9.1), you would have:

1. Content
 a. Text
 b. Building the Visuals
2. Layout
 a. What will best show off the content of the site?
 b. Is the layout clean and unencumbered; in other words, easy to navigate?
3. Effects
 a. How many?
 b. Are effects needed, or will they overwhelm the content?
 c. Will the majority of the visitors be able to see them?

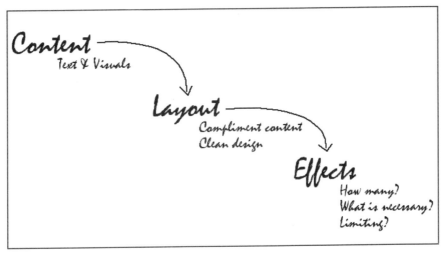

FIGURE *A relational graphic is extremely important when first beginning your design.*
9.1

LIVING BY THE CODE

In the near future, there will be one more decision you will have to make. Today's Internet is based on the decades-old HTML code. While HyperText Markup Language has evolved to keep up with the changing needs of Web designers, it is a singular beast that doesn't stray from its own kind. It is a language that has its roots in desktop computers, and that has not changed in more than 20 years.

Unfortunately, the days of the desktop are quickly becoming numbered. Right now, there are several delivery methods for your work—interactive television, broadband, wireless devices, and Personal Digital Assistants (PDAs). To reach these various technologies, you need to start looking at incorporating Extensible Markup Language (XML—not to be confused with the XFL) into your thought process. The base of XML is still HTML, but it expands this decades-old code to meet the needs of a widening audience.

XML gives you the ability to, in short, create templates for the afore-mentioned systems. When someone accessing your information is using a PDA, for example, the visitor will be transported to the template that works with his or her device. Think of XML as a traffic cop that knows which cars belong on which road. and safely guides them onto it.

XML is also the perfect solution for databases, because it can translate files to be read on any system anywhere, no matter its age. So, if your boss

is still using an original Amiga computer to get online, whatever you create using XML will be readable by him (or her) as well.

I won't go further into this because it's not overly pertinent to the focus of this book. However, it would behoove you to visit sites such as www.xml.org to start boning up on what XML can do for you and how you can quickly and efficiently begin implementing it into your database and/or site design for optimal performance over varying delivery systems.

PUTTING THIS INTO PRACTICE

As you know, anyone can talk a great game—the proof comes from execution. Here is where we start executing.

Up until now, you have gotten a good feel for what the various Macromedia programs—Flash, Fireworks, Freehand, Director, and Coursebuilder—can do to enhance your site. You got an inside track on the differences between Dreamweaver and Dreamweaver UltraDev, so you have the information you need to select the version that will most readily meet your needs. The previous chapters were an overview, designed to start your creative juices flowing by seeing what this application-filled family can do. Here is where we bring it all together.

This chapter, as you can see, is a long one. It's broken down into three segments that correspond with the outline you just read. Section 1 deals with content, Section 2 with Layout, and Section 3 with Effects. Section 4 puts it all together with Dreamweaver 4. It might be a good idea at this stage to put in a bookmark, go get some coffee or a soft drink, go outside to see the sun for a few moments, and then come back and dive right in.

CONTENT

The biggest challenge for Web designers—or any artist, for that matter—is coming up with ideas. It's especially difficult if you specialize in Web design because, after a while, you begin to find yourself reusing layouts. In this section, layout will be the top priority. You'll see how the design for the *Summer of '66* site came about, and how a theme was created that stayed with the overall sense of the show and its thematic location.

When the Muse Strikes
The creative muse is a fickle friend. This genderless tease comes and goes as it pleases, often at the most inopportune times. It can hit you in the mid-

dle of the night, rousing you from sleep until you satisfy its cravings. On the other hand, it can leave you faster than you can say "site design," often while you're smack-dab in the middle of that site design process. There's no way to tame The Muse; no way to make it appear when you want it to. The Muse rules you and, if you are creatively inclined, you learn to live with this little fray in the fabric of your existence. You learn to embrace it when it comes, ride with the tide while it is there, and then rest when it moves on to its next victim. When The Muse hits, it hits like a cannonball slamming into your brain. It causes all sense of time and outside influences to dissolve into a blurred blob that has no bearing on your life. For those living with a person like you, The Muse can be an unwelcome guest who appears unannounced at the door expecting to stay for as long as it wants without any regard for your or your loved ones' feelings.

At times, The Muse can be reeled in to do your bidding. This usually happens when your client or your work is so defined that it's impossible not to have ideas flowing lava-like from your brain. Such is the case with the *Summer of '66 site* (which, I promise, we're about to get to). A subject like this literally throws The Muse at you, daring you to not come up with ideas. And what's so fun about subjects like this, so many ideas are generated that, I'm sure, each of you has your own take on how to present it.

The Muse is also extremely focused. When it wants to create a specific image, it doesn't want to be interrupted. It literally puts on blinders and, until that project is completed, doesn't want to have to take those blinders off. When it is ready to bring all the images together into a cohesive package, it wants to do that and nothing else. Yes, during breaks, it might allow ideas for other things to flow, but it won't cough up more than bits and pieces that will be retrieved when the time comes to focus on that particular idea.

The Muse, therefore, is your friend, albeit a very high-maintenance friend. It may not be your significant other or spouse's friend; in fact, it can be the bane of their existence, but for you and your clients, it is the best friend you will ever know (especially when the money starts rolling in!). It is a friend you should embrace wholeheartedly when it arrives, and one that you should not try to harness as it leaves. Go with the flow and let the good times roll, to use a couple of very old sayings.

The Muse has become such as good friend of mine that I literally decided to give it a face; to give it a solid form as a reminder of how close we really are. Figure 9.2 shows my vision of my Muse so that, before we really get down to business, you can have a good chuckle and know that a total lunatic is at the helm of this ship.

FIGURE *For some, like the author, The Muse becomes a*
9.2 *living, breathing entity.*

Creating the Look

You have already gone through the process of creating elements for use on the Web site. Now it's time to really get down to business and modify them for various uses. We'll move from appropriate program to appropriate program for each element as these files are honed. It might seem like flitting at times, but it's the best way to really get a feel for how all the programs are intertwined, and shows one way for them to become integral parts of your design life. You might even get to the point of reconfiguring your hard drive, creating a special partition that is solely to house them.

The first thing is creating the base elements for the site. Figure 9.3 shows the set of stylized blocks we made way back at the beginning of this book. It's time to modify and add to them.

We may create more elements than will probably be used. I always like to begin with more, so that when The Muse's focus has shifted to the site layout itself, it doesn't have to change gears to go back and create more elements. These elements need to fit into an overall modifiable design scheme, a rough sketch if you will, of what the site template will eventually become. I'll discuss templates later in this chapter. For now, though, I'll begin with the rough draft so I know where the elements I will need will be temporarily placed, which then lets me determine what elements I am going to need to build.

Research is the key. There are numerous books that deal with the 1960s—although many are difficult to find and may need to be special ordered, or can only be found in a large library—as well as numerous sites on the Web. What makes the task a little more difficult is the fact that 1966

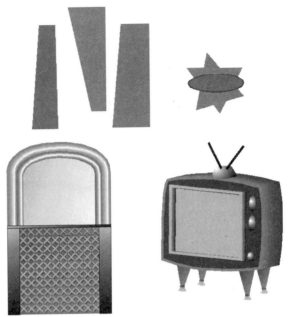

FIGURE *Revisiting the stylized elements that were created*
9.3 *in Chapter 1.*

was a time of great transition. The music, while mostly rock, had not progressed to what was then called Acid Rock, and it hadn't totally divorced itself from the music of the 1950s. The Beatles and The Rolling Stones were still performing what could be better described as Pop music; it would still be a year or so before they started adding sitars and stream-of-consciousness-like lyrics into their songs. Groups such as The Mamas and the Papas, and Peter, Paul, and Mary were beginning to bring folk music into the limelight, although the theme of the songs hadn't turned toward protest yet. Love songs like *Hold Me, Thrill Me, Kiss Me* still carried a certain innocence. The same goes for the artistic style of posters and print advertisements. Psychedelia hadn't taken root yet, but it was beginning to creep in. The break from the straight-lines style of the 1950s and early 1960s design sense was changing into what would soon make Peter Max and Andy Warhol household names.

How do we capture that time, then? Is there anything that truly separates 1966 from what came before and what would come after? Not really. What we have, though, is a distinct time that still had an innocent *Ozzie and Harriet/Leave It to Beaver* feel. For those who were a part of that decade, the nostalgic feel is one of tranquility and good, clean, wholesome fun in

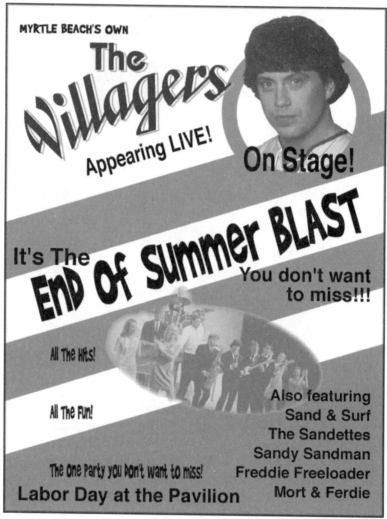

FIGURE **9.4** *Is there a way this can be modified to fit our needs? Figure 9.5 shows one possible design that might work. It incorporates the angled bars that emulate the concert poster design concepts of the years leading up to and somewhat including 1966. Looking at it more closely, though; it definitely makes the site look very busy.*

the same vein as the Frankie Avalon and Annette Funicello beach party movies. Because of this, we can draw from both the styles that preceded and the styles that shortly followed, blurring the lines between reality and nostalgia.

So, we know that a design based on poster art as shown in Figure 9.4 (which you also saw in Chapter 1) could work for us. The problem is, it's

FIGURE *One possible page design that uses the concert poster style of that year.*
9.5

way too busy and would take too much time to load if incorporated into
the site design. It could be made into a background image, but then two
very basic problems arise. First, the cleanliness of the design would be
negatively impacted. Second, it would negatively impact the way in which
we can lay out the elements. Lining up text and images, not to mention
any rollovers, would become a nightmare. So, that idea is being put in the
ol' circular file (or mental trashcan if you prefer).

For those of you who aren't sure what the term busy *means,
in this circumstance it means cluttered. When an image or
a scene is called "busy," the person means there is so much
content that it's visually overwhelming.*

After much contemplation, emulating the poster design would not be
the best way to go. So, in the immortal words of The Terminator: "Hasta la
vista, baby."

The Idea List

What else can we use for inspiration? Thinking about it, and taking my mind off the stylistic approaches of 1960s advertising, it's time to make a list of what makes *Summer of '66* what it is.

1. Timeframe
 a. Pre-psychedelic
 b. Primary colors were the norm
 c. No wild shapes, undulating shapes—only clean lines
2. Location
 a. South Carolina
 b. Beach
 c. The Pavilion (the venue where the band played)
 d. Cruising the Strip
3. Other Facts
 a. More innocent time period
 b. Viet Nam just coming into the public consciousness
 c. Had just gotten over the Kennedy assassination and the Bay of Pigs
 d. Bikinis still above navel
 e. Teens still wore pedal pushers and straight leg pants (no jeans)

That's enough for now. Reading that list gives a better feel for the time and location, both of which we can use to help come up with a look.

On thing that jumps out at me is 'b' under location. The main setting for the musical and where the musical is performed is the beach. That could well be the thread that ties all the pages together. Look at Figure 9.6. This design is a little different, with an area that stretches horizontally across the bottom of the page. This area could have two functions. The first is to define the bottom-most part of the Web page. I wouldn't go beyond that point and all content would fit in the large area above it. Second, it can house graphic and navigational buttons.

This area would be perfect to give the feel of a beach, which can be created in a 3D program such as Corel's Bryce, Eon Software's Vue d'Esprit, LightWave [v6], 3D Studio Max, or others. This could be a pretty cool look. The only problem is that I would be forcing the blending of two distinct styles—photorealistic with highly stylistic, almost cartoonish elements. This was done successfully in 1969 with The Beatles' *Yellow Submarine* movie, but this isn't a movie. Combining these very diverse styles would be more disconcerting visually that advantageous. It would be better to stay with the stylized look, subliminally keeping a retro look and feeling of fun.

Here are a few more reasons why the stylized beach will work better for this design:

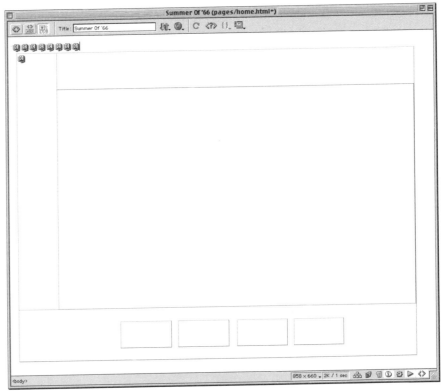

FIGURE *A second page layout style that will work much better for design purposes.*
9.6

1. I can draw the beach in such a way that I can add rollover buttons over the image that use the same color scheme, I can give the impression of the button pushing in or out from the sand. This idea plays off the mental image of kids building sandcastles. Maybe it's just my strange way of looking at the world around me, but if I build rollover buttons that appear to press into the image, it reminds me of the times I spent digging in the sand, creating troughs where sea water could collect.

2. Using the beach gives me one more idea for the look of the site. I can make the background a light sky-blue color that will tie in with the overall ambiance. This blue will have to be very light; otherwise, it will quickly become annoying rather than fun— so light that it's almost subliminal itself. This will also help to offset the glaring quality of a white background, while not fighting any text that we will add to the site.

3. I will also add some wispy clouds to the upper portion of the site that will remain static in the area where the *Summer of '66* logo will go. The biggest question regarding this is whether the clouds and background color should be created as an image, or if the clouds should be separate—I'm leaning toward the latter. This way, I can place the clouds more accurately. Moreover, I can use Freehand to determine what color value the blue should be, and place the clouds over that so that the cloud image matches the background perfectly.

4. I plan to have the Sun image in the background of each page. It will be enlarged to encompass most of the right quadrant of the main area. Of course, it will be muted so that it doesn't overwhelm the page and detract from the content. What's more natural than the sun in the sky?

There's the look, then. The beach scene will be one of the elements we will need to create in Freehand 9—so will the clouds and the background sun. The other elements to be built will be the buttons, which will be done in Fireworks. Figure 9.7 shows a sketch of the page layout.

FIGURE 9.7　*Here is a look at the basic page layout. I will use this as a visual template for creating the Web page.*

Numeric Considerations

Now would also be a good time to determine just how many link buttons we need to create. I have to keep in mind that, not only will I have those rollover buttons, basic vector shapes will be located around the page. Each of these elements, of course, will affect the loading time for the page(s).

Here are, what I call, the "Segment Head Pages" for the site (in no particular order at this point):

- **Home page**. The standard home page.
- **Cast**. Contains bios and photos of the cast members.
- **The Show**. A synopsis of the show and a brief history of the beach.
- **Audio/Video**. Links to music and video downloads from the show.
- **Trivia**. Incorporating those trivia questions from Chapter 8.
- **Get Info**. The info form that was created earlier in the book.

Some of these pages will have links to secondary pages. Figure 9.8 shows how the final site tree is laid out, and what links to what.

This means I need 12 rollover buttons. Each of the links will have a rollover button, and there will be one button for each that is a static graphic that will not be assigned as a link, but will act as a visual locator so the visitors know which page they are on.

The Cast, Show, Trivia, and Audio Video pages will have other rollovers, advanced rollovers where information will appear when the cursor moves over them. These secondary rollovers will be located screen left. Here's the breakdown for those:

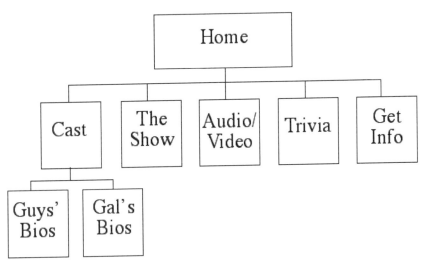

FIGURE *The site tree, with all pages and how they relate to each other.*
9.8

1. **Cast**. This will link to pages titled *Guys and Gals*.
2. **The Show**. This will link to a scrapbook page with photos from the performance.
3. **Trivia**. Will give visitors the option of going to multiple-choice or fill-in-the-blanks trivia questions.
4. **Audio/Video**. This will contain separate links to the audio downloads and the video downloads.

I have the habit of putting links and secondary information on the left side of the page. I do this because 90 percent of the world reads from left to right, so it feels more comfortable for things such as links, secondary links, copyright information, and so forth to be positioned in this manner. While this is nowhere near a hard-and-fast rule for me, my designs always seem to reflect this. I can't really think of any site I've designed where I have positioned these elements differently.

I also find it more pleasing, designwise, to put copyright information in a small block located below other elements on the left-hand side of the page, rather than put that information horizontally along the bottom of the page. It harkens back to my days dealing with newspapers and periodicals, where the legal information was positioned in this way.

So, there we have it: the initial thought processes that went into the design of this site. From here, it's time to create the elements and then incorporate them onto the page.

BUILDING THE RECURRING VISUALS

It's time to open Freehand and begin putting together the base images for the site. These images will include the following:

1. One variation on the Sun image created earlier in the book
2. Extra stylized vector graphics
3. A stylized beach for the lower third of all the pages

These elements, especially numbers 1 and 3, are recurring images, meaning that they will definitely be seen on every page. In regard to number 2, the vector graphics that will be designed may or may not be used on the site. They are what I spoke about before—having more elements than are actually needed so that, when we get into the site design process we don't have to go back and build more elements to fill in gaps.

So, let's go to Freehand and get started.

Sun...

We'll begin with the simple stuff first—the sun graphic. Import the Sun graphic from the Chapter 9 folder, or use the one you created at the beginning of the book. This file has Guides turned on. You'll need to turn them off and make sure Snap To Guides is turned off as well. For the former, go to View>Guides>Show and View>Guides>Lock to deselect them. Then go to View>Snap To Guides to turn this feature off.

Open the Layers window. The first thing to do is select all the layers containing sun elements. Making sure these layers are unlocked by clicking on the padlock icon by their name, hold down the Shift key on your keyboard and click once on each element layer. From the options pop-up menu immediately above the Layers list (seen in Figure 9.9), choose Merge Selected Layers. More than likely, you'll also need to group the resultant elements by using the Command/Ctrl + G key combination.

Next, create a new layer. Move this layer directly underneath the sun elements as you see in Figure 9.10. What you will be creating is the background image that will appear on every page of the site. This means that we will need to select the color that is assigned to the rectangle. Remember from earlier in the chapter, this will be a very light blue to give the impression of being the sky. The sun will then be positioned within the rectangle and modified, which is described later in this section.

It's a good idea to get used to locking layers that you aren't currently using so that you don't accidentally place an element on the same layer by accident.

FIGURE *Choose Merge Selected Layer from the pull-down menu in the Layers window to*
9.9 *make the sun layers into a single layer.*

FIGURE *Create a new layer and make sure it is positioned under the sun elements in*
9.10 *the Layers window.*

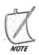

*Make sure the unit of measure is set to pixels by clicking on
the measurement pop-up selector at the bottom of the page.*

For the interior color of the rectangle, I chose the following RGB settings:

Red: 239
Green: 250
Blue: 250

This produced an extremely light sky blue, almost the type you would
see on a hot, hazy day at the beach. While it can be argued that a sky
viewed from a location like this on a day such as described would actually
have a slight aqua tinge to it, it is not a common occurrence for the general
population to see a sky this color. Almost all of us equate blue as the color
of the sky, and this is why I didn't go for a more "realistic" color.

We need to resize this rectangle to match the specs for the site window
itself. In the Information window, change the width to 800 pixels and the
height to 600 pixels.

Now it's time to work on the sun. If you locked this layer, unlock it
now. You might also want to lock the rectangle layer you were just work-
ing on.

Select and drag the sun element to the center of the rectangle. Select the
Scale tool and enlarge the sun so that it is approximately two-thirds the
height of the rectangle as shown in Figure 9.11. Remember to hold down
the Shift key as you resize the sun so that the proportions are constrained.

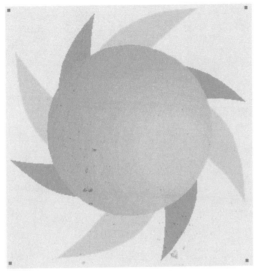

FIGURE *The sun has been resized and positioned*
9.11 *as it will appear on the Web pages.*

The colors of the sun are way too brilliant. They will overwhelm the page and make any text placed over them difficult to read. This sun image is not supposed to be the focus of the page; it's there to subliminally tie the entire site together and give continuity to it. I'm sure that you have visited Web sites that have a different look and different layout for each page. It's very disconcerting, because your first reaction is to look at the URL to see if you accidentally went to another site. People usually do this so they can show off some other nifty little design element—be it a look for the layout, a new effect, or simply because they didn't know any better.

What we need to do, then, is lighten the colors, creating a washed-out effect. The best way to do this for our purpose is to go to Xtras>Colors> Lighten Colors. Do this six times to soften the colors in the sun until it is almost invisible. The sun will now look like you see in Figure 9.12.

Finally, position the sun so its rightmost rays are almost at the right interior edge of the rectangle. Figure 9.13 shows the final position for this element.

The question could be raised as to why I didn't place the sun directly against the edge of the rectangle. I also considered placing it so that the center of the sun was aligned with the right edge of the rectangle and then masking off the outer half. The answer to both is the same. Consider your travels around the Internet. You've undoubtedly come across sites that use tiling images for the background. And what usually happens to those

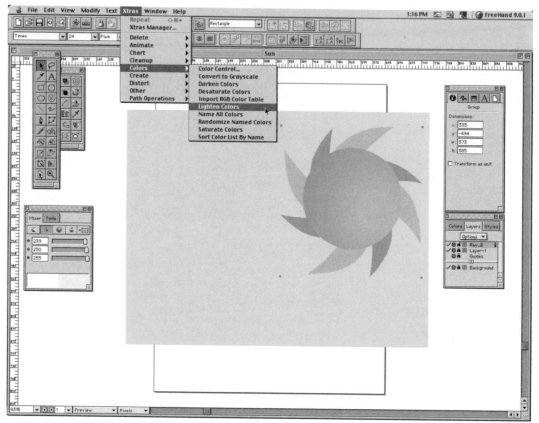

FIGURE *Using the Lighten Colors command under the Xtras pop-up, you can lessen the brilliance of an*
9.12 *element so it can be used as a background image.*

images? They repeat infinitely, often creating an unwanted pattern or a very unappealing tiled look. I understand that this can happen with the background image we're creating, so I did something to alleviate most of that problem.

I don't have to worry about scrolling up and down since we're going to design our site so that it isn't necessary for the visitor to do that. What I have to worry about are those visitors who have their monitors set to extremely high (1024 × 768 or higher) resolutions who extend their browser window to fill their monitors. If I positioned the sun in the center of the rectangle, it would tile unattractively across the horizontal plane. If I created an effect of the sun being at the edge of the standard 800-pixel width of the average monitor, then the tiling would be more noticeable as the sun abruptly ends and the blue begins again (Figure 9.14). Of the two

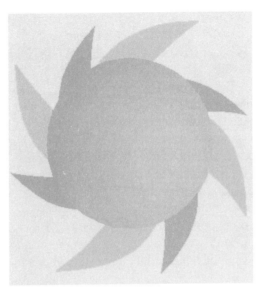

FIGURE *The sun is placed in its final position. For the purpose of this book, I used the*
9.13 *prelightened sun so it can be seen better in a black-and-white image.*

FIGURE *An unattractive look for the tiling background image where the sky abruptly*
9.14 *cuts into the sun image. No matter what I did to soften the impact of this, the*
background image would take precedence over the site content because of how
harsh the tiling is.

scenarios mentioned here, I prefer the first, because there would be some sense of preconceived motive to the tiling layout.

By placing the sun as I have on this image, though, I somewhat kill two birds with one stone. I create a seamless texture because the little bit of blue between the right edges of the rays and the rectangle will make a smooth transition in the tiling. Also, by placing the sun to the right of center, I can pretty well say that, unless someone is using a 21" monitor set at a high resolution, many of the visitors will see the blue going off to the right, but the tiled sun will more than likely not be seen. What I have done is give the image some "pad." I've created an area of repetition, while giving enough room so as, most of the time, not to reveal repetitive content. Figure 9.15 shows what I mean.

All that is left to do now is save the file as a 72dpi JPEG image. Name the file sunbkg.jpg and save it into a site-specific holding folder; in my case, I named the folder So66SiteElements. It's where I will store all my

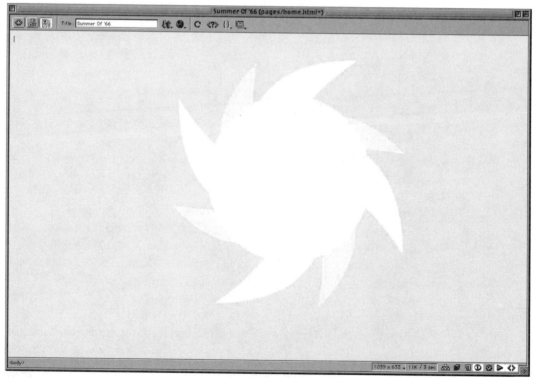

FIGURE *This image shows how "padding" your artwork can help alleviate tiling problems that would*
9.15 *threaten to become the focal point of the site.*

finished art. Then I can import the elements into Dreamweaver 4 with a minimum of fuss.

A Quick Diversion

Now would be a good time to discuss organization. I have the habit of organizing my work (be it site creation, print ads, logo designs, etc.) in three different ways. My first organizational priority is assigning a Zip 100 or 250 disk on which all the elements of the site will be stored. If I use the latter Zip media, it will also store the Dreamweaver site itself. I also use a small three-ring binder, and print out images and site pages so I can keep an easily accessible visual log of the site throughout its design process. The last thing I do is burn a CD-ROM for permanent storage of the site and elements. I am then able to erase the Zip cartridge and use it to temporarily store other projects.

You might be asking yourself why I didn't animate the sun, which can easily be done in Freehand. Animating this element could be pretty cool—the first or second time someone visits the site. It would give an extra "ooh-ahh" factor to the site. However, I don't want visitors to ooh and ahh over a specific element or effect; I want them to focus on the message while letting the visuals quietly amplify that message. To animate the sun would draw more attention to it rather than to the body copy. I also know that I will be creating a small rotating sun element in Flash to use at different points in the site that I want to highlight. The two rotating elements would fight each other when they appeared together on the same page, for one. Second, imagine how difficult it would be to synchronize the spins so that, after the smaller highlight sun loaded, the background sun and it spun in the same direction at the same speed. That would be extra work that ultimately is unnecessary—so that's why I didn't have the background sun rotating.

...Fun...

You have already created a few vector graphics, but now it's time to build up a library of them so that they're available if needed. These vector graphics will be very colorful and come in many fun shapes and sizes, and will be used for anything from simple decorative elements to highlighters that draw attention to an important element on the page.

Hopefully, Freehand is still open. If not, do so now.

What types of patterns were big in 1966? It was a transition time for clothing as well as for the entire country and the world. We in the United States were being influenced by what was happening in the United Kingdom because of the British Invasion, which began three years earlier with the appearance of The Beatles on the *Ed Sullivan Show*. They sang *I Want*

To Hold Your Hand to millions of teenage girls, starting the frenzy that has lasted for decades. Guys began wearing their hair in Beatles Cuts to impress women and hopefully make those girls swoon like John, Paul, George, and Ringo did. And over in that corner of the world, clothing styles were beginning to influence the way guys and gals dressed here. Skirts became shorter, colors bolder, and patterns were more defined. While it took a little while longer before these changes became the prevalent form of dress, they had enough of a foothold that even the more conservative clothing sported some form of bright patterns.

We're going to create the patterns that were printed on the clothes. Circles and interlocking rectangles in bright, primary colors were the rage. Geometric patterns such as the ones created earlier in the book were also popular. It was definitely a fun, glaringly original time for clothing and graphic designers.

This is a fairly simple process that we are doing here, without any gradations or effects, so there's really no big secret to this section. The tricky part is in designing elements that will, when added to the Web page(s), add to the feel of the timeframe. Figure 9.16 shows the first set of ele-

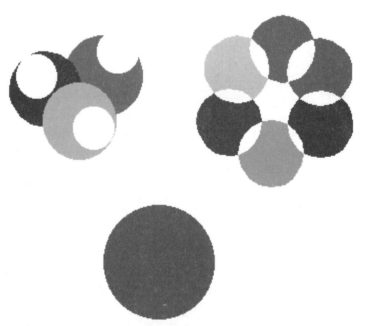

FIGURE *The first set of vector graphics that were created. The upper left*
9.16 *is called circlemadness.jpg, the upper right is cicleintheround.jpg, and the bottom is plain old circle.jpg. I saved that file as a four different files—circlegreen.jpg, circleyellow.jpg, circleblue.jpg, and circlered.jpg.*

FIGURE *The second set of vector graphics for the site. The upper left is called*
9.17 *cityscape.jpg, the upper right is stairstep.jpg, and the bottom is*
mixandmatch.jpg.

ments that were created. The design seen at the top left of this image incorporated resized white circles to create the cutouts. The top right design set used the Divide feature (Modify>Combine>Divide) to make the cutouts.

The second set of elements is a series of nonstylistic rectangles laid out in various patterns.

For the last of this vector graphic series, I have created three more images that incorporate more stylistic approaches to the rectangles, as shown in Figure 9.18.

Gradations were not included in the design process because it was not the way things were done during that time period. Even as tie-dye began to become popular, the process didn't create readily noticeable graduations from one color to the next; at the most, it was like what you see in Figure 9.19. If you look at Figure 9.20, you can see a fairly good recreation of the type of pattern that was applied to dresses in the mid-1960s. In effect, this is what we're recreating with these vector graphics.

FIGURE **9.18** *The third set of vector graphics for the site. The upper left is called stylescape.jpg, the second is called puzzlescape.jpg, and the bottom is called stylemix.jpg.*

FIGURE **9.19** *This recreation of a tie-dyed look shows how there is very little graduation between colors. What is there is because of the bleeding effect inherent to the material itself.*

FIGURE *A look at how bright colors and interesting patterns were incorporated into the*
9.20 *clothing styles of the mid-1960s. This image was created in the Poser Pro Pack*
from Curious Labs, which was discussed in Chapter 3.

...and Sand.

With the vector graphics created and saved as both JPEG and vector files, it's time to move to the beach. Here, we'll create the lower-third graphic that will be the final element used to tie the entire site together. We'll create a stylized beach that compliments the look of the sun and logo graphics, and matching elements. We will then take these latter elements into Fireworks (later in the chapter), and turn them into rollover buttons. We'll position the rollover buttons above the beach graphic so that, when a visitor clicks on the links, it will appear as if they are pushing into the sand.

Opening a new document in Freehand, the first thing to do is make a layer that will hold a sizing template. Since the Web site is going to be built

to be viewed at 800 pixels by 600 pixels, we know that the width of this template should be the first number—800 pixels. The question is, how tall should this graphic be? It has to be tall enough so we have enough space for it to be recognizable as a beach, but short enough that it doesn't cut into too much content space in the main area of the page. It also has to be tall enough that the text elements that will be included in the rollovers are easily read, and that the rollover effects themselves are effective.

Too many sites these days are using small fonts that are extremely hard to read on high-resolution monitors. Couple that with a somewhat misguided color sense, putting light blue text over a medium blue background for instance, and you have way too many sites that could cause visitors to have to visit their eye doctors. I don't know about you, but when I come upon a site that uses text sizes that equate to 3-point text on the printed page, I run as if a pit bull is nipping at my heels.

The use of smaller font sizes came about for two distinct reasons. First, it was the design du jour because it appeared hip and trendy. Second, it provided a way to put even more links and information on a page while taking up less space. I'm not so sure *trendy* is the term I would use any more in regard to this practice, and I sure don't believe it helped in making a site more responsive to its visitors' needs because now it takes longer just to find the desired link as visitors sift through all the other links.

Again, many of the initial visitors to this site are going to be above the median age of avid surfers. They're in their forties, fifties, and sixties, which means that keeping the site and its elements "unfashionably" larger is extremely important.

While it may seem that I've listed every reason to use a larger font size for the site, there is still one more reason: the stylized font family I'll be using will not lend itself to being reduced too drastically. I sure don't want the font to compress to the point that it becomes unintelligible. As you know, when you use thick fonts such as Brady Bunch (seen in Figure 9.21), drastic size reduction can often give the appearance of having the letters butt up against each other, causing it to become unreadable.

Here's a story Of a site 'Bout the '60s

FIGURE *The Brady Bunch font, an example of a very thick, stylized family (all puns*
9.21 *intended).*

With all that in mind, and considering the size of the sun image that will be in the background (which is built on a 600-pixel height ratio), the beach should take up no more than 100 pixels. After adding other graphic elements to the design, this will leave us with approximately 350 to 400 pixels in which to display the contents of each page. So, let's make the template rectangle 100 pixels high and 800 pixels wide.

Without deselecting the rectangle, duplicate it using the drop-down menu in the Layers window (Figure 9.22). Then lock this layer. Create a new layer and name it Bkg (or bkg, if you don't like to use capital letters). Paste the rectangle (Command/Ctrl + V) onto it. Then, using the same RGB settings as used for the background created earlier in the chapter, fill in this rectangle.

Just so you don't have to flip back to it, here are those settings again:

Red: 239
Green: 250
Blue: 255

Now create another new layer (making sure to lock the Bkg/bkg layer before doing so). Name this layer ocean.

Create a new rectangle that is 797 pixels wide and 50 pixels high. We'll give this a greenish-blue color.

Red: 59
Green: 174
Blue: 177

FIGURE *Use the Duplicate Layer command in the Layers*
9.22 *window drop-down menu to make a new layer that*
contains a copy of the sizing template.

Don't worry about positioning this element yet. That will happen after we create the next elements for the scene.

We now need to create another layer. Lock the Ocean layer (all layers should be locked at this point), and name the new one Beach (or beach). Your workspace should now look like Figure 9.23.

FIGURE
9.23
The sizing template rectangle (with the border), and it's filled-in copy as they should appear on your workspace. The Layers window shows the new Beach layer active and ready to be drawn on.

Using the Pen tool, and referring to Figure 9.24, draw an undulating beach. Make sure as you reach the edge of the template border to use the Shift key to create straight edges for the sides and bottom of the element.

When you are finished, fill the beach with a sandy color. I used the following RGB settings:

Red: 237
Green: 215
Blue: 156

FIGURE *The completed outline for the beach.*
9.24

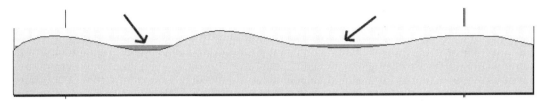

FIGURE *The Ocean layer, indicated by the arrows, is positioned so it is barely visible behind the lower*
9.25 *levels of the Beach layer.*

Select None for the border.

You can now unlock the Ocean layer for a moment, but lock the Beach layer so you don't accidentally move it. Now move the Ocean layer until it is barely peeking out from the lower areas of the beach, as shown in Figure 9.25. Once you have done this, re-lock the Ocean layer.

While I want a stylized look, I certainly don't want a flat appearance to the artwork. We need to add some shadows to give a semblance of dimensionality to this image. A pool of standing seawater will also be incorporated. Before starting this process, do what should be second nature to you now—create a new layer and lock the preceding layer.

With the Pen tool still selected, start at the top center of the beach graphic you just created and make a shape that follows the outline of the beach. Use the following RGB settings for the fill color:

Red: 225
Green: 177
Blue: 142

Select None for the border. Refer to Figure 9.26 to help you in create this first shadow shape.

Make at least one more shape like the previous one. Figure 9.27 shows the one I did, which gives the feel of an indentation in the sand.

Copy this last shape, and paste it onto the layer. Move it so it is over the copied shape. Double-click it so the border you see in Figure 9.28 appears. This border indicates that you can now resize the selection. Click on any of the four corners, and reduce the size of the shape so that it fits inside the original one. Fill this shape with the same color used for the ocean (R 59, G 174, B 177), and then position it as shown in Figure 9.29. You have now built what looks like standing sea water in a depression.

Since you have not made a copy of any other element since the last copy you made, go ahead and use the Paste command to lay down another version of the copied element. Double-click on this new element and change its shape by dragging down from the top center control point. Refer to Figure 9.30 to see how this newly transformed shape should look.

FIGURE *The first shadow shape in place and filled with a darker color.*
9.26

FIGURE *A second shape is added to the image. This one gives the feeling of an indentation in the sand.*
9.27

To make things easier from this point, hold down the Shift key and, with the element you just transformed still selected, select the shape that is closest to it so that both are selected. Copy these two elements. Then use the Reflect tool (shown in Figure 9.31) to flip these two elements on the horizontal plane. Position them as shown in Figure 9.32.

FIGURE *When you double-click on an element, this border appears around it,*
9.28 *indicating that you can resize the selection.*

FIGURE *The second element has been turned into standing sea water. I have modified*
9.29 *this image slightly so that you can see the water better.*

FIGURE *Resizing the element horizontally can give you an entirely new look.*
9.30

FIGURE *The Reflect tool.*
9.31

FIGURE
FIGURE *The copied elements flipped and repositioned on the beach.*
9.32

Basically, you're now finished. However, take a good close look at the scene. Notice anything? The edges are entirely too smooth. I want to create a little chaos along the edges. To do this, we'll need to use the Roughen tool. You access this by going to Window>Toolbars>Extra Tools. The Roughen tool, seen in Figure 9.33, is located in the lower-left corner.

Unlock the Beach layer and click once on it so it's selected. Then click on the Roughen tool. For the beach, I only want to give it a slightly roughened edge. The best way to do this is to move the cursor over the selection and click once. This creates a very slight roughening of the edges.

Lock the Beach layer again and, if necessary, unlock the Ocean layer. Using the Pointer tool, select this element and then reselect the Roughen tool. The ocean needs to be roughened more than the beach, so this time,

FIGURE *The Roughen tool is located in the Extra Tools window.*
9.33

FIGURE *By clicking and dragging on an element with the Roughen tool, you can create extremely chaotic*
9.34 *edges. Here you see my Ocean layer. The Beach and Shadows layers have been made invisible so*
you can see what this element looks like.

move the cursor into the selected area, and click and drag slightly until you
get the roughness that appeals to you most. Figure 9.34 shows how my
ocean looks.

Now you also have a good idea as to why we made the ocean element
thinner than 800 pixels. If we had given it the same width as the overall
image, the roughened element would jut out from the sides which would
1) be unacceptable, and 2) make our image wider than 800 pixels when
we save it. Depending on how much you roughened your ocean, though,
you might need to scale it down horizontally so it doesn't violate the edges
of your beach.

Before moving to the next project, there is one more thing we need to
do: take measurements for the buttons. Go to View>Page Rulers>Show if
the rulers aren't visible. Then switch the unit of measure to Inches (in that
nice little pop-up menu at the bottom left of the workspace window).

Move the Guides layer to the top of the list (Figure 9.35). You will also
want to position the 0 point to the upper-left corner of the image. Do this

FIGURE *The Guides layer has been*
9.35 *moved to the top of the list*
so no image elements will
block the guides from view.

by clicking on the small box in the upper-left corner of the workspace window and dragging the cursor down until it's on the corner of the image. Move your cursor into the horizontal ruler and drag down until the guide is just below the lowest shadow on the image as shown in Figure 9.36.

FIGURE *The first guide is in place, positioned immediately beneath the lowest shadow element.*
9.36

Move another measurement guide to the bottom of the image. This lets you know the maximum available space for the buttons. Of course, you don't want to have the buttons all the way to the bottom of the page. You want to leave some pad (open space) at the bottom if, for nothing else, esoteric reasons. It will look much better if the effect affects an area inside an image rather than all the way to the edge of that image.

A third guide, positioned so it is a half-inch beneath the topmost guide, lets us see that this would be the perfect size for the buttons, as you can see in Figure 9.37. What is my reasoning for this being the perfect height? If you focus between the two upper guides, there is a sense of balance to

FIGURE *The upper two horizontal guides show a comfortably positioned location on the image, as well as*
9.37 *a workable size for the height of the button.*

this location. There isn't too much space above or below to make it feel off
kilter. No, it's not perfectly centered on the image, but it's comfortably cen-
tered on the beach. This is the important part because the sky that makes
up the upper part of the image will be blending into the background. This
means that the button placement needs to fit comfortably inside the beach.
This also provides us with an area large enough to make the text readable.

The width of the buttons will be determined by the text placed inside,
but a good rule of thumb for a text button is to make it slightly wider than
high. In my case, I'll make the width of the button one inch. This gives me
room to comfortably place text and enough room to have the five buttons
fit inside the beach.

Now that the size for the buttons has been determined, save your file as
beachimage.jpg or something equally (or hopefully) more creative, and
close Freehand. It's time now to move into Fireworks to create the rollover
buttons that will be positioned over this image.

Digging In

Rollovers are pretty much universal elements in today's Internet presenta-
tions. If a button doesn't glow or rotate, there's almost an underlying sense
that something is missing. People will often use rollovers to make some-
thing appear that wasn't there before. I'm not talking about advanced (or
remote) rollovers, which, when activated, make an image or text block ap-
pear at another location on the page. I'm talking about creative types out
there who build an image, slice it into equal parts, and then modify some
of those slices to change when the cursor rolls over it. While cool, unless a
first-time visitor has some indication that a hidden rollover is present, it's
almost a waste of time. But when a nonreadily apparent rollover is discov-
ered on a page, it gives the site a gamelike feel; visitors will go from page
to page, rolling their cursor over every image to see if they can find more.
It turns the site into a virtual e-Easter egg hunt. In this case, though, the de-
signer has given himself more work because he should have at least one or
two of these types of elements on each page.

For the *Summer of '66* site, most of our rollovers are basic, run-of-the mill rollovers. As you know, they will be positioned inside the beach graphic, so we'll need to assign the same color as the sand in that graphic. As a reminder, this color is R 237, G 215, B 156.

There are two ways in which you can accomplish these rollovers. The first is as follows.

Rollover Design

In Fireworks 4, create a new document. Set the workspace size to the same size as we need, 100 pixels by 50 pixels. Choose Custom for the background color, and set the color to the sand color we assigned to the beach.

Go to Insert>New Button to open the button creation workspace shown in Figure 9.38. If need be, set the Canvas Size for this window to 100 pixels by 50 pixels.

FIGURE **9.38** *After selecting the New Button command, this related workspace appears. This is where you will do all of your work on the buttons.*

I don't want the buttons to have sharp corners. Again, there's no real reason for this other than the thought of sharp corners when a depression in the sand is made doesn't make sense to me. If you try to dig a block into sand in real life, there will be some roundness to the corners, and that's what I'll try to emulate with these buttons.

The first thing to do, then, is select the Rounded Rectangle tool. Draw the rectangle out on the workspace, go to the Info window, set the width and height to 100 × 50 pixels, and change the color using the Color Mixer to the sandy color that's being used. Refer to Figure 9.39 to see how this will look.

While we'll have text to differentiate these buttons from the beach image, I want to give it another slight difference: I want to add roughness to the image. To do this, open the Fill window and, in the Texture pop-up seen in Figure 9.40, choose Plaster. This gives the button a grainy look that works well for sand.

FIGURE **9.39** *The button has been sized and assigned the sandy color we're using. Here you can see the button on the workspace, and the Info and Color Mixer windows.*

FIGURE **9.40** *The Fill window and the Texture selections.*

Why, when the beach image itself uses a smooth fill, do I want to add a grainy appearance to the button? First, as mentioned previously, I want to give one more visual clue that the button is there. That clue will more than likely (you can never be 100-percent sure until you start receiving feedback) make people move their cursor over it to see if something happens. Second, I'm drawing from old cartoons like *Scooby Doo, Where Are You*. Whenever there was something in the background, like a secret door, that area always looked different from its surroundings. While not being as blatant about the difference as the old cartoons were, I wanted to use that idea to make the buttons stand out a little bit.

With the modified rectangle selected, copy it (Command/Ctrl + C). We'll paste that into the Over position when we move to that area.

It's time to add text. The first text element we'll add is Cast. Return to the Up layer. Click on the Text tool, and then click once over the rectangle on the workspace to bring up the Text input screen shown in Figure 9.41. Type in "Cast," and use the following settings (which appear in Figure 9.41):

FIGURE *The text and its settings for the first button.*
9.41

Font: Fontdinerdotcom Loungy
 Bold
 Centered
Size: 50
Horizontal Scale: 125

Let the color of this text remain black. There is a reason for this that will become readily apparent.

Duplicate the Cast layer, and assign the background (sand) color to the text. To do this with the button's texture applied at the same time, use the Eyedropper tool to copy the button's assigned color. Notice how the black underlayer bleeds out from the edges of the word *Cast*. This is what all the nonactivated buttons will look like.

Click the Over tab in the Button window. The button itself should be on the workspace. If not, paste it by using Command/Ctrl + V (since you already copied it).

Open the Effects window and, with the rectangle selected, go to the pop-up menu and select Bevel and Emboss>Inner Bevel.

On this screen, shown in Figure 9.42, set the bevel type to Smooth and keep it at 10 points. In the bottom-most pop-up, change the setting to Inset.

FIGURE *The indented button and the Bevel and Emboss controls.*
9.42

What's cool is that it already darkens the image, so you don't have to assign a new color to it. Although this color is darker than the one we used to make the shadowy areas on the beach artwork, it will suffice for the button.

To make things a bit easier, reselect Up and copy the first text layer (the black text). Go back to the Over layer and paste it into place. Go to the Effects window and assign a Gaussian Blur of 3 pixels to this layer.

Go back and copy the top text layer with the sand color assigned to it from the Up state. Go back to the Over state and paste it onto the workspace. To add to the sandlike feel, assign an inner bevel to this text and leave all the controls at the default settings. You can see what this looks like in Figure 9.43.

With this window still open, click once on the main document (which should be called untitled-1). Select Preview, and give your rollover a try. If you're happy with the results (as I am for this project), go ahead and save the file.

For the other buttons, repeat the previous steps, resizing the text to fit into the 100-pixel by 50-pixel rectangle.

It's time now to export it for use in Dreamweaver. There are two ways we can do this. The first is to create separate image files that can be used

FIGURE **9.43** *The upper layer text has been assigned an inner bevel effect to give it more of a sandy appearance.*

with the Rollover function in Dreamweaver (which I personally like because then I can assign the link very easily when I'm ready). The second is to save this rollover as an HTML document for insertion into Dreamweaver.

You can save the file as separate images in two ways. You can save each image (Up and Over) as image files stored in the images folder in your site's root folder, or as Library elements. You can do this either from the document itself or from the Button window.

Go to File>Export. From the Save As pop-up, choose Images only. For Slices, select None. Figure 9.44 shows the Export screen with these choices selected.

I'm working with the Cast button right now, so I'll call this one castup.gif. Since this isn't a photographic image, saving it as a GIF file will optimize the load time very nicely without losing too much quality.

Finally, in this screen, navigate to the Images folder in your site's root folder and save the file there. You can do this in the standard method you usually use to locate the area in which you want to store your files, or you can select Put Images In Subfolder at the bottom of the Export screen, and use the Browse button to tell Fireworks which folder to store the file in. Refer to Figure 9.44 again to locate this option.

FIGURE *The Export screen set up to export the image file as an image.*
9.44

Go back to the Button window, select the Over state, and repeat this process. Make sure to rename the file to castover.gif. I can't tell you how many times I've forgotten to change the name and written over an existing file. I don't know exactly what that says for me, but I'm also not sure I want to know.

Another note before moving on to the second way of exporting your file: Notice that I'm using all lowercase (castup, castover, etc.) text on these images. This is because many ISPs don't recognize uppercase letters in file-names, often rendering the files unreadable. You need to check with your ISP to see if uppercase letters are allowed.

The second way to save the file is to let Fireworks write the HTML code associated with the buttons. Later in the chapter, we'll discuss bringing this code into Dreamweaver. For now, though, let's look at how to use this feature.

Select the Up state in the Button window, and then select Export.

Choose HTML and Images from the Save As pop-up menu. Leave the HTML pop-up as is—it should read Export HTML File. This image doesn't have slices assigned to it, so select None from the Slices pop-up. Select Put Images In Subfolder, and browse to the Images folder in your site's root folder. Simply name this file Cast.htm. Figure 9.45 shows the Export screen in this configuration.

Repeat this process for the Over state.

There's still one more way to save your file: create a Library element that will be stored in the Dreamweaver's Library folder. With the Up state se-lected, choose Export and, in the Save As pop-up, choose Dreamweaver lib. You will be asked to assign a library folder in which to store the files, and a navigation screen like the one shown in Figure 9.46 will appear so you can select the appropriate one.

The window you see in this section of the book is the Mac screen. There isn't much difference between this and its Windows counterpart.

You can use the existing Library folder you see in Figure 9.46, or you can create a new folder—it's up to you. For now, select the existing Library folder by clicking on it once and clicking the Choose button. You will be taken back to the Fireworks Export screen.

In this screen, select None for Slices, and Put Images In Subfolder. If you decide to go with the default folder selection, a new Images folder will be created in the Library folder and your image will be stored there. You can also click the Browse button and navigate to the main Images folder to store the files in it.

FIGURE *The Export screen set to save the button as HTML and Images.*
9.45

FIGURE *The Choose a Folder screen, asking you to save your Dreamweaver Library file*
9.46 *to the Library folder.*

The "What Page I'm On" Image

You probably noticed that I didn't do anything to assign links for the rollovers—that was done very purposefully. One of the great things about Fireworks 4 and Dreamweaver 4 is the way the two programs talk to each other. We'll be able to import the buttons, create the necessary pages, assign names to those pages, and then go back and assign the links to the Fireworks files without leaving Dreamweaver. I'll explain that when we get to the Dreamweaver section of this chapter.

I'm sure you also remember that I said I would be creating special images that will remind people of what page they are on (as if the text won't be enough . . . which, for many people, it won't be). I want to use the Down state image for this. By using this state, I'm able to keep the continuity and provide a definite visual cue as to which page the visitor is on.

Saving this particular image is a pretty uncomplicated procedure. Merely select the Over state in the Button Editor. Export the image with the following criteria assigned:

Save As: Image Only
Slices: None

Notice that when you assign these parameters, the other selectors become grayed out as shown in Figure 9.47. Since you're just saving the file as an image, Fireworks doesn't have to do anything else.

FIGURE **9.47** *When saving as Image Only and with Slices set to None, all other selections are grayed out on the Export screen.*

Navigate to the Images folder in the site's root folder, and save the file as castlocator.gif.

Content in a Flash

This section of the chapter focuses on the various Flash elements that will be used throughout the site. Most will be recurring files, and many will be created using the third-party software applications that were discussed in Chapter 3. Most notably will be the newest version of Poser, Poser 4.2, also known as the Poser Pro Pack. More on that in a few moments.

First, let's look at the basic design for the site again in Figure 9.48 to refresh ourselves on the overall site design. There is going to be a recurring element that sits in the upper-left corner of each Web page. This file will be in the small square area that you see. This portion of the page has no other purpose than to be decorative and, hopefully, fun. The basic idea for this area is to have the *Summer of '66* initials (So66) flying into place, as the sun rises into place. The initials will lock into place in front of the sun. Each time a new page loads, the animation will play again, but it will not loop. If it did, it would become extremely monotonous and have the op-

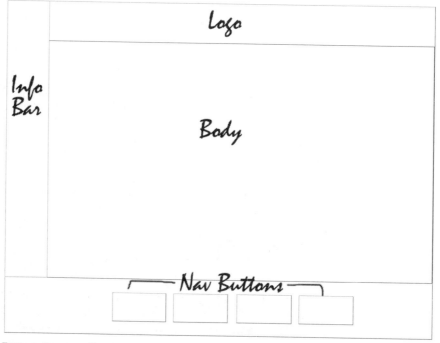

FIGURE *Continually reviewing your site design will help keep you focused as you create*
9.48 *your site elements.*

posite effect of what I want, which is to catch people's attention but not to fight the rest of the site. To create this file, we'll use Swift 3D and Flash.

We'll also build two animations within the Poser Pro Pack that will 1) show a couple dancing, and 2) show a Poser character holding a sign that has a message written on it. The former will appear on the audio download page, and the latter will be used in the lower-right corner of the page, positioned as if standing on the beach (although the character will be somewhat out of proportion to the size of the beach).

The Upper-Left Animation

The upper-left quadrant of the screen, basically that area where the vertical and horizontal layers meet, will be a small, nonlooping animation. The actual dimensions of the file for this area is 100 pixels by100 pixels—not very large, but it doesn't have to be. Any smaller, and it wouldn't have much of an effect on the site's visitors; any larger, and it would overpower the site.

Again, what is going to happen is we will watch the sun rise from the lower right-hand corner—ah yes, we're using that multifunctional sun file again. Once the sun is centered on the screen, the three-dimensional So66 initials will come in and lock into place. This entire sequence should not last more than five seconds.

 Both the Swift 3D file and the final SWF animation are in the Ch09 folder on the CD-ROM.

Moving into Swift 3D, type an uppercase "S," lowercase "o," and two "6"s in the input area. Make sure to use one of the appropriate font families for this, preferably the Fontdinerdotcom Loungy font.

Using the techniques you learned in Chapter 3, rotate the text so it is facing away from you as shown in Figure 9.49.

Next, scale the text down dramatically so it looks like what you see in Figure 9.50.

We will be saving this at the optimum frame rate for Shockwave animations—12 frames per second. I want the text to come in and lock into place over a three-second (:03) period, so click on Frame 36 and get ready to reposition the text to its final position.

Rotate the text so it is facing forward, and then resize it to its original size.

After repositioning and scaling the text back to its approximate original size, select Frame 18. Move the text to the left (as you're facing the screen) until it is almost against the right edge of the window as shown in Figure 9.51.

FIGURE
9.49 *The text should start facing away from you.*

With that finished, go ahead and preview the animation by clicking on the VCR-like controls immediately beneath the timeline. Something strange has happened, as you can see in Figure 9.52. The text has flown forward, but it isn't in the correct location on the workspace. Time to fix that.

Click on Frame 18 in the timeline (the midway point of the animation). Position the text screen left as shown in Figure 9.52.

Now go to Frame 36. Move the text to the right until it is centered on the workspace. Once this is finished, preview the animation again and you'll see that the text now moves toward screen left, turns, and then locks itself into position correctly. It looks as if the text is flying out in a semicircular path from behind something—which it will be doing once we move into Flash.

We may need to make some other slight modifications so that the animation works correctly. Just move the Timeline indicator back and forth to

FIGURE *The second part of the setting up the starting point for the text animation is to reduce the size of*
9.50 *the text.*

make sure everything lines up as it should, especially when the letters are
close to the left edge, and move the text slightly to the right if needed.

The last thing to do before rendering this file is to assign colors to the
text. In the colors panel, choose the Glossy tab, and drag Orange/Yellow
onto the front face, the bevel, and the edges of the text.

Make sure the fps input next to the VCR-like controls under the timeline
is set at 12 as shown in Figure 9.53, and export this animation as an SWF
file and save it to your file folder. Then get ready to piece the elements to-
gether in Flash—which we will do shortly. First, though, we need to build
some other files.

Next, we'll move on to Poser and build the male model animation. This
guy is going to act as a virtual advertisement for the upcoming *Summer of
'66* online store that we'll add to the site shortly after the main site goes
online.

FIGURE **9.51** *The text repositioned as it should appear midway through the animation.*

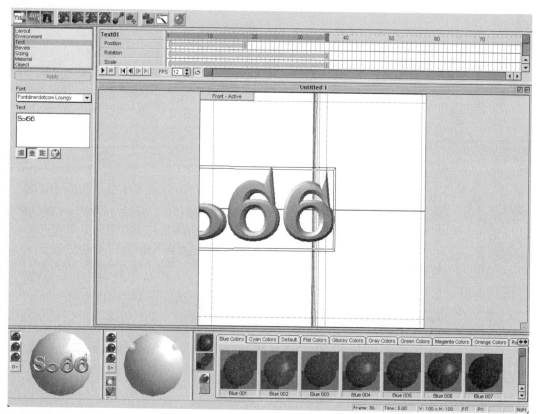

FIGURE **9.52** *After resizing the text and playing the animation, you'll see that the end position of the text isn't right.*

FIGURE *Make sure that 12 is typed into the frame rate field immediately to the right of the playback*
9.53 *controls.*

Store Preview Animation

In the lower-right corner of the screen, positioned just above the sand, will be a guy standing in place. He will be wearing a T-shirt that says "Coming Soon: The Summer of '66 Online Store." The online store will offer such items as a *Summer of '66* T-shirt, polo shirt, and turtleneck, as well as a CD of the original cast recording, posters, and more.

The reason this area of the site will not be available immediately is because we are still in the process of determining if it would be better for us to set up a secure server and do all of the fulfillment work ourselves, or use existing online sites specializing in providing this service to sites like this. We have to determine whether the cost to use a second-party site will be advantageous in the long run, as well as if we can make the page appear like the rest of the site so it gives the impression that the visitor hasn't been transported to some other location. Also, some second-party sites want to limit the initial units of each item until they know they are going to sell, so they don't use up their storage space with unneeded inventory (if they are the type of company that also handles the actual order fulfillment). Others will send a report of sales on a daily basis and expect the client (in this case, us) to take care of the shipping. These are extremely important considerations to the client, so we are taking our time in order to get the right match for his needs.

Returning to the project at hand—the animation will be a 150-pixel by 200-pixel file and will appear only on the homepage. It will be merged with text that mirrors the message on the T-shirt, which won't be extremely readable at this size. The logo will be recognizable, though, which is what I want for this.

ON THE CD *The texture file for the T-shirt is in the Chapter 9 folder on the CD-ROM. There is also a bump map file, although we won't need it for the Flash animation.*

This is going to be a subtle animation. He will tap his foot, once in a while motion to his shirt, and that's about it. However, it will be very dif-

ferent because this is a full-fledged humanoid Flash animation, something that has been extremely difficult to produce up until now.

 This is not a beginner's guide to working with Poser. Knowledge of how to find and load models onto the workspace is needed for this section. If you are unclear on how to do this, please refer to the Poser User Manual that comes with the program, or refer to The Poser 4 Handbook by R. Shamms Mortier, published by Charles River Media.

Upon starting Poser, load the P4 Nude Man model. Tacky as it may sound, since the Poser models are anatomically correct, if the genitalia is visible on this model, go to Figure>Genitalia and turn it off.

Now go to Clothing-Male, click once on Men's T, and click the Create New Figure button (with the double check mark) at the bottom of the model shelf. When the T-shirt is loaded, go to Figure>Conform To... and select Figure 1 from the pop-up menu in the window that appears.

Repeat this process, selecting Men's Slacks, and the Sandal Men's Left and Sandal Men's Right shoes. Always conform these model elements to Figure 1.

Next, add some hair. The Jesse Ventura bald look was not in style at that time. Use the Male Hair 5 model for this. In this case, merely double-click on the Male Hair 5 icon in the model shelf to place it on the man. Your "male model" should now appear as shown in Figure 9.54.

Now it's time to change some of the colors of the clothing and hair, as well as add the T-shirt texture. We definitely want to change the color of the guy's slacks and his dock shoes, since these items, while stylish in this location at that time, did not come in those colors.

Go to Render>Materials to bring up the Materials screen shown in Figure 9.55.

Select Figure 2, which should be the pants, from the Object pop-up menu. If you don't see "pants" listed in the Material pop-up, select a different figure until you find the right one. Another thing you could do is close the Surface Material screen by clicking Cancel, select the pants on the workspace, and see which figure it is listed as at the bottom-left corner of the workspace.

In the mid-1960s at the beach, khakis were the *cat's meow*. (Yes, I know that's a term from a different era/generation, but I have wanted to use it in the whole book and finally found a reason to do so.) Click once on either the Object Color swatch or the Object Color button on the Surface Material window to bring up the color selector screen. Choose a light-tan color.

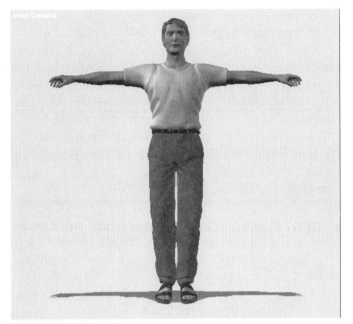

FIGURE *The male model is ready to have textures added to him.*
9.54

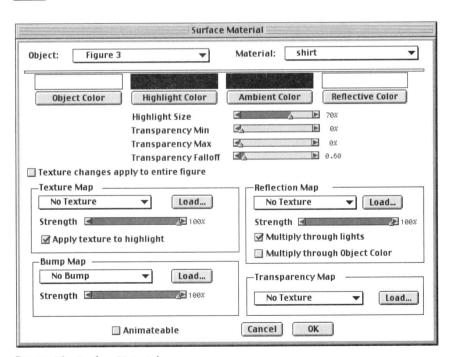

FIGURE *The Surface Materials screen.*
9.55

Now to the T-shirt. Instead of changing the color, we'll add the image map that was supplied on the CD-ROM (So66tshirt.jpg). Select Figure 3 for the Object. First, click Texture changes apply to entire figure. In the Texture Map area, click the Load button. Navigate to the T-shirt image file, and select it. Figure 9.56 shows the file selected in the Texture map area of the Surface Material window. Figure 9.57 shows a preview rendering of our male model.

Now it's time to set the keyframes for the animation. Again, this will be a 12fps animation (it's being saved as an .swf file, you'll recall). I want it to run for five seconds before looping. That means we need to have 60 frames assigned ($5 \times 12 = 60$).

Open the Animation Controls at the bottom of the screen. Click once on the second number field at the center of this screen (highlighted in Figure 9.58) to bring up the text field, and change the number of frames to 60.

For the starting frame, we're going to make it appear as if our guy has his hands in his pockets. It's impossible to actually put his hands in his pockets, because the pockets of the pants are merely "folds" in the mesh and aren't modifiable per se. Therefore, we have to create the illusion of

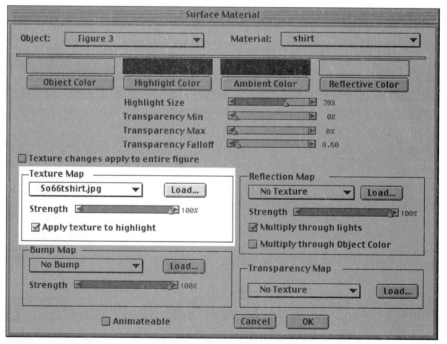

FIGURE *The So66 T-shirt image is assigned to the T-shirt model via the Texture Map*
9.56 *area of the Surface Material window.*

FIGURE *After assigning all textures and colors, the model should look similar to this.*
9.57

FIGURE *Change the numerical value in this input field to change the number of frames in an animation.*
9.58

this. We'll work with the right arm (which is the one on the left as you look at the workspace). Change the parameters to the following, while always making sure that Figure 1 shows in the leftmost pop-up at the bottom left of the workspace:

 Right Collar
 Twist: 0
 Bend: 23
 Front-Back: −4
 Right Shoulder
 Twist: 5
 Front-Back: −22
 Bend: 46

Right Forearm
 Twist: 0
 Side-Side: 34
 Bend: 69

Right Hand
 Twist: 0
 Side-Side: 0
 Bend: 12

We also need to change the position of his foot. Again, we'll use the right foot to make these changes.

Twist: 0
Side-Side: –24
Bend: 0

Now, here is why we only worked on one side. We can mirror the parameters we just set, making the left side mirror the right side, by going to Figure>Symmetry and selecting Right to Left from the sub-pop-up selections.

Unfortunately, the left side of the T-shirt didn't change with the body. Click on any part of the T-shirt model or select Figure 2 from the pop-up at the lower left of the workspace. Repeat the preceding step and your model should now look like Figure 9.59.

FIGURE *The Poser guy is in his starting pose.*
9.59

Move the Timeline Indicator to Frame 60. Click the Add Keyframes button (the one that looks like a plus symbol) on the right side of the Animation panel to set a keyframe. By doing this, we're guaranteed that the animation will start and end on the same pose and we won't get a hitch or jerk as the animation loops.

Go to Frame 12 and make the following changes to the right arm:

Right Shoulder
 Front-Back: –43
 Bend: 50
Right Forearm
 Side-Side: 15
 Bend 53

Add a keyframe.
Go to Frame 16 and make the following changes:

Right Forearm
 Twist: –27
 Side-side: –6
 Bend: 63

Go to Frame 24 and make the following changes:

Right Shoulder
 Twist: 5
 Front-Back: 10
 Bend: 49
Right Forearm
 Twist: –37
 Side-Side: 37
 Bend: 61

Right Hand
 Side-Side: 7
 Bend: 41
Head
 Smile: .684
 Twist: 15
 Bend: 7

Add a keyframe.
Now move the Timeline control forward and make minor corrections at the points where the model, as it returns to its hand-in-the-pocket state, violates the body mesh. I could go through every setting, but that would

only take up too much time. The modification process shouldn't take more than a few minutes from this point, anyway.

The other thing to do is get the foot tapping. We'll use the left foot for this motion. At every other half-second point (six frames), move the foot up by changing the Bend to − 12, at the other half-second points move the foot back to 0.

There are only two more things to do. First, go to Display>Ground Shadows to deselect this feature, and then go back to Display>Background color… and change the background color to the same as the sky color for the site.

Time to render.

Go the Animation>Animation Set-up. Change the frame size to 150 by 200 pixels. Make the Frame Rate 12. Refer to Figure 9.60.

Now go to Animation>Make Movie to bring up the Movie setup screen shown in Figure 9.61. In the Name field, call the file Shirt (Shirt.swf). Make the Sequence Type Flash Animation (.swf). Leave the other fields as they are, but click the Flash Settings button at the lower left of this window.

In the Flash Export window shown in Figure 9.62, change Number of colors to 16 and deselect Draw outer lines.

Click OK on this screen, and then click OK on the Make Movie screen. Save the file to the same folder as all the other site files, and let Poser do its thing.

FIGURE *Poser's Animation Output Settings screen and the appropriate numbers*
9.60 *plugged in.*

Movie: Shirt

Frame Rate:
◉ Use Movie's frame rate (12)
○ Use this frame rate: 12

Sequence Type: Flash Animation (.swf) ▼

Resolution: Full ▼
Size: 150 x 200

Quality: Current Display Settings ▼

Time Span:
Start: 0 : 0 : 0 : 0
End: 0 : 0 : 4 : 11
Duration: 0:00:05:00
Frames: 60

[Flash Settings] [Render Settings] [Cancel] [OK]

FIGURE *The Movie setup screen with the appropriate settings.*
9.61

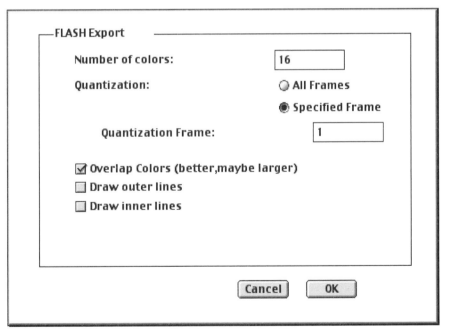

FLASH Export

Number of colors: 16

Quantization: ○ All Frames

 ◉ Specified Frame

 Quantization Frame: 1

☑ Overlap Colors (better,maybe larger)
☐ Draw outer lines
☐ Draw inner lines

[Cancel] [OK]

FIGURE *How the Flash Export window should look after making your changes.*
9.62

The Second Poser Animation

The second Poser animation that I want to produce is a group of three people doing the dance, The Monkey. I chose this dance because it's easy to build, meaning it's also quick. While I won't go into as much detail regarding the posing of the characters, I'll give you some idea of how you can use one character and save the animation sequence for use on other characters in the scene.

Since we're using the Poser Pro Pack, I figured I might as well use some of the lower-resolution models that come with the update. Using a lower-resolution character or prop for Flash animations is not detrimental to the final rendering; in fact, in the case of this type of animation it can actually make the final output better. This is because there isn't as much detail that has to be recreated as there is in a figure like the one just used.

Figure 9.63 shows four screens from the dance sequence created in Poser. It shows the main character, named Ginger, in the various poses that make up the dance. This is a one-second animation—12 frames—so the dance is fairly quick. The image size is 250 pixels by 250 pixels. It's also set up for looping.

FIGURE *Do The Monkey with me!*
9.63

Once the positions for the model are set, you can save this file in the Pose area of the model shelf. When saved, it can be selected for use on other models. In other words, you are creating a bvh file, which is a standard motion file in the 3D industry. To save this file, open the Poses folder in the model shelf (shown in Figure 9.64).

From the pop-up menu, select Add New Category (Figure 9.65). In the resultant screen seen in Figure 9.66, type in a name such as "Original Animations" in the New library name: field. After clicking the OK button, the newly created library will be accessible via the Poses pop-up menu (Figure 9.67).

Select the Original Animations library and click the plus symbol at the bottom of the model shelf to save your animation. Give it a name, assign it as a multiple-frame animation when prompted, and then watch it magically appear in the library (Figure 9.68). Now this animation, with the correct positioning of the body elements, can be assigned to any characters you place on the workspace.

FIGURE **9.64** *The Poses area of the model shelf.*

FIGURE **9.65** *Add a new category by highlighting this selection in the Poses shelf.*

New library name: Original Animations

Cancel OK

FIGURE *In this window, you assign a name to the new library.*
9.66

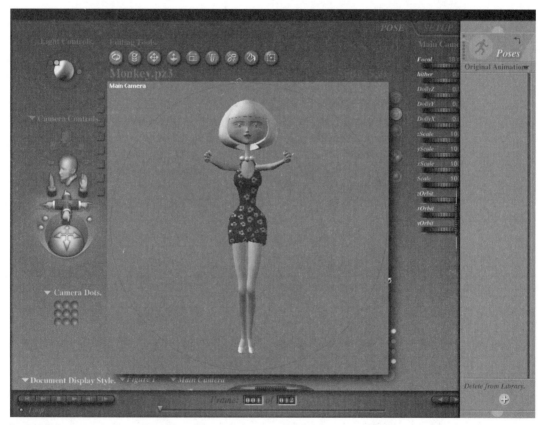

FIGURE *The newly created library is accessible from the pop-up menu.*
9.67

As you can see in the Monkey.swf file located in the Chapter 9 folder on the CD-ROM, I added two more figures to the scene and assigned this saved animation to them, thus creating a group dance sequence. This sequence will be used on the Audio page of the site, and will not need any modifications assigned in Flash.

FIGURE *The saved animation*
9.68 *appears in the library*
folder of the Poses shelf.

The Shockwave files have been created now, so that's enough about Poser. If you want to delve deeper into what Poser can do, pick up *The Poser 4 Handbook* by Shamms Mortier, also published by Charles River Media. Time now to bring the needed files into Flash so we can create the final output for the site.

Going Wild(form)

The very last preproduction element we need is some text to go along with the previously produced Shirt.swf animation. What we will build are two very simple files using Wildform SWFx: Coming Soon, and Online Store. For this section, I'll focus on Coming Soon; Online Store will use all the same settings.

The first thing to do upon starting up SWFx is to set the dimensions. For these animations, I want a 200-pixel by 70-pixel ratio. Set this in the Movie section of the workspace (shown in Figure 9.69).

FIGURE *The dimensions for the files are set in the Movie section of the workspace.*
9.69

You also need to make sure that the fps (frames per second) is set to 12.

I don't want to use a stylized font for this because it would actually be too much when combined with the animation of each letter. In my case, I chose a typeface called Impact, which is a very thick, easily readable font family. I also set the Size to 28 point. These settings are made in the Font window (Figure 9.70) that appears when you click on the font in the Font section of the workspace.

In the Text Entry box, type "Coming Soon!" (with the exclamation point).

Change the color of the font to a bright red by clicking on the color selector in the Font area of the workspace. Red, as you know, is an international color that makes a person automatically look at it. While it means danger, it also means "stop and be aware of this." That has been drilled into us since birth and is why emergency vehicles use the color for their lights.

A great effect to use for this animation is Dot Dorjay. Don't ask me what it means; I really couldn't tell you. It looks like a starburst that draws out

FIGURE *Selecting a font via the Font style and size using the Font window.*
9.70

the text on the screen and fits well with that whole sun-and-sand theme we have going. Merely select it from the list by clicking on it once. If you don't have Auto Preview selected, click the Preview button in the SWF section of the screen to see how this effect looks.

Make sure that loop output is deselected, and save this file by clicking the Save As button. Name the file comingsoon.swf, and in the Save as Type field in the Save As screen, make sure Macromedia Flash Player 4.0 (swf) is selected as shown in Figure 9.71.

For Online Store, I used the Rainbow effect, which changes the color of each letter as it appears on the screen, ultimately locking into the final color assigned to the text. This is a good effect to use because it won't fight the Dot Dorjay effect assigned to the "Coming Soon!" text. Save this file as onlinestore.swf.

And that does it for the preproduction files. It's time to move into Flash and put them all together.

Finalizing the SWF Files in Flash

With the SWF files built and saved, we now need to finalize the animations in Flash. The first one we will work on is the melding of the So66 initials we made in Swift 3D and the sun.

The Upper-Left Animation

Open a new document in Flash and resize the workspace to the size apportioned for the corner art: 100 pixels by 100 pixels.

If you don't want to go back to Freehand to turn the Sun file into an SWF file, use the one that is located in the Chapter 9 folder on the CD-ROM. When imported into Flash, these two SWFs will automatically be assigned transparencies, so all the white areas will be clear.

Lock the first layer in Flash, and then create a new layer. Name this one Sun. Go to File>Import and import the Sun.swf file. Select all the elements (Command/Ctrl + A) and group them (Command/Ctl + G). Then resize the sun image so it fits into the workspace as shown in Figure 9.71.

Next, create another layer and call this one So66 Lower. Import the so66corner.swf file you either just created or loaded from the Chapter 9 folder on the CD-ROM. It will automatically be positioned on the workspace.

Delete the first frame of the animation, which is a placeholder that is automatically added to the Swift 3D file.

Now create another new layer. Name this one So66 Upper. Select all the frames from Frame 18 to Frame 37 of the So66 Lower layer as shown in Figure 9.72.

Move these frames to their corresponding frames on the So66 Upper layer as shown in Figure 9.73. You could also copy and paste these frames

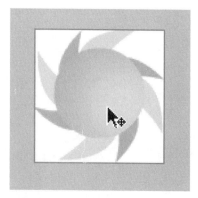

FIGURE *The sun has been grouped, resized,*
9.71 *and positioned in the workspace.*

FIGURE *Frames 18 to 37 are selected and ready to be moved.*
9.72

on the second layer, or duplicate the So66 Lower layer and then delete the appropriate sets of frames from each of them (18–37 for the Lower layer, 1–17 for the Upper layer). Then move the Sun layer between the Lower and Upper layers as shown in Figure 9.74.

What we are doing is creating the effect that the text is moving from behind the sun to in front of it. Go ahead and check it out by previewing it to see how it looks so far. Remember to extend the frames for the Sun layer so it matches the number of frames in the overall animation.

Because we are going to be making the sun rise into the scene, we have to reposition the so66corner animation. If we don't, the text will pop into full view, thereby ruining the effect that we're building. Move the So66

FIGURE **9.73** *The selected frames have been moved to the new layer.*

FIGURE **9.74** *Position the Sun layer between the two So66 layers.*

Lower frames so the animation begins at Frame 14. Then move the So66 Upper frames so they start at Frame 31.

To make the sun rise into the frame, select Frame 1 and drag the sun to the lower right-hand corner so its centerpoint is aligned with that corner.

Create a motion Tween between Frames 10 and 21. Your timeline will look like Figure 9.75.

Select Frame 20 and move the sun into position at the center of the workspace. If you need to line up the sun with the rest of the frames (which you probably have to do), copy Frame 21. Create a new layer and paste the copied frame at Frame 20. Use this copied frame as a visual guide for the final position of the sun in the Sun layer. Delete this new layer when you're finished.

FIGURE **9.75** *A motion Tween has been created between Frames 10 and 20.*

There is one more thing to add: the sky color. The easiest way to do this is to select Layer 1 and draw a rectangle that fills the entire work area. Assign the light-blue color to it. Now, play your movie so you can see how it looks.

The last thing to do, as if you didn't already know, is to export this as an SWF file. I've named this corneranimation.swf, and it's available in the Chapter 9 folder on the CD-ROM.

BUILDING THE SITE

Well, the time has finally arrived. I think the previous examples give you a very good idea of how the preproduction process plays a big part in the overall construction of your sites. Now it's time to actually use these (and other files) to put your site together.

DELVING INTO DREAMWEAVER

Let's go over a few things that need to be decided before we actually design a Web page. This is basically the last thing to do before actually opening Dreamweaver and building the site, because it will determine how you set everything up.

First, we need to decide if the site will contain Cascading Style Sheets (CSS) information. CSS have both pros and cons associated with them, and in my humble estimation, the cons outweigh the pros, even though there are more pros when you build a comparison list. I'll explain why as we delve into this area.

The Pros

Cascading Style Sheets (or Style Sheets for short) allow you to assign properties to various elements on a Web page by adding additional HTML coding to the pages. Because of this, once the CSS parameters are set, a lot of time can be saved since you don't have to reproduce settings for repetitive elements on your pages. These elements include special text headers, text blocks, links, and more. When you assign Style Sheet parameters to these elements, every other page that contains them can be linked to the style sheet and the additional HTML code writing is done for you.

Another plus is that style sheets act as a one-stop modification shop (sort of like a lean, mean code-modifying machine) that acts on a global level. If, for example, you wanted to change the parameters assigned to a header like you see in Figure 9.76, all you would have to do is change it once in the style sheet. All pages linked to that style sheet would then reflect the change. To be more specific, the header in Figure 9.76 is set to

FIGURE *An example of text set to act as a headline to a page.*
9.76

Size 6, Bold, and has been assigned a dark-green color. I want to change that to Size 7, Bold, Italic, and red. This header is seen on six pages of a Web site. Without a style sheet, I would have to reassign those settings to each page. With a style sheet, however, I make the change on the master style sheet file and, voilà!, the change is automatically reflected on all pages linked to it.

While this sounds like the easiest, most time-efficient method of page production, there is more to it. (Doesn't it seem there always is?) Style sheets come in three flavors described next:

 The following assumes you have some experience with HTML coding. If you are unsure of what is being discussed here, refer to the book Web Design and Development *by Kelly Valqui and Eunice Freire available from Charles River Media.*

- ***Internal****. These are style sheets that are contained within the Head item (inside the <Head> </Head> containers) of a Web page. They affect only the page on which they reside, and not numerous pages throughout a site. If you have a page with many text elements and need to have quick control over those various parameters assigned to them, this is the type of style sheet that you should use.*
- ***External****. This is the one to use to give all the pages on your site a common appearance. Basically, you link each page to one common file that is stored externally (or not in the Head section of the page). External style sheets have a .css extension at the end of the file, which is usually written as a separate document. The link to this type of style sheet appears inside the Head element of the pages between the <Link> </Link> commands.*
- ***Local****. This type of style sheet affects a specific item on a page, such as a word in a block of text that needs to be highlighted or italicized. A <Style> </Style> command would be positioned on either side of the element to be affected. Of the three style sheet types, this is the one that should be used least because, in the long run, it makes things a bit more difficult. Why? Because this type of style sheet affects only the element to which it is assigned, whether a word or text block for example, and fits only between the <P> </P> (paragraph) tags. Each word or text block (continuing with this example) would have to be assigned a separate setting, even if it were the same as a previous setting. When modifying this type of style, you would need to change every instance of it on the page, not just a universal setting.*

The Cons

As you can see, Cascading Style Sheets can really make your design and modification life a lot easier. So, what negatives could there be to these?

CSS technology is anything but universal; it isn't recognized in the same way in every browser. This means you could spend hours setting up Internal and External style sheets that make your site look outstanding, only to find out that these styles are not reproduced correctly from browser to browser. When I'm talking about browsers, I'm talking about Netscape Navigator/Communicator, Internet Explorer, the proprietary AOL browser, and WebTV's proprietary browser. To me, this is a gigantic negative to the technology.

Hopefully, in the near future, this compatibility issue will be resolved, but I'm not holding my breath as of yet. CSS standards weren't around before 1996 until the release of what is known as CSS1. CSS2, which is the standard now used, was finalized in 1998. CSS3 is in the works at the time of this writing. If you're interested in keeping up with what is happening in the CSS world, you can visit www.w3c.org for the latest information.

While you can find out which browsers support which CSS functions by visiting www.webstandards.com, you're still faced with many older browsers that do not support everything you want to do. Therefore, the headaches surrounding CSS production outweigh the positives to using it.

I also want to point out that the CSS issue is not a platform issue; in other words, it has nothing to do with whether you're using a Mac, a PC running any version of Windows or Windows NT, an Amiga, or whatever other machine might happen to be out there. This issue revolves around the way specific browsers recognize the code that makes up a CSS file, and it won't be solved until that code is standardized and implemented the same way on every browser.

One CSS Workaround

There's a nice, simple way around this: create a master page that only contains the blocks or layers that will not change from one page to the next. Assign the styles to the elements in these blocks, and then do a Save As, naming each of these pages as they will be for the site. This way, the elements are in place on each page and all you need to do is fill in the blank spots with whatever differing content should be included. Yes, it's the poor person's way of doing this, but it definitely solves the browser compatibility problem. Moreover, it doesn't take any more time to do it this way than to build the style sheets and assign them to different pages or elements on a page.

As I'm sure you have guessed by now, I won't be implementing CSS onto this site. There will be a master page from which all design work will be done for each page of the site. There will not be tags assigned that will be globally located, either in an Internal or External style sheet.

A Good Story Is Hard to Resist

When I create a Web site, and when I talk with my clients about their Web sites, I always tell them that what I am trying to do with their site is tell a story. I'm writing a book, if you will, or a lengthy magazine article. That book might well be likened to a coffee table style book, with content that flows smoothly from one idea to the next with pictures that help illuminate the story.

This especially appealed to Jim Owens, the creator and owner of the *Summer of '66* stage show. In fact, the show tells the true story of that year in his life as he produced and managed the rock group, The Villagers. Everything that has been created up to now, and every image that has been chosen (but not necessarily discussed in this book) were all selected to help bring this story to life.

While the book analogy may seem like a perfect match for this site, the idea of thinking of a Web site as if it were a book can be used on any site you create. You have a beginning: the Table of Contents (Home Page) and the first couple of chapters that introduce the characters to the audience (Backgrounder page or pages). Then you have the story: the product the company/client is selling. This can be anything from actual products for sale or a virtual art gallery showing the work the subject has created. Then you have the denouement: the way to contact the subject, or the information-gathering page.

If the book analogy doesn't work for you, think of the site as a television show or a movie. Think of it as a story you're telling while sitting around the campfire. But bottom line, remember that, like any good story, there is a beginning, a middle, and an end.

So many site designers forget about flow. They don't think of the site in this fashion. They throw more and more elements onto the pages or more and more pages into the site structure—usually with neither rhyme nor reason. The general thinking is often "dazzle 'em with so much stuff they'll have to be impressed." Unfortunately, if there isn't a cohesive whole to the site, all that's happening is that the visitor is being hit with too much input and often loses sight of what is trying to be accomplished with the site.

Remember Number 5 from the movie *Short Circuit?* The robot kept crying out for "more input." Well, forget him! In the case of a Web site, more input is often the recipe for more visitors deciding not to return because there is no reason for them to do so—they've seen everything. Moreover, to find something new is a study in patience that even Job might not have. Tell a story as succinctly as possible. "Leave 'em wanting more," as PT Barnum would say. Make them come back to see what's new, and then make

it easy for them to find it—all the while remembering that the story is the main theme.

So, with that said, let's begin to create the site.

THE HOMEPAGE

There is very little to do to this page. It will have a color assigned to it and the Director file that was created a couple of chapters ago will be added to it. Links to the Flash and non-Flash versions of the site will also be added.

If you're familiar with Dreamweaver, you know that when you first start the program it will ask you to assign a root folder. This root folder is where all the files are stored and where Dreamweaver retrieves them for display not only on your desktop, but also on the Web. Dreamweaver automatically creates a path to the file based upon how you have set up the placement of the files in the root folder.

What do I mean by this? After the root folder has been created (which we'll do in a moment), for each file you add to a page associated with that site that is imported from an outside folder, you'll be asked to store it in the root folder. This will happen each time you add one of the elements you have stored in that "holding folder" I asked you to create for the files built throughout this chapter. You can create a subfolder inside the root folder, such as animations, images, and pages, and store the appropriate files in each of these. The path to that file will then include that subfolder.

So, let's start up Dreamweaver and assign the root folder. It doesn't matter where it is located on your hard drive, or you could assign the root folder to an external drive. If you do this, make sure that every time you want to work on that site you have the appropriate drive installed (especially if it's a Zip 100 or Zip 250 drive, for example).

Figure 9.77 shows the initial Set Definition for Unnamed Site window, as well as the subsequent windows that appear as you define the root folder. You'll note that this shows a site being created on a Macintosh computer. The procedure is no different between platforms—just follow the on-screen prompts to set up your folder.

Using Figure 9.77 as a visual guide, in the Define Sites window, click the New button to bring up the Site Definition window. Here you assign a site name (in this case, SummerOf66), and tell Dreamweaver where the Local Root Folder is to be built. Click the Folder button next to this field and navigate to where you want the root folder stored via the Choose Local Folder window. When you get to the area where the root folder is to be stored, click the New button on this window to create a new folder. I named this So66. Click Create, and then Choose. Click OK in the Site Definition win-

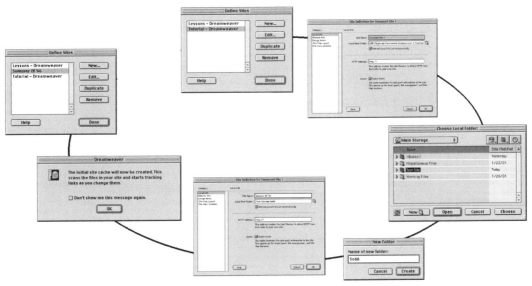

FIGURE *A composite image showing the various windows associated with setting up the root folder for the*
9.77 *site and their association with each other.*

dow. When completed, the site shows up in the list of folders from which
you can choose. Click Done, and you're off and running.

Before doing anything else—and this should become a habit with you—
go to the Site Title field at the top of the page and change the name to
Summer of '66 (or whatever your site name is). This way, when the page
loads on the Web, it will show the name at the top of the window and, if
bookmarked, will have the name assigned to the bookmark.

When it comes to the site title, I always assign the same name to each
page, rather than try to come up with a descriptive name for each one. It
just adds to the uniformity of the site.

Also, in the Toolbar (located on the left of the screen by default) make
sure that Standard view is selected in the View choices at the very bottom
of this bar.

THE ENTRANCEWAY

The Entranceway is different from the home page. This is the first page vis-
itors will come to. Plus, its layout is different from the home page, which
uses the main look for the site design. The Entranceway (or many call it
the Entrance page) is a single image—that Director animation you created

earlier in the book—with a link to the Flash-enabled and non-Flash-enabled version of the site.

First, add a Layer to the page. Layers in Dreamweaver, shown in Figure 9.78, act like a text box in a page layout program. They can be positioned anywhere on the workspace and can house everything from text to image and animation files to other Layers.

The first layer you want to lay down will act as a template of sorts. Remember, this site is going to remain at 800 pixels by 600 pixels. It makes no difference whether it's this entry screen or the main site— 800 by 600 is the max. After drawing out this layer, go to the Properties window and change the width and height to match these dimensions.

Next, we'll nest another layer inside this first layer. Nesting makes one layer sit within another and, while it remains independent for accepting elements or text that differs from the "parent" layer, if you move the parent to another location, the nested layer will move with it.

The easiest way to nest layers is to activate the layer that will become the parent by clicking on it once. Then select and either drag out or click once on the Draw Layer tool. The new layer will be nested inside the active one. How do you know if it's nested? Look at Figure 9.79. The small

FIGURE **9.78** *The Draw Layer tool, which is highlighted in this image.*

FIGURE **9.79** *The nested layer's indicator is inside the "parent" layer. This is how you can tell a layer is actually nested inside another.*

indicator square with the C inside it is inside the large layer. This shows that the layer is nested. If it were outside and immediately next to the layer selector square, it would not be nested. If you moved the "parent" layer to another place on the workspace, you would see that the nested layer moves with it.

After placing this element on the workspace, go to the Properties window and change the Width and Height to 640 × 480 (the size of the Director file). After resizing, drag this layer so it is centered in the "parent" layer as shown in Figure 9.80.

Now, drag a Shockwave placeholder into the layer you just created. You'll be asked to link to a file upon placing it.

When you select a new file to place on the workspace that is outside of the root folder, the screen you see in Figure 9.81 appears. Click Yes to have the file placed into the root folder. You get to decide where this file is stored, so in the resultant screen (shown in Figure 9.82), create a new folder called animations and store the file there.

FIGURE *The nested layer is centered inside the "parent" layer.*
9.80

FIGURE *This is the screen asking if you want to add the file to the root folder. Always*
9.81 *click Yes unless you have a very good reason not to.*

FIGURE *After telling Director to add the file to the root folder, you'll be asked where to*
9.82 *store it.*

Doing this will create a duplicate of the file. If you are short on storage space, you might want to delete the original file following this procedure.

After you have placed the Director Shockwave file, you will more than likely need to change the placeholder's size. In the Properties window, change it to 640 × 480—the same size as the Layer on which it's located.

The next thing to do is change the page color to black. The easiest way to do this is to open the Code Inspector window—Window>Code Inspector or use the F10 key—and look for the following:

<body bgcolor="#FFFFFF" text="#000000">

What you see in the quotation marks, the series of Fs and the series of zeroes, represents the computer equivalent to a color. In this case, the Fs represent white and the zeroes represent black, so the bgcolor (background color) is set by default to white, and the text is set to black. We what to reverse that. In the Code Inspector window, select the Fs and change them to six zeroes. Then select the zeroes and change that to six Fs so the code reads:

<body bgcolor="#000000" text="#FFFFFF">

When you click on the workspace, the background color will change to black. This works perfectly since the main background to the Director Shockwave file has a black border around it.

We need to add two buttons to the page, one that lets visitors choose to go to the Flash-enabled site, and one to go to the non-Flash site.

Since Dreamweaver uses the same type of design structure as a page layout program such as QuarkXPress, I have gotten into the habit of making layers for every element on a page. This way, I can control various attributes—such as placing one image over another—very easily. You'll see what I mean by that later in this chapter. For now, add another layer to the workspace and position it at the bottom left of the Director file.

These new layers that will house the buttons should be nested inside the large layer. Therefore, before placing the new layer, make sure the large one is active.

Before proceeding, save the file. Call this page index.html, since many of the Web hosting sites use index.html as the main page that appears when first accessing the Web site.

After the new layer is nested, select Insert Flash Button from the Tools window. This time, instead of just clicking on it, click and drag the Flash Button into the Layer you just placed. Upon doing this, the screen you see in Figure 9.83 will appear.

Scroll down to the bottom of the list. For this site, I used the StarSpinner button, which has a look somewhat reminiscent of the elements already created for the site.

Change the Button Text to read "Enter Flash." It makes no difference what font you use, although something easily readable is definitely preferred over trying to get fancy. Sometimes fancy can work against you, even if it is staying with an overall theme you have created.

Don't worry about linking the button to anything yet; we can do that later after creating the home page. You do, however, what to change the background color to black so it matches the page background. After you do that, simply click OK and your newly created button will appear in the layer.

Before clicking OK, you can preview what the button will do when the cursor moves over it by moving your cursor into the preview window.

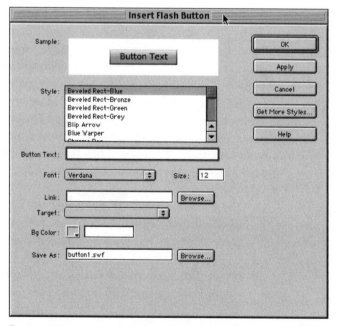

FIGURE *The Insert Flash Button window. Here you can select*
9.83 *from a series of prebuilt Flash buttons.*

Resize the Layer so it's the same size as the button. Do this by clicking on the layer itself and dragging it by one of the handles that appear.

Create another layer and position it with its right edge aligned with the bottom-right edge of the Director Shockwave layer. Repeat the preceding steps to place and create a second button. This one should read "Non-Flash."

Finally, we need to give some instructions so people know what those buttons mean. I know, I know—by now, surfers should know what these mean. However, millions of new surfers hit the Internet wave each year and you have to be aware of them. As they always say in advertising and broadcasting: "write your commercials as if you were writing for a fifth grader." (I aged that a little bit since they originally said for a two-year-old.) Create one more layer and position it between the two buttons. Click once in this layer and begin typing. Here's the text I used:

> This site utilizes Flash animations and is best viewed at
> 800 × 600 pixels.
> If you cannot view these animations, please click on the Non-Flash button to go to the non-Flash version of this site.
> If you are able to view Flash and Shockwave files, click on the Flash Site button.

Select all the text and change the settings to the following (refer to Figure 9.84):

Font: Arial, Helvetica, sans-serif
Size: 3
Style: Bold
Alignment: Centered

All that's left to do now is save the page again.

FIGURE *The Parameters window with the settings for the text we just added.*
9.84

THE HOME PAGE

Now we come to the home page, the starting point for the visitor. This is where that person will enter our world, meander through our lives, and hopefully like what he or she sees. Just as many companies know, the entranceway to their business is the most important aspect of getting potential clients to actually become clients. The entryway is that person's first experience with you. It is the defining point in a relationship. Remember, first impressions count more than you may think.

Create a new page (Command/Ctrl + N) and don't forget to title it.

Our first order of business is to place the background image; everything else will flow around that. Go to Modify>Page Properties to bring up the screen you see in Figure 9.85.

Click the Browse button next to the Background Image text field and navigate to where you have the sunbkg.jpg file stored. Select this image and then, when prompted, store it in a new subfolder titled images inside the root folder. Click OK and your image fills the screen.

Now we'll set up the layers.

The first one we'll place will act as our placement guide. Create a new layer and resize it to 800 pixels by 600 pixels—the final size of the page.

FIGURE *The Page Properties window.*
9.85

 If you have a dual monitor setup, now will be a good time to use it. That way, you can expand the workspace so you can see the entire 800-pixel width.

Nest another layer in the upper-left corner of the placement Layer. Resize it to 100 pixels by 100 pixels. This is where we'll place the So66 sun animation you built earlier. If you'd like, go ahead and put it in now by placing a Flash placeholder inside it and linking to that file.

Next, place another layer at the bottom of the page, setting its dimensions to 800 pixels by 100 pixels. Place an image placeholder inside this one, and link to the beachimage.jpg file you made. Your page should now look like Figure 9.86.

Before going any further, save this page as home.html and save it in a new folder called pages.

Have you noticed anything that is missing? Any important element that should be there, but isn't? Yes, we have the sun logo rising into the scene

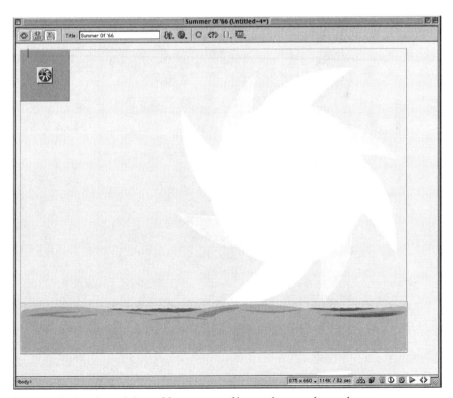

FIGURE *The beach and the So66 animation files in place on the workspace.*
9.86

and the *Summer of '66* initials, but nowhere on the page is *Summer of '66* spelled out. There is nothing to reaffirm the subject of the site.

In the Chapter 9 folder on the CD-ROM is a file called so66logo.jpg. This is a modified logo in which the sun, palm tree, and dancers have been removed, leaving only the text portion. It will fit perfectly next to the rising sun.

As discussed earlier, there are differences in the way in which browsers read the information that is being sent to them. With what we are about to do, you have to be very aware of this fact. First, try this: Select the large layer (the "parent" if you will) and drag a new layer into it. Now place an image placeholder inside this new layer. Link the placeholder to the so66logo.jpg file, and then position the layer so the bottom edge is flush with the bottom edge of the layer containing the sun animation. Figure 9.87 shows how this should be placed.

Now preview the page in Internet Explorer. If you don't have this Web browser, I would advise downloading it and having it on your system. The more browsers you can view your work in prior to making it active, the better chance of finding a problem before it's seen by millions. Figure 9.88

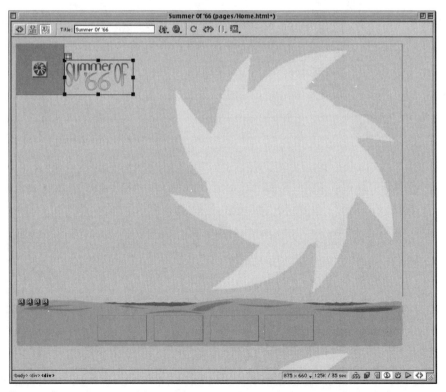

FIGURE *The text portion of the logo has been added to the home page, nested inside of* **9.87** *the main layer.*

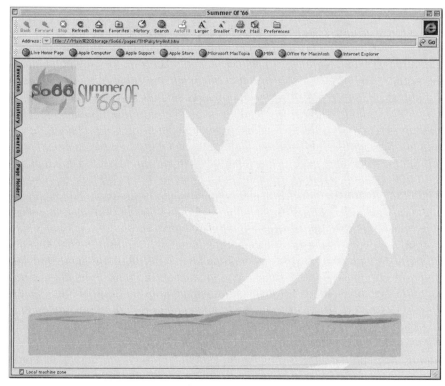

FIGURE *The home page as previewed in Internet Explorer.*

9.88

shows how this page looks in IE. It holds up well, with all elements where they should be.

Now preview the page in Netscape Navigator/Communicator. Figure 9.89 shows that there's a problem with this setup; for whatever reason, Navigator/Communicator does not read the nested layers correctly.

There is a way to fix this, though.

The layer you put this logo into should be Layer 8 in the Layers window as seen in Figure 9.90. If this window isn't open, go to Window>Layers or use the F2 key to open it. This is a wonderful screen. You can rename your layers for easier recognition, you can change what's called the Z order (which determines which layer goes on top—or in front—of another layer), or you can change the nesting structure by dragging a layer on top of another.

Before doing this, click on the layer that houses the corner animation and expand it so it's wide enough to fit the logo layer. Refer to the Layers window to see which layer this is—it should be Layer 2. After doing that, go to the Layers window and move Layer 8 on top of it.

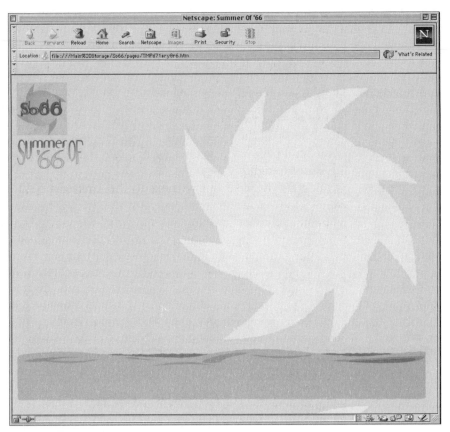

FIGURE *The nested layers prove to be a problem for Netscape.*
9.89

FIGURE *The Layers window. Here you see Layer 8 highlighted. This layer is the one*
9.90 *housing the* Summer of '66 *text image.*

Now preview your site in both Explorer and Netscape. You'll see that the logo is in the correct place in both. This is a great example of why correct nesting is so critical to the successful display of your sites.

Now, back to our regularly scheduled design work.

After saving the home.html file, we might as well go ahead and create the link from the Enter Flash button on the entranceway page. Reopen the index.html file you just finished creating. Double-click on the Enter Flash button to open the Insert Flash Button window. It's time to link this to the home.html page we're working on. Might as well do it while we're thinking about it, right?

Click the Browse button next to the Link text field. Navigate to the pages folder and select the home.html file. Click OK to set the link. Take a moment to preview the site in any and all browsers you have assigned to Dreamweaver, and make sure the link is working correctly. When finished, close the index.html file and save it when prompted.

It's now time to place the link buttons created in Fireworks. Nest a separate Layer for each button inside the layer containing the beach image, and place them as you see in Figure 9.91.

FIGURE *The layers where the rollover link buttons will be placed in their position on the*
9.91 *beach.*

This is the point I spoke about earlier; the time when we look at how to import those Fireworks rollovers we saved as both the Dreamweaver Library and HTML documents.

First, let's look at the way to import the HTML files.

Activate the leftmost rollover layer, and then click inside of it to create an insertion point. Now you can do one of two things: you can either go to Insert>Interactive Images>Fireworks HTML, or you can click on the Insert Fireworks HTML button in the Object panel. This button is located in the Common section of the Object panel. Figure 9.92 shows the former path to bringing this document into Dreamweaver.

When you do either of these, the screen shown in Figure 9.93 appears. Use the Browse button to navigate to where the Fireworks HTML file is located. For this layer, we want to use the castup.html file.

I would not recommend activating the Delete file after insertion option; otherwise, the master file will be thrown away. Even though this process will make a copy of the file in the folder you designate, being able to have the original file to fiddle with if need be can be a great help. I just hate getting rid of files because I never know when I might need them again. I have work I did 10 years ago on disks, just in case those businesses (many of which have closed their doors) might need them.

FIGURE *Use this path to insert the Fireworks HTML files you created.*
9.92

FIGURE *The Insert Fireworks HTML screen where you assign the file you want inserted*
9.93 *into the layer.*

Anyway...

Notice how the HTML code has been inserted into the site's code. Figure 9.94 shows the Code Inspector window, which can be accessed by going to Window>Code Inspector or by using the F10 key.

Some modification to the code will need to be made so that you can include the castover.html file and make the rollover take place. Like I said previously, I'm not much on adding extra work to my schedule, and writing HTML code is, to me, work. I have all the respect in the world for

FIGURE *In the Code Inspector window, the HTML code you just inserted is highlighted.*
9.94

people who can build an entire site through the writing of HTML or XML code, but it's not for me.

So, for lazy people like me, there's the Insert Rollover Image command (Insert>Interactive Images>Rollver Image). When you access this, the screen you see in Figure 9.95 appears. Here, you can assign the Up and Over buttons, and create the link with a minimum of fuss. Moreover, since the images were created and saved along with the HTML documents, they're ready to be used.

Before we assign these rollovers to their respective layers, though, I want to add the rest of the layers that will make up the main pages of the site. Refer to Figure 9.96 to see where these layers were placed.

This page, although currently saved as home.html, is going to be used as the master format for the bulk of the pages on the Web site. As you re-call, we have four main pages: Cast, Story, Audio/Video, and Trivia. These pages will each use this same layout. Using Save As, we can save this file as each of these pages. That's what you should do right now; do a Save As and name the pages cast.html, story.html, audvid.html, and trivia.html.

Why didn't I save it as a template? I could have, but then I wouldn't have a ready way to insert the rollover buttons and immediately create the link to the appropriate page. Also, I'm not planning on using this site de-sign for any future sites, so I really don't need a template file in this in-stance.

Now let's go and create some rollovers.

Activate the leftmost button layer. We'll assign the Cast button here. Go to Insert>Interactive Images>Rollover Image to bring up the Insert Rollover Image window. Name this one Cast. In the Original Image field, assign the

FIGURE *The Insert Rollover browser window. Here you can assign images for the*
9.95 *different rollover states. As you can see, the Cast rollover images are being assigned here.*

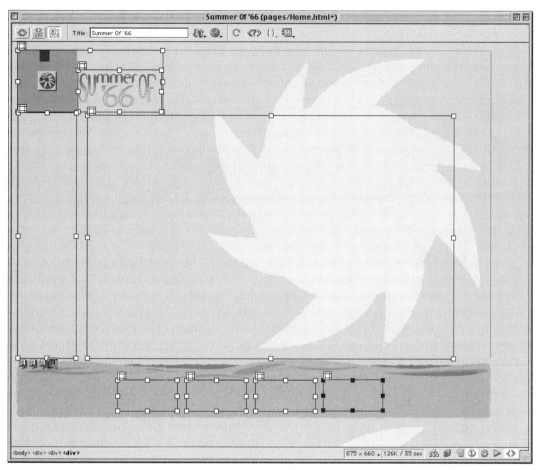

FIGURE *All layers for the page have been positioned.*
9.96

castup.jpg image. In the Rollover Image field, assign the castover.jpg image. Then, in the When Clicked Go To URL field, click the Browse button and link to the save cast.html page. Repeat this process for each subsequent layer, assigning the images as you see in Figure 9.97. The order in which I'm placing the rollovers is as follows:

Cast
Story
Audio/Video
Trivia

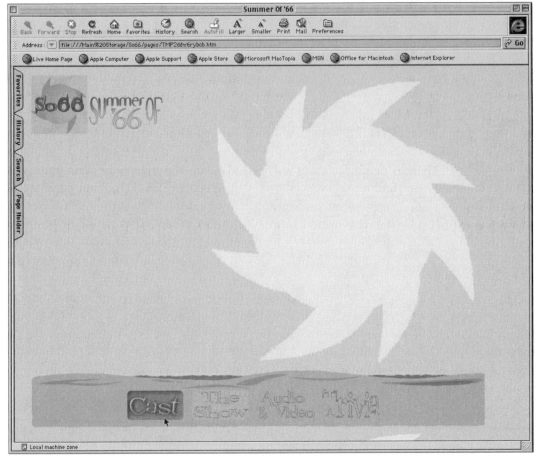

FIGURE *The rollovers have been placed, as can be seen in this preview image.*
9.97

ANCILLARY DESIGN ISSUES

You probably are wondering about that open space in the upper mid- and right quadrants of the window. This was done very purposefully. As the show begins to travel, I will be able to add information about the cities it will be coming to, or announce special offers. It's natural that the eyes start at the top of something and then work their way down, ultimately creating the entire picture we call vision. Therefore, by using that natural eye movement and placing special announcements where they will be seen immediately, I can add that much more value to the site. Again, it is information that is easily found; it's designed so there is no searching through gobs of information to find the latest news.

You can refer to the CD to see the home page in color. The rest of the site is pretty well laid out in the same manner, with different pictures (all of which are on the CD-ROM in the Chapter 9 folder), and, of course, different text. You will want to view the site at www.summerof66.com to see how these pages all flow together.

STAYING THE COURSE

There is one more thing we need to create: the trivia page. This page uses Coursebuilder extensively, as well as some SWF files I put together in Poser. You were introduced to Coursebuilder in Chapter 8. At the end of the chapter, I was pretty cruel in teasing you with some trivia questions, but not giving the answers to them. After this section of the chapter, you'll be able to amaze your friends and family with your acute knowledge of the 1960s—and if that's not worth the price of admission to a Saturday matinee, I don't know what is.

Let's refresh our memories regarding the questions we'll be asking.

The first page will be multiple-choice questions.

Q1: In what show did the host say "I see Tommy. I see Jane. I see Frankie. And I see you, too"?
 a. *The Big Valley*
 b. Walt Disney on *The Wonderful World Of Disney*
 c. *Romper Room*

Q2: What group sang *I Think I Love You* and *C'mon Get Happy*?
 a. The Cowsills
 b. The Monkees
 c. The Archies
 d. The Partridge Family

Q3: What was introduced at the 1964 World's Fair and cost the exorbitant price of $2,368?
 a. The first home computer
 b. The refrigerator of the future with built-in ice maker
 c. An around-the-world flight on a jumbo jet
 d. The Ford Mustang

Q4: What was Thurston Howell's pet name for his wife?
 a. Snookums
 b. Lovey
 c. Doll Face
 d. Dingbat

Q5: Finish this phrase: "Up and at 'em, _____."
- George of the Jungle
- Will Robinson
- Atom Ant
- Speed Racer

Meanwhile, the second set of questions are fill-in-the-blank.

Q1: What group sang the song *Blowin' in the Wind*?
Q2: What is the name of Buffy and Jodie's older sister?
Q3: What did Agent 86 have in his shoe?
Q4: What did the astronauts drink while in orbit?
Q5: Coca-Cola wanted to teach the world to do something. What was it?

Let's get started with building this section of the site.

First, open one of the existing site pages and remove every layer except for the one that houses the beach and the rollovers. Nest a new layer inside the main layer. This is where we will nest the Coursebuilder questions.

With this new layer active, click on the Insert Coursebuilder Interaction button in the Objects window. Click OK on the screen seen in Figure 9.98.

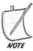 *It takes a few seconds for all the files to be copied. These files include all image files for the buttons, and the graphics that make up the look of the screens.*

The Multiple Choice design is the default layout that comes up for the Gallery choices in the Coursebuilder Interaction window shown in Figure

Copy Support Files

The support files will be copied to the following locations:

Scripts: file:///Main Storage/So66/pages/scripts
Images: file:///Main Storage/So66/pages/images

Options: ☑ Copy images (recommended)

☑ Overwrite existing image files

The script files must exist to use the CourseBuilder Interactions.
The image files are needed by the Interactions which contain graphics.

[OK]　[Cancel]　[Help]

Figure **9.98** *By clicking OK on this screen, Coursebuilder will set up all the necessary folders and transfer all the needed files to your root folder.*

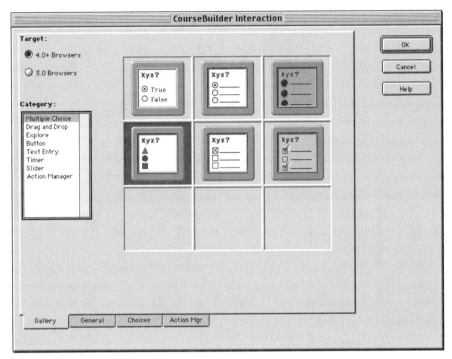

FIGURE *The Coursebuilder Interaction screen with Multiple Choice selected.*
9.99

9.99. To keep with the overall theme of the site, I chose the design that is located at the left in the second row.

On the next screen, seen in Figure 9.100, type in the first question in the Question Text field.

Set the following parameters for this (and all subsequent Multiple Choice screens):

Judge Interaction: When the user clicks a choice
Correct When: All Correct and None Incorrect
Tries Are Limited To: 3
Time Is Limited To: 30 (seconds)
 Reset: Activate

Use Figure 9.101 to help you with this set-up.

Click on the Choices tab to move onto the next screen.

In the Choices window, click on Choice 1 (correct). It won't be correct, but we'll change that in a moment. Then do the following:

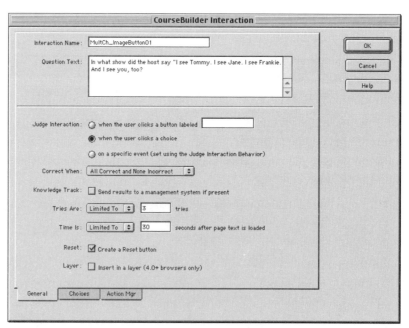

FIGURE *Here is the first question on the way to stumping our online contestants.*
9.100

FIGURE *The settings for the Multiple Choice questions.*
9.101

Name: Leave as is
Text (optional): Sesame Street
Place Before Text: Deselect
Appearance: Sphere Blue (for all the choices)
Choice Is: Incorrect.

All of the settings will remain the same for each choice. Following are the answers, in order, and the Choice Is setting:

Choice 2—Text (optional): The Big Valley (Incorrect)
Choice 3—The Wonderful World of Disney (Incorrect)
Choice 4—Romper Room (Correct)

Once you have put in the answers, click OK.

I did some dressing up to the page, horizontally resizing the Coursebuilder layer, adding a text layer, and an animation you'll find in the Chapter 9 folder on the CD-ROM titled tappinglip.swf. This was a Shockwave file I made in Poser. You can see what the page looks like in Figure 9.102.

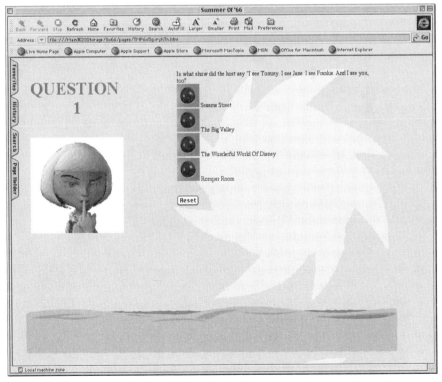

FIGURE *The first page of the interactive quiz, which was gussied up with a silly*
9.102 *Shockwave animation created in Poser.*

The next thing to do is create a link button to the next page in the quiz. Create a new layer to the right of the Reset button as shown in Figure 9.103. Nest a Flash Button placeholder inside this new layer, and use the same one that we used for the entrance page built earlier in the chapter.

Save this page as trivia01.html, and then input the next question and its answers. Save the pages in numerical order. The easiest way to do this is to select the question and go to Modify>Coursebuilder>Edit Interaction. This way, you can assign new questions and answers, and then save the page using a different number in its title.

Let's go over building the Fill In The Blanks questions and how to set those up.

First, you will have to remove the Coursebuilder interaction entirely from the layer. You can't edit the interaction and change the type of inter-activity assigned to it. So, after you delete the multiple-choice elements, click on the Insert Coursebuilder Interaction button and choose Text Entry from the Gallery window. For these questions, we'll use the first text field layout shown in Figure 9.104.

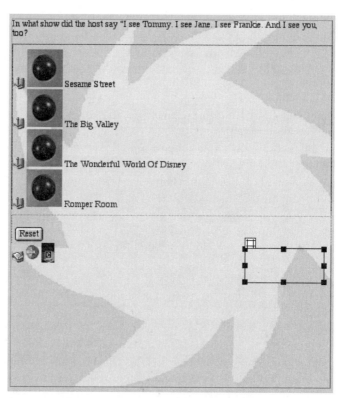

FIGURE *Add a new layer to the right of the reset button that will*
9.103 *be used to link to the next page of the quiz.*

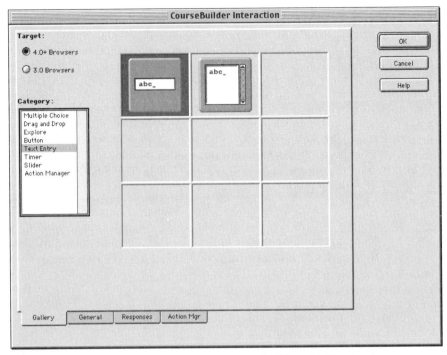

FIGURE *Use this text input layout when designing the fill-in-the-blank quiz.*
9.104

In the Initial Text field, write in the question. In this instance, it's "Who sang 'Blowin' in the Wind'? Tries will be limited to three, and the time allotted for answering the question is 60 seconds. Everything else on the screen remains the same.

In the Responses window, which is set up virtually the same as in the Multiple Choice window as you can see in Figure 9.105, assign answers for the question and the correctness of that response. For the most part, it's best to leave case sensitive unselected.

When a wrong answer is given when using this format, the participant will get a screen as shown in Figure 9.106.

As you can see, it's not difficult to set up interactive areas for your visitors. They can be a lot of fun—not only for the site visitor, but for you as well.

Also, as promised, here are the answers to the rest of the questions:

Q2: What group sang *I Think I Love You* and *C'mon Get Happy?*
The Partridge Family

FIGURE *The Responses window is a virtual duplicate of the one for Multiple Choice*
9.105 *answers.*

Q3: What was introduced at the 1964 World's Fair and cost the exor-
bitant price of $2,368?
The Ford Mustang

Q4: What was Thurston Howell's pet name for his wife
Lovey

Q5: Finish this phrase: "Up and at 'em, _____."
Atom Ant

Q6: What group sang the song *Blowin' in the Wind?*
Bob Dylan and **Peter, Paul & Mary**

Q7: What is the name of Buffy and Jodie's older sister?
Sissy

Q8: What did Agent 86 have in his shoe?
A Phone

Q9: What did the astronauts drink while in orbit?
Tang

Q10: Coca-Cola wanted to teach the world to do something. What
was it?
To teach the world to sing

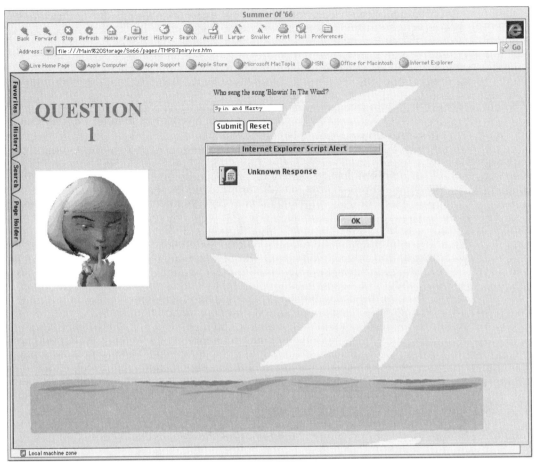

FIGURE *The screen that appears when a wrong answer is given.*
9.106

GETTING A DESIGN ON THE WEB

There is so much to learn when it comes to designing for the Web—and so much to consider. If you think about it, trying to come up with an interesting, eye-catching, original layout for a site—or for multiple sites—is a very tough thing to do. But then, so is laying out the pages of a magazine, putting together a television show, or just finding a few extra moments for yourself. The fun comes in the challenge, and the challenge is definitely waiting for you to meet it.

Through the course of this book, you were hopefully able to get a better handle on the ways the family of Macromedia programs can work in

conjunction with each other to make your Web design life a little easier. Each program is an extremely professional package, and it would take thousands of pages to go over every detail about how to use each one thoroughly. However, that wasn't what this book was about. It was designed to help you come up with new ways of looking at Web design, of how to save time (and ultimately money) by using these packages as they are meant to be—a cohesive whole that gives you the ability to design the best sites you possibly can.

We are also on the cusp of new and more exciting advancements in how our products can be distributed. With greater hardware portability, wireless access, access via telephones, the increasing presence of broadband that will soon lead to our TVs being the main means of accessing the Web—it's mind-boggling and almost impossible to keep up with. However, if you stick with the tried-and-true methods—tell a story from beginning to end and don't oversell yourself or your client by adding too much content—you'll soon be on the forefront of what is being presented on the Web.

APPENDIX

Software Information

The following is a list of software companies, their URLs, and the programs they produce. Each company is discussed in this book.

MACROMEDIA

www.macromedia.com

Dreamweaver 4
Dreamweaver 4 UltraDev
Flash 5
Fireworks 4
Freehand 9
Director 8 Shockwave Studio

THIRD-PARTY SOFTWARE MANUFACTURERS (IN ALPHABETICAL ORDER)

COOLFUN

www.coolfun.com

Illusion (Win): A special-effects program that creates particle-systemlike animations such as waterfalls, fireworks, and lava flows.

CURIOUS LABS

www.curiouslabs.com

Poser 4 (Win/Mac): A 3D humanoid and character animation program.

Poser 4 Pro Pack (Win/Mac): An update to the popular Poser program that includes the capability to create Flash animations.

ELECTRIC RAIN

www.erain.com and www.swift3d.com

Swift 3D (Win/Mac): A 3D text and graphic creator for Flash.

LASSO STUDIO FROM BLUEWORLD

www.blueworld.com

MEDIA LAB

www.medialab.com

TECHSMITH

www.snagit.com

SnagIt (Win): A powerful screen-capture utility for Windows.

Effector sets: A set of Lingo scripts for Director.

Photocaster: A set of Lingo effects scripts for Director.

PhotoWebber: A stand-alone application that allows you to build entire Web pages and manage photographic images.

WILDFORM

www.wildform.com

SWfx (Win): Lets you create complex text animations.

Flix (Win): Lets you convert AVI and QT video files to SWF format.

APPENDIX

What Is Included on the CD-ROM

The companion CD-ROM is jam-packed with files, videos, and program demos that enhance the use of this book.

DEMOS

Demonstration versions of all the Macromedia products discussed in the book are provided, including:

Flash 5
Fireworks 4
Dreamweaver 4
Freehand 9
Director 8

These are time-limited programs. To upgrade to the full versions, please visit www.macromedia.com.

OTHER DEMOS ON THE CD-ROM

SnagIt (Win only) from TechSmith
Illusion 1.1 (Win only) from Coolfun
SWfx (Win only) from Wildform

FONTS

The folks at FontDinerDotCom (www.fontdinerdotcom) provided the following fonts for both Mac and Windows:

Fontdinerdotcom
Fontdinerdotcom Loungy
Fontdinerdotcom Sparkly

FILES

There are over 100 image, vector graphic, and QT/AVI video files that correspond with the chapters in this book. You can find the files in the appropriate chapter folder. You'll find Director 8 files for you to modify, original photographs from the *Summer of '66* stage productions, music clips, and files created specifically for this book.

Take a few moments to browse the CD-ROM to see all the cool stuff at your disposal.

Index